# OCEANS

## EXPLORING THE HIDDEN DEPTHS
## OF THE UNDERWATER WORLD

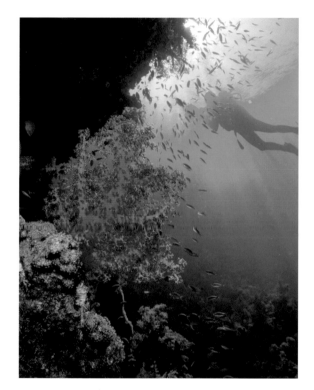

PAUL ROSE & ANNE LAKING

# OCEANS

## EXPLORING THE HIDDEN DEPTHS
## OF THE UNDERWATER WORLD

UNIVERSITY OF CALIFORNIA PRESS    BERKELEY    LOS ANGELES

# CONTENTS

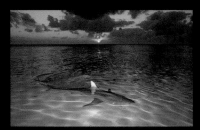
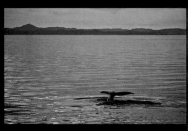

# FOREWORD

A POLAR BEAR LUMBERED PAST ME as I stood on the bow of the *Lance*, a north Arctic research vessel and my home for the past three weeks, to survey the heavens. It was 3 a.m. but in the land of the midnight sun I was staring into a near-perfect summer sky, while being surrounded by a stark, white desert of ice.

Securely ensconced in pack ice just a few hundred miles south of the North Pole, I reflected that a year-long odyssey around the oceans of the globe was coming to an end. From Mexico to Eritrea, from the Arctic down to Tasmania we had explored and documented some of the oceans' deep, dark mysteries – no small undertaking for our team: Paul Rose, a fearless diver, explorer and expedition leader; Tooni Mahto, an intrepid oceanographer and marine biologist; Lucy Blue, a pioneering maritime archaeologist and me. Together we had embarked on a great adventure underpinned with serious scientific ambition.

Bathed in a polar glow, my mind wandered back a few months when, off the coast of Sudan, I was staring down rather than up, into the shimmering moonlit waters of the Red Sea.

Coming face to face with five enormous sperm whales or being surrounded by hundreds of giant, cannibalistic Humboldt squid, these expeditions with the *Oceans* team had seen their fair share of excitement. But Sudan had special significance for me. Not 45 years earlier my father Philippe Snr, an accomplished diver who died in a seaplane crash before I was born, explored these waters. Sitting under the same stars that once looked down on my father, I found myself wondering what he was thinking during his great undersea adventure. Did he share the same hopes and dreams for the future of our planet as I? Did he know a similar fear for what might occur if we did not fight harder for a sustainable future? He once wrote, 'Adventure is where you lead a full life.' Well, this year has been a full life indeed.

Of course, these expeditions have raised similar questions for all of us. We had faced some of the greatest challenges of our lives and somehow not only survived but became stronger. We were a team united by the bonds of shared passion for exploration. Tooni called it a pilgrimage and that seemed to fit. For us the oceans not only stirred a sense of adventure but washed over our very souls.

The oceans are the life support system of this planet. They regulate climate, provide the primary food source for over two billion people and contribute up to

ABOVE *United by a shared passion for exploration; maritime archaeologist Lucy Blue (left) and Philippe Cousteau.*

70 per cent of the oxygen we breathe. They cover two thirds of our world and yet we have explored less than five per cent of them. As the author Arthur C. Clarke once remarked, 'How inappropriate to call this Planet Earth when clearly it is Planet Ocean.'

But our exploration came with a psychological price as we witnessed first hand the heavy toll that humanity has wrought on this planet. From tuna farms in the Mediterranean and the shark fin harvest off Mozambique to the thinning ice cap of the Arctic, the oceans are changing rapidly and humankind bears the burden of blame.

While this year has been an amazing adventure for me the best aspect of it all was a chance to share it with the rest of the world. Through film we have captured rare glimpses of some of the greatest phenomena and wonders that lie beneath the waves. In hindsight I think that the more we learned, the more we felt a sense of urgency to tell these stories before it is too late. The consequences of ignorance, like those of irresponsibility, can be fatal. It is my sincere hope that through this work we will make more urgent still the chorus of voices crying out to save the oceans among a new generation connected by a common dream, a universal hope and united by our search for a better tomorrow.

*Philippe Cousteau*
Summer 2008

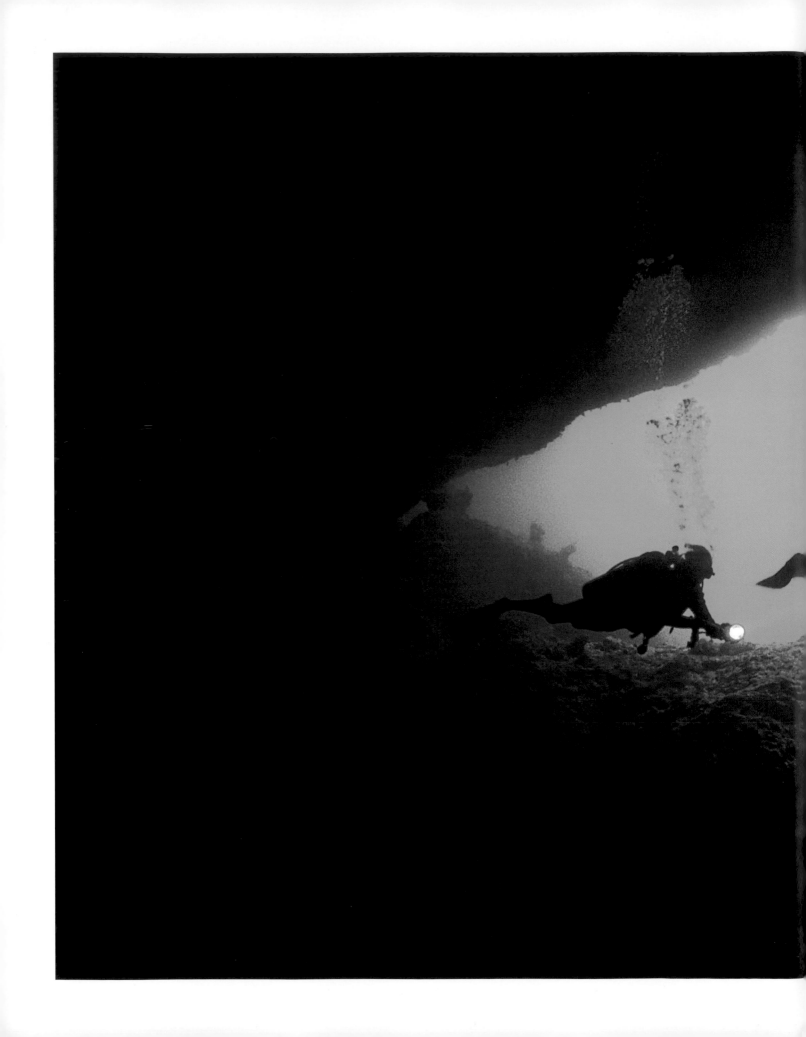

# INTRODUCTION

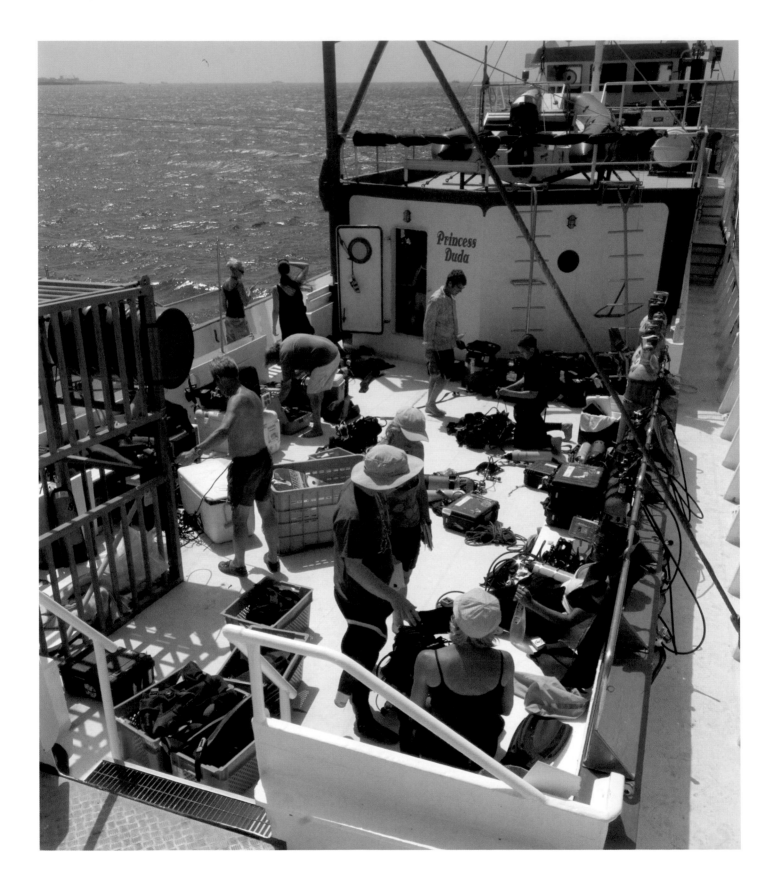

IT WAS THE FIRST DAY of a meticulously planned, year-long quest to reveal the secrets of the planet's oceans and immediately we'd hit a problem. A 25-strong team with 150 heavy boxes of technical gear, 40 suitcases and a shark cage was gathered on the harbourside ready to board, but the dive boat that was to be our home and transport for the next 15 days was nowhere to be seen. A boat is pretty fundamental to the success of any venture focused on the planet's oceans but *Princess Duda* was still several days away, chugging ponderously through the Mediterranean. It was an inauspicious start to a bold endeavour that would lead to cutting-edge exploration of the seas and oceans of the world. There was just the tiniest, barely acknowledged slither of concern that perhaps this entire venture was a tad too ambitious.

*... a remarkable adventure ... that was mesmerizing, sometimes hazardous and largely unknown.*

A year later and we all agreed that the mission had indeed been audaciously ambitious. We had laboured through storms, illness, equipment failures, life-threatening accidents, and close encounters with hostile military. But despite all that, no one on the trip would have swapped a single moment. It was a remarkable adventure that took us into the realms of an underwater world that was mesmerizing, sometimes hazardous and largely unknown. We were pushing back the boundaries of our personal knowledge in unseen oceans as well as extending scientific knowledge

## HOW LITTLE WE KNOW

To most of us, seas and oceans are flat, featureless expanses. On a good day, the vast mirrored surfaces stretching endlessly towards the horizon provide a picturesque foil for a sunset. Yet these glassy surfaces hide an utterly extraordinary world inhabited by curious creatures that are often rare and elusive. The seas teem with life, which barely causes a surface ripple. Four fifths of all life on earth is found below the waves and there is still much to be discovered in the depths of the deep blue. There are mountains that dwarf the Himalayas, waterfalls bigger than Niagara and more active volcanoes than anywhere else on the planet. Beneath the South Pacific in 1993 scientists located the largest known concentration of active volcanoes, a group of 1133 volcanic cones and seamounts in an area the size of New York State. The mid-ocean ridge, a chain of mountains that runs through all the great oceans, is 37,300 miles long, with an average height of 3000 metres above the ocean floor. Together, the oceans make up an unimaginably vast environment wrapping around more than 70 per cent of the surface of the planet.

OPPOSITE *Several days later than planned, the Oceans team loaded its technical gear, luggage and a shark cage on to the* Princess Duda*. When the ship finally got underway, it marked the start of a year-long quest to investigate and report on the health of seven of the world's seas and oceans.*

PREVIOUS PAGE *Four fifths of all life on earth is found under the seas, which cover more than 70 per cent of the planet. The team set out to investigate this extraordinary nether world in eight expeditions which included more than 1000 dives.*

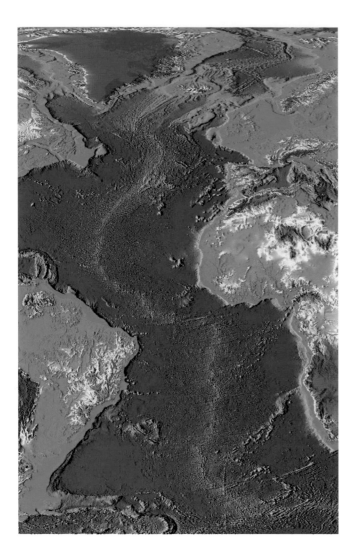

This is the world we scan with barely a second thought during flights or voyages to foreign destinations. It's on the edge of our consciousness. But the seas have always been vital for mankind. They have shaped our history and now our very survival depends on them. The seas and oceans allowed global exploration, which assisted immeasurably in the progress of the major civilizations. Their rich harvest steered commercial growth from ancient times and the seas helped to model political destinies, being the theatres for decisive battles.

Today, the oceans provide over half the oxygen we breathe, via the photosynthesis of millions of tonnes of microscopic plankton. The marine life the seas sustain provides food and livelihood for billions of people. Ocean currents drive the weather and climate system of every country in the world.

As for the future, rising sea levels are threatening many coastal populations. Salt waters are becoming more acidic due to the absorption of greater amounts of carbon dioxide and this is damaging the marine food chain. Meanwhile, warming seas could trigger a change in the ocean systems that maintain our climate, perhaps causing a devastating catastrophe that inevitably accompanies extreme weather.

And yet, despite its pivotal importance, remarkably little is known about the wilderness of our oceans. Indeed, we know more about the surface of Mars than the deep ocean floors. Scientists estimate that there may be as many as a million new species out there waiting to be discovered and, while the dry lands of the earth are now almost completely known, the vast majority of the sea bottom is unmapped and unexplored.

## THE *OCEANS* EXPEDITION

Given this lack of knowledge, it seemed like a perfect time to launch a series of global ocean expeditions to probe at least some small part of the planet's seas. It proved to be an irresistible project and we were able to assemble a crack team of ocean experts. Explorer and expedition leader Paul Rose, ex-base commander of the British Antarctic Survey and dive trainer to the US

navy; renowned maritime archaeologist Lucy Blue; marine biologist and oceanographer Tooni Mahto; and conservationist Philippe Cousteau, grandson of the well-known underwater pioneer Jacques Cousteau. All have individual specialist expertise but they are united by one thing: a lifelong passion for the sea. As Tooni Mahto put it, 'When I was a kid, I wanted gills. Other kids wanted wings – I wanted gills.'

It was a bold, almost excessively bold undertaking. Over the course of a year we set up eight separate expeditions to seven different seas and oceans across the globe, every one crammed with a range of strenuous and energetic investigations. For each, we needed a ship, diving equipment, a great crew and at least three weeks. All of them were filmed for a television series, in which our aim was to seek out the hidden stories of our oceans, to observe some of the oddest inhabitants of the seas and to chart some of the complex and surprising changes that are taking place. And ultimately, to understand better how much we rely on these enigmatic and alien places.

Here's a swift snapshot of what this entailed:

▶ More than 1000 dives.
▶ More than 700 hours spent under water.
▶ Eight expedition ships, which ranged from a beautiful hand-built yacht to a worn-out converted cargo ship and a brilliant Norwegian ice-breaker.
▶ One director detained by the authorities.
▶ One ship boarded by the authorities several times and impounded once; and numerous bouts of seasickness.

> 'When I was a kid, I wanted gills. Other kids wanted wings – I wanted gills.'

OPPOSITE *The dive team stretch their sea legs in advance of more than 700 hours under the waves.*

Additionally, there were close encounters with African shipwreck-salvage divers, the Eritrean army and any number of bureaucrats from port authorities and government departments. In short, 25 people travelled the world with around 2 tonnes of equipment, which we packed, carried, shipped, assembled, re-paired, loved and hated.

The team were already armed with a list of fascinating facts about the oceans:

▸ The oceans represent over 99 per cent of the living space on earth.
▸ Earth is the only planet or moon in our solar system that has liquid water on its surface. Ours are the only oceans in the solar system.
▸ The oceans are continually growing. This is because the rocks on the sea floor are being created anew at the mid-ocean ridge and pulled back into the earth at deep trenches and island arcs. The sea floor is new compared to the continents.
▸ The highest ocean waves are known to be higher than 30 metres from trough to crest, and occur more often than previously thought. These waves, now being identified by satellite surveillance, are an obvious danger to ships.
▸ If mined and shared among the world's population, all the gold suspended in the world's sea water would amount to more than 8¾ pounds per person.
▸ A new species is discovered during almost every deep-sea dive.
▸ Humans consume 90 million tonnes of animal protein from the ocean every year – the equivalent in weight to more than 900 fully armed aircraft carriers.
▸ If the thermohaline circulation system ('global conveyor belt') collapsed the Gulf Stream could switch off and Britain might have the same climate as Alaska.
▸ Oceans house the oldest living creatures on earth. In the 1980s, living stromatolites found in the Bahamas were estimated to be about 2000 years old.
▸ Our blood is as exactly as salty as the sea.
▸ If all the oceans were to evaporate, the entire planet would be covered by a layer of salt 50 metres (half a football pitch) thick.
▸ The average depth of the oceans is about five times the average elevation of the land. The deepest part measures 10,924 metres, in the Marianas Trench near Guam. If the world's highest mountain, Mount Everest, was placed in the trench it would be covered by over 1¼ miles of water.
▸ The average time a water molecule spends in the oceans is 3200 years.
▸ Water that sinks in the Arctic will surface 150–250 years later on the equator. The direction of the crucial current that takes it there is changing, due to alterations in the sinking effect in the Arctic.
▸ The Gulf Stream transports 55 million cubic metres of water per second. This is more than 50 times the flow of all the rivers in the world.
▸ The weight of all the plankton in the oceans is greater than that of all the dolphins, fish and whales put together.
▸ Some of the types of plankton that form red tides produce the most potent nerve poison known to man. Depending on the species, they can cause paralysis or trick all the nerves into firing constantly. Other plankton blooms can cause people to lose their memory.

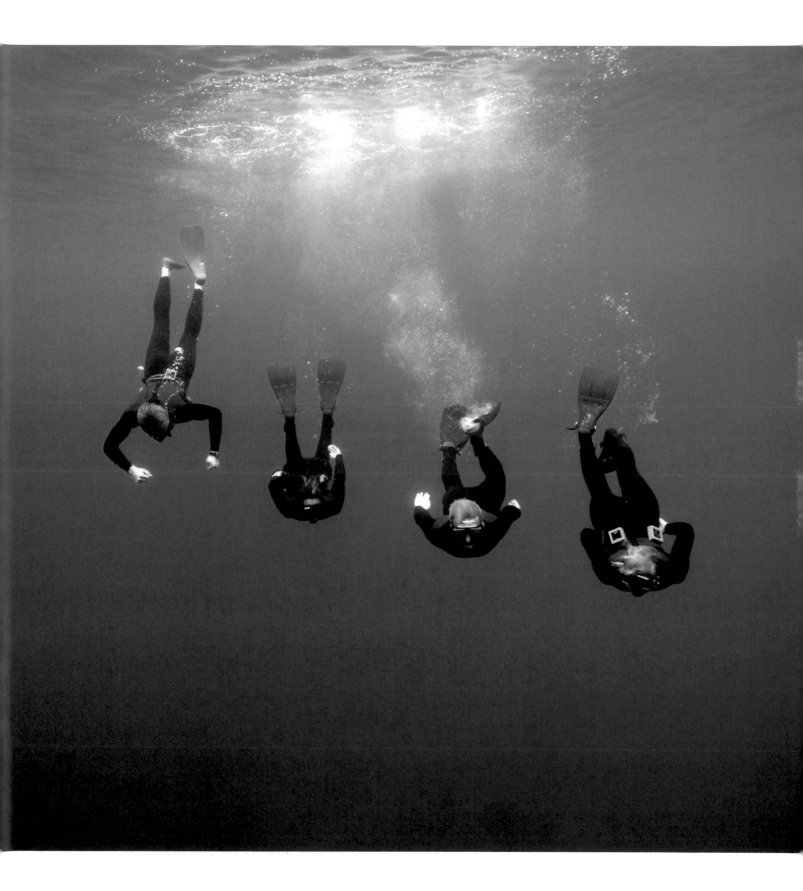

## MORE QUESTIONS THAN ANSWERS

OPPOSITE *The dive team took full advantage of their opportunity to dive on some of the world's most beautiful coral reefs.*

OVERLEAF *These maps illustrate the locations of the seven oceans and seas that the team visited and also indicate the routes taken around them.*

The dives telescoped the 'great climate conveyers', the ocean currents, into human scale.

But there was much more to discover. The *Oceans* team found underwater caves that preserved the remains of lost civilizations, and wrecks that spoke of ancient battles; they saw rare and endangered creatures that are clinging to survival, and swam with ocean leviathans that dwarf mere humans; they dived in extraordinary, almost alien, marine environments: pitch black waters turned purple by toxic bacteria, and eerie tannin-stained waters that housed bizarre deep-sea creatures. They dived between the edges of the earth's crust to see how oceans are formed and found one of the last remaining places to see the creatures that brought life to the oceans 3.5 billion years ago; rock-like objects called stromatolites that were the first life forms to pump oxygen into the sea and the atmosphere. They dived into a throng of sharks to test out a new shark repellent – and were relieved to find it worked! They observed rarely seen behaviour in sperm whales, and in the Arctic, found a potentially new species of amphipod – a great find as these tiny creatures provide a crucial link in the entire Arctic Ocean food chain.

There were numerous other highlights, including a rare encounter with a green-eyed sixgill shark, a dive alongside Seri Indians using rudimentary gear fashioned from a paint-spray compressor and a beer barrel, and swimming among the terrifying Humboldt squid. They saw thermal vents and underwater volcanoes, dugongs and weedy sea dragons. The dives telescoped the great 'climate conveyers', the oceans currents, into human scale.

They found evidence of the changes wrought by mankind: warming seas destroying unique ecosystems, overfishing decimating entire species and pollutants triggering a catastrophic invasion of predatory squid. But there were also signs of hope: coral that might harbour a special heat-resistant algae that could also protect the other coral of the world, scientific projects that could restore balance to the seas, and marine creatures that display remarkable abilities to adapt to their changing world. They found out how coral grown in nurseries could replenish damaged reefs. And they were the first to film the fluorescence in Eritrean corals. The phenomenon remains a mystery to scientists who still don't know whether it is part of the coral survival strategy.

The *Oceans* team travelled to nearly all the oceans of the world and several of its seas. And remarkably, each one turned out to have a distinct character, and added its own piece to the enigmatic puzzle that is our marine world.

The salt-lined Mediterranean, with its turbulent straits as well as sun-kissed beaches, is littered with relics from the ancient past, and this trip revealed how the seas have played a crucial role in shaping civilizations.

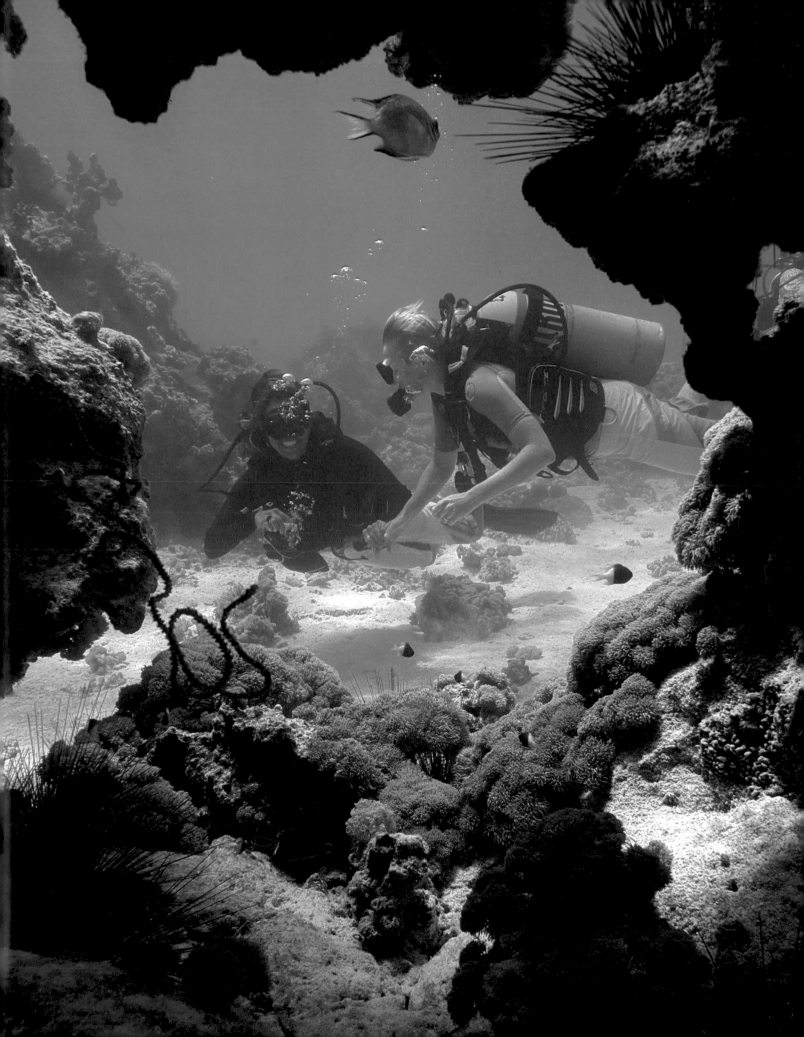

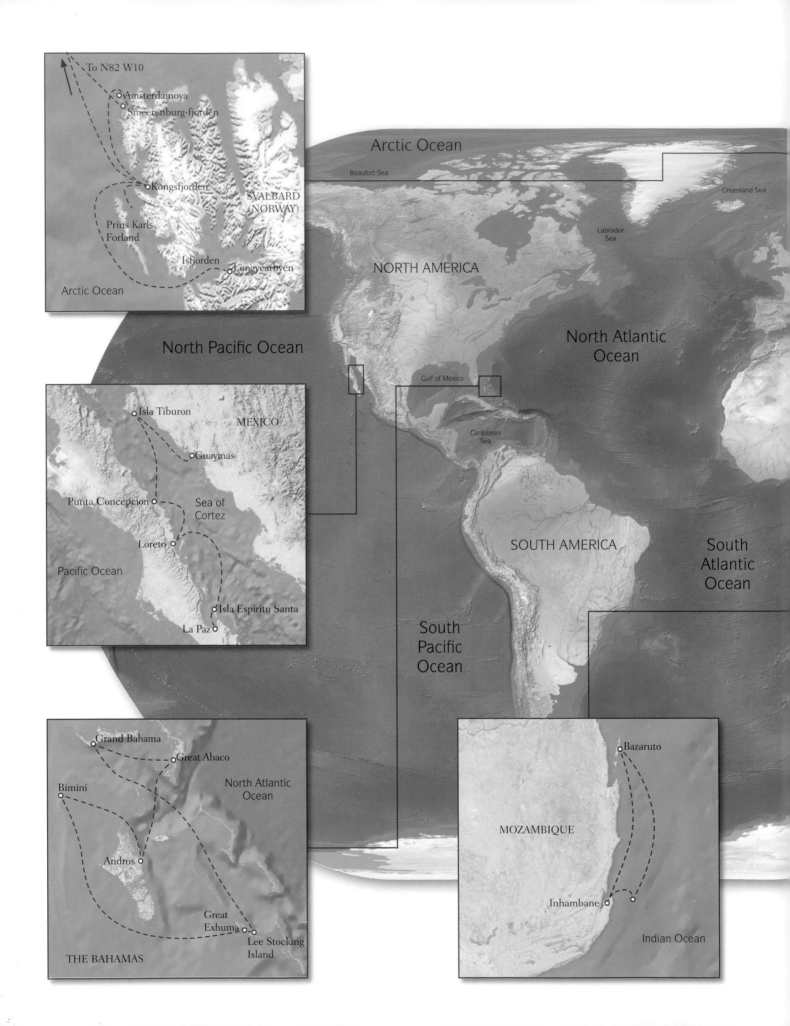

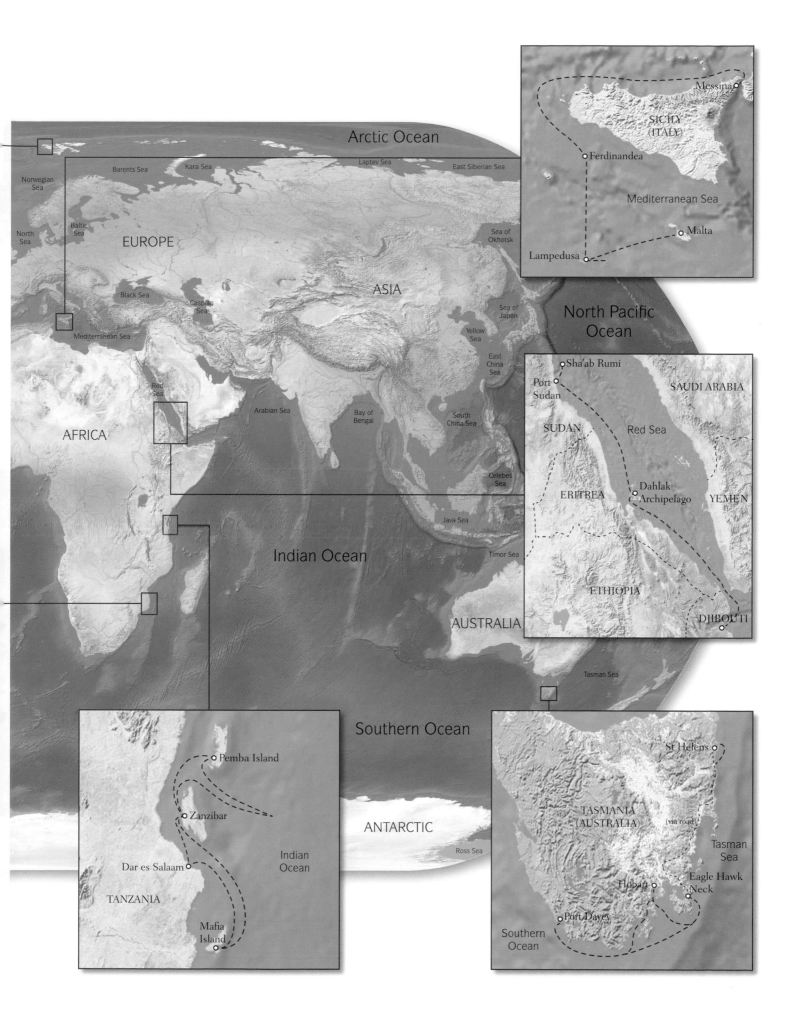

Arctic Ocean

Norwegian Sea

Barents Sea

Kara Sea

Laptev Sea

East Siberian Sea

North Sea

Baltic Sea

EUROPE

Black Sea

Caspian Sea

Mediterranean Sea

AFRICA

Red Sea

Arabian Sea

ASIA

Sea of Okhotsk

Sea of Japan

Yellow Sea

East China Sea

South China Sea

Bay of Bengal

Celebes Sea

Java Sea

Indian Ocean

Timor Sea

AUSTRALIA

Southern Ocean

Tasman Sea

ANTARCTIC

Ross Sea

Messina

SICILY (ITALY)

Ferdinandea

Mediterranean Sea

Malta

Lampedusa

North Pacific Ocean

Sha'ab Rumi

Port Sudan

SAUDI ARABIA

SUDAN

Red Sea

ERITREA

Dahlak Archipelago

YEMEN

ETHIOPIA

DJIBOUTI

Pemba Island

Zanzibar

Dar es Salaam

TANZANIA

Mafia Island

Indian Ocean

St Helens

TASMANIA (AUSTRALIA)

(via road)

Tasman Sea

Hobart

Eagle Hawk Neck

Port Davey

Southern Ocean

The Sea of Cortez is renowned for its abundant life, especially whales, sharks and dolphins. But it was also the place we discovered the surprising and unpredictable impact of human activity. While overfishing has decimated the population of hammerhead sharks here, the team observed that sea lions were showing signs of successfully adapting to their changing environment.

Measuring the frantic currents of the Indian Ocean could help predict the climate of the future, and the *Oceans* team was on hand to play its part. This mighty sea revealed the immense power of the ocean as we saw how it carves islands and drives cataclysmic storms across the land.

The world's youngest and saltiest ocean, the Red Sea, is one of the most important: it was here that early humans first crossed out of Africa and eventually populated the entire globe. The team found evidence of their first encounters with the sea. In these warm waters the divers sank in leisurely fashion between tectonic plates whose unbidden movement causes deadly earthquakes and tsunamis. And they swam in the slipstream of underwater pioneer Jacques Cousteau, who had set up an experimental underwater village in the Red Sea two generations ago.

The Atlantic is the second largest of all the world's oceans. Despite its size, it was the first to be crossed by boat and by plane and so showed how oceans could be used to bridge cultures and continents. It is also home to the Gulf Stream – one of the most important currents on the planet.

The mysterious Southern Ocean, where the waters of the Atlantic, Indian and Pacific Oceans mingle, is also the biggest carbon sink in the world, and has an elementary effect on weather patterns.

The Arctic is the smallest of the world's four oceans, at just one and a half times the size of the US. And the lowest temperature ever recorded was here, at a bone-chilling minus 68°C. However, the Arctic is the fastest warming region on the planet. Thanks to polar amplification, the effects of global warming are two or even three times greater here. Our dives underneath the polar pack ice revealed the scale and speed of change in the Arctic. In our lifetimes the Arctic Ocean will change so much that it will become unrecognizable to us.

At the end of 12 months the challenge had been embraced. We had evidence, film, photos and eye-witness accounts of some marvels for mankind to share. But, as the divers hauled themselves out of the water for the last time, the overwhelming feeling was not one of relief, or even of a job well done. It was that there were still more questions than answers as far as the world's oceans were concerned. We know more than ever before – but there is still more, much more, to know.

OPPOSITE *Paul Rose and Tooni Mahto survey the scene, on board the* Odalisque *off the coast of Tasmania.*

Measuring the frantic currents of the Indian Ocean could help predict the climate of the future …

# THE MEDITERRANEAN

## Cradle of Western Civilization

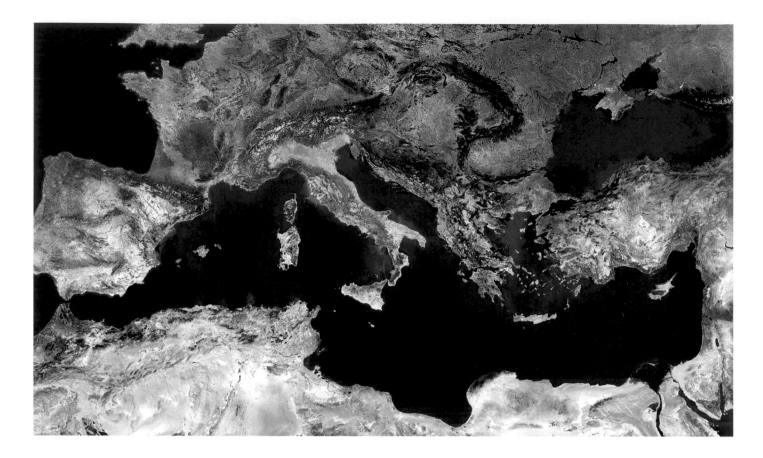

IN 1961, MARINE GEOLOGIST WILLIAM B. RYAN and senior oceanographer John Brackett Hersey, armed with a newly developed seismic profiler, set out to explore the floor of the Mediterranean Sea. Their trip was long and arduous, made more tiresome by apparently aberrant readings from this newfangled echo sounder. But as they progressed it became clear that these were not, in fact, faulty readings.

Rather than the bedrock they had been expecting to find on the seabed there was, in fact, something entirely different, which accounted for the extraordinary results. Ten years and one deep-sea drilling project later it was finally proved that the seabed was covered by a layer of salt, over 1¼ miles deep.

This discovery was nothing short of astonishing. The layer of salt, nearly as high as the Alps, could only mean one thing – that the meandering Mediterranean Sea, which covered an area of 965,000 square miles and held 1.1million cubic miles of water, must have once completely dried out. As scientists pieced together the geological data, a fascinating story emerged.

## THE EARTH MOVES

At some point, about 6 million years ago, the African and European tectonic plates moved together, closing the ring around what was then called the Tethys Ocean. The ocean was landlocked. With no water flowing in from the

neighbouring Atlantic, its levels started to plunge. In addition, the volume of water from the rivers feeding into it was far less than that lost from its surface through evaporation and so, over a period of about 2000 years, this great sea simply disappeared, leaving nothing but a thick layer of salt. All marine life vanished with it and a deep, dry valley separated the three continents of Africa, Europe and Asia.

It remained like that for 200,000 years – a low-lying arid land basin nestled between the Atlas Mountains to the south and the Alps to the north. Eventually (about 5.3 million years ago) cataclysmic tectonic activity ripped apart the Strait of Gibraltar. The Atlantic ocean poured in to the valley and over a period of just 100 years, the sea we know today as the Mediterranean was formed.

It was at this sea that the *Oceans* expedition arrived, on a hot, dusty, June day. We'd come to the port of Messina in Sicily to pick up our boat, *Princess Duda*. For the mostly British team, the Mediterranean, with its sun-drenched beaches and blue sparkling waters, was familiar from numerous holiday memories. But the Mediterranean we were about to explore on this trip would reveal a very different picture. Much more than a holiday destination, this sea holds a rich legacy. The entire heritage of Western civilization, embracing the Egyptians, the Minoans, the Mesopotamians and the Phoenicians, as well as the Greeks and Romans, can be directly linked to it. Hidden deep below the Mediterranean are significant clues that tell the story of how it nurtured our cultural heritage. And it was those clues that we wanted to investigate.

But before we could leave, we just needed to sort out one, tiny detail. The boat. The gritty, sweltering port of Messina had many different boats at anchor. There were gleaming pleasure cruisers, tourist day-trip boats, working fishing boats, huge trans-Mediterranean liners, sailing boats – even wind surfing boards. But no *Princess Duda*. She was still days away in the middle of the Mediterranean while we, with 150 heavy boxes of equipment, were waiting at the port. But there are worse places to be kept waiting and no amount of cursing was going to make her come quicker.

Our aim, when we were finally able to begin the expedition, was to uncover the unique relationship that this sea has with humanity. The earliest evidence of that is not here in Messina, but hidden in extraordinary submerged caves in the Balearic Islands further west. A small team set off to investigate.

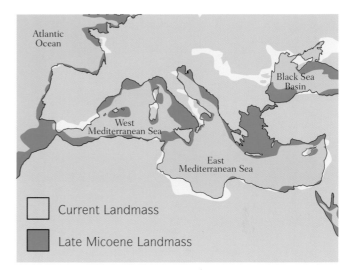

**ABOVE** *The Tethys Ocean (named after the Greek goddess of the sea) comprised what are shown here as the East and West Mediterranean Seas. It originally divided the landmasses of Laurasia (to the north) and Gondwana (to the south). Some 6 million years ago the two landmasses moved together, cutting off the sea's water supply. Within about 2000 years the sea had disappeared.*

## CAVE CLUES

To uncover the Mediterranean's early history we must explore beneath the waterline, by delving into an extraordinary submerged cave. Bizarrely perhaps, the entrance to the Cova de sa Gleda is on land. Just short of the coast of Mallorca, near Porto Christo, is a vast sinkhole – 30 metres wide and 30 metres deep. And at the bottom is the entrance to a huge network of submerged caves.

The water at the surface in the caves is fresh water, from rainfall and river run-off. But several metres down the picture is altogether murkier, thanks to a phenomenon known as a 'halocline'. This occurs when water of two different densities mixes, creating a swirling, 'lime cordial' effect. Here, it's the mixing of the surface fresh water and the sea water underneath that creates the ethereal halocline – evidence that the caves go deep under the sea.

These are the world's longest underwater caves and are decorated with breathtaking formations. Approaching through narrow submerged rock tunnels, it's a dangerous and taxing dive. But suddenly the cave opens out into a vast, spectacular room. The walls glisten with grotto-style crystalline deposits that reflect the torchlight. Exquisite configurations of rock hang from the roof of the cave or rise up from the floor. It is a spectacular gallery of natural formations.

> Exquisite configurations of rock hang from the roof of the cave or rise up from the floor.

But the most extraordinary thing about this cave is that none of these magnificent structures should be here at all. Up-reaching stalagmites and downward pointing stalactites, collectively known as speleotherms, are formed by the evaporation of calcium-laden water as it drips. But evaporation can only happen in air – and these caves are completely submerged.

There can be only one explanation – at some point in the past, these caves were bone dry. Carbon dating has put most of the spindly speleotherms at between 80,000 and 143,000 years old, which means they were formed during an era that fell between two ice ages. And this explains how the caves could have been dry – during these ice ages global sea levels fell dramatically as water was drawn out and deposited in mile-high ice structures around the North and South poles.

But that's not the only surprise here. As the divers look around they uncover strange bulbous structures unlike anything they have seen before. Resembling giant blackberries on stalks, these bulbous structures reveal further changes in the sea level of the Mediterranean. Each 'nobble' is a mineral deposit, which was formed at the surface of the sea and needed air and water to grow. So, as sea levels rose or fell new lumps would be created. These highly unusual, rounded speleotherms are a unique record of these

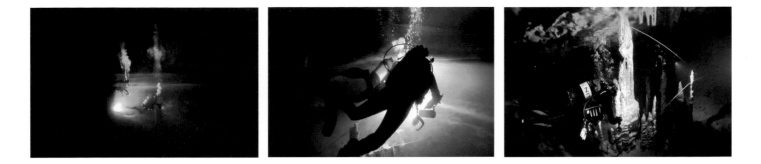

changes, caused not by the ice ages, but by climatic events (both warm and cold) that caused sea levels to fluctuate.

So here in the Mediterranean we have an intriguing view into the ancient past, when the sea was much shallower than it is today, and when these caves were water-less and high on the shores of the sea rather than deep within it.

This remarkable fact makes sense of some other archaeological findings from the cave systems – fossilized remains discovered just 40 years ago of an endemic prehistoric deer, now extinct. These deer were prolific between 5000 and 6000 years ago.

*ABOVE Stills from video footage of Toomi Mahto and Paul Rose diving in the caves at Cova de sa Gleda. They discovered stalagmites and stalactites formed by the evaporation of drips of calcium-laden water which meant that in the distant past these vast underwater caves must have been dry.*

## THE EARLIEST SETTLERS

Perhaps the most exciting finds around these caves are the evidence of early humans. Leading from one cave, Cova Genovesa, to higher ground are the remains of an ancient stone-paved pathway dating from around 2000 years BC. Over a hundred pottery fragments have also been recovered from the cave, dating from the Bronze Age, clear evidence of ancient human settlements on the coast of the Mediterranean.

The caves near Porto Christo have revealed proof of coastal settlers here in Mallorca but there is also evidence of early cultures in other areas of the Mediterranean, including settlements in Lebanon, Palestine, Syria, Anatolia and northern Mesopotamia. Once coastal communities were established, it was the special characteristics of this sea that allowed them to travel and colonize other parts of the Mediterranean. At that time, it was a tiny sea, and almost completely enclosed, which gave it largely calm waters and innocuous tides. This allowed the very early coastal inhabitants to travel throughout the region using rudimentary rafts and boats made of reeds and perhaps even logs. Early man paddled his way across the waters, to places like the Aegean Islands, Sardinia and Sicily, and eventually populated the entire 28,600-mile coastline of the Mediterranean, living by and off the sea. There's a wealth of archaeological evidence to support this Iron Age and Bronze Age diaspora.

For example, caches of obsidian – volcanic glass used in tool-making – dating from around 10,000 years ago were identified on mainland sites in Greece when the only source of this material is the Cycladic island of Milos. Some ancient dwellers of the region obviously liberated it from Milos and took it back to Greece.

Back at Messina, in Sicily, the *Oceans* team is still awaiting the arrival of the expedition boat. The Strait of Messina is one of the busiest shipping lanes in Europe. Every day, liners and transportation ships plough back and forth across this narrow strip of water. But there is still no sign of *Princess Duda*. We have no option but to carry out our planned dives from much smaller launches. It's not a welcome prospect. In all of the relatively calm Mediterranean – this strait is the most dangerous stretch of water.

> In all of the relatively calm Mediterranean this strait is the most dangerous stretch of water.

## THE MYSTICAL STRAITS

A restlessly treacherous, funnel-shaped tract of sea severs the island of Sicily from Calabria on the Italian peninsula, at its narrowest point just under 2 miles wide. Here the waters of the Tyrrhenian and Ionian seas seethe, as difficult to navigate today as they were in ancient times.

In the Strait of Messina the tides change every seven hours and the waters flood back and forth through a waterway that is not only narrow but in places just 80 metres deep. Conversely, at other points the depth is as much as 2000 metres. These abrupt topographical changes create the energy that fires up violent swells here. Notorious for whirlpools and strong currents, the dangerous waters of the strait have caused problems for seafarers throughout history and accordingly it became known as the dwelling place of monsters.

In Greek mythology a grotesque six-headed monster named Scylla lived by the cliffs of the Italian peninsula. She would devour sailors if they came within her grasp. On the Sicilian side there was an all-consuming whirlpool called Charybdis which would suck sailors to their deaths. Homer's epic poem the *Odyssey* describes how sailors like Odysseus had to carefully pick out a route between the two menaces in order to survive.

If the strait was not already mythical enough, it is also a known hot spot for Fata Morgana mirages, the same phenomena that sometimes conjure up cities in the Sahara Desert. Fata Morgana mirages are impressive optical illusions, which occur when two layers of air – one hot and rising, the other cooler and descending – meet in the sky. Most people have seen small-scale mirages above a road on a hot day which are essentially refractions of light

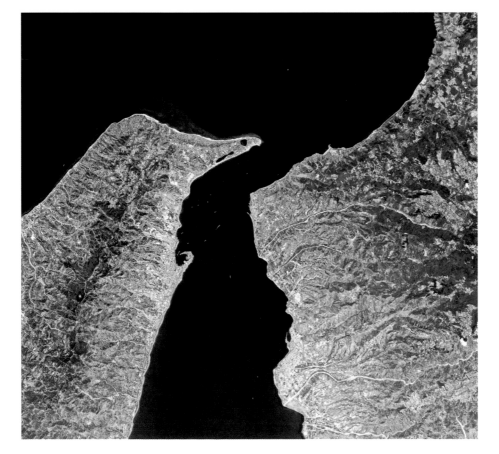

**ABOVE** *The port of Messina in Sicily was originally called Zancle, a local word which means 'scythe', and derives from the shape of its natural habour.*

**LEFT** *The Strait of Messina, which divides Sicily from mainland Italy, is where the waters of the Tyrrhenian and Ionian seas meet. Notorious for their strong currents, these waters have caused problems for seafarers throughout history.*

# Modern Monsters of the Deep

**The sixgill shark** is both primitive and distinctive. Instead of the more advanced five-gill arrangement, which has evolved in most sharks, the sixgill has, unsurprisingly, six gill slits. With six rows of blade-like teeth, white-edged fins and fluorescent eyes it measures up to 5 metres long. The sixgill shark that exists today is virtually unchanged from fossil forms dating back 200 million years.

Very little is known about this shadowy shark, largely because its natural habitat is at extreme depths, say around 2000 metres, so they are inaccessible to humans except those in submarines. There are only two places in the world where it is possible to dive alongside sixgill sharks and one of those is the Strait of Messina where the upwellings force creatures from the sea's abyss nearer to the surface. Even then chances of a sighting remain slender. Only for a few hours between tides at a new moon in spring are the conditions right. Then sixgills may come up to a depth of 40 metres to search for food. Even then, they can move with incredible speed for short periods and this, coupled with a drab brown/grey coloration, makes finding them in the gloom of a skittish current a long shot.

I had already made two exhausting midnight dives and had failed to make contact. I'd followed the local advice, which was to dive in the dark of a new moon, and my diver's sense told me to go for slack water at tide change so that the heaving swell of the strait would be more manageable. To extend my search I decided to dive at 1.30 a.m., the end of slack water. This meant I would travel faster as the dive progressed and therefore cover more ground. I assembled the largest twin diving cylinders I could find and convinced the dive shop to pump them up way over the normal safe working pressure. This would give me about ten more precious minutes under water. Finally, I added a 8¾-pound lump of fresh tuna to my weight belt. Maybe it would attract a shark's attention in a way that I previously couldn't.

It was a relief to head out into the darkness of the strait, getting away from the noise that pervades so many Mediterranean resorts. Everyone needs to be focused before a challenging dive, and extra effort is needed in the strait as the nightclub music, racing motorcycles and fast cars all blast noise over the water. I felt on the cusp of cultures. The noise of its engine blocking out the sound of disco music, my boat was surging through powerful currents feared since mythological times and below me could be a prehistoric shark.

To leave the boat and feel the water take my weight and that of the heavy dive gear was pure joy, a comfort as I descended through those dim waters into the unknown. As I levelled out at 40 metres I could just make out the shallower parts of the sea bottom as I raced over them in the vice-like grip of the current. After 30 minutes I'd had no luck.

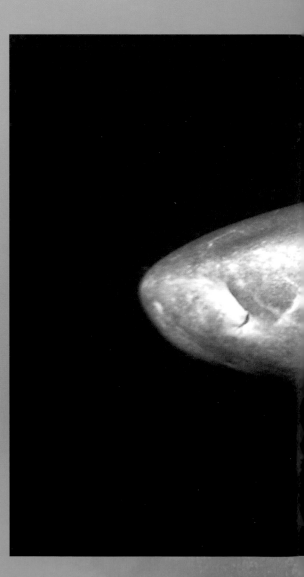

**BELOW** *The bluntnose sixgill shark, so called because of its distinctive snout, closely resembles fossil sharks from the Triassic period. Little is known about this species as it generally lives at extreme depths, only coming up to the shallows at night to feed.*

Then suddenly, ahead of me glowing in the darkness were two green eyes. A beautiful sixgill shark about 3 metres long was heading straight for me. After we crossed paths I was about to turn around and chase it, but amazingly it doubled back and joined me on my drift with the current.

## ... in the darkness were two green eyes. A beautiful sixgill shark ...

Diver contacts with sixgill sharks are so rare that I expected this to be just a fleeting meeting but the shark stayed, enticed perhaps by my fishy odour (the tuna). It glided left and right and even became vertical, with its head up, for a minute. Unable to resist temptation, I reached out to touch it as we cruised the black strait together. Time was short. I only had a few minutes of oxygen left and desperately wanted to be there when the shark swam off. But it lingered until I couldn't stay a moment longer. It was wonderful to begin my long ascent and see the shark continuing the drift. I soon lost sight of it in the dark, but those piercing green eyes haunted me for much of my journey to the surface.

OPPOSITE *Phoenician merchant ships were single masted with one square sail. The sail was managed by ropes attached to the two lower corners, which must have been held in the hands of sailors. As long as the wind served, the captain used his sail; when it died away, or became adverse, he dropped the sail on to the deck, and made use of his oars.*

making the air shimmer like water. But these superior mirages happen in the sky on a grand scale because there are no boundaries. The effect is like a lens that magnifies anything beyond the horizon, in several different stratas. When conditions favour Fata Morgana mirages, mariners around the strait are still warned about them as land may apparently loom where none in fact exists.

But these dangerous waters are the only place in the Mediterranean – and indeed one of only two places in the world – to see another early inhabitant of the oceans. Not human settlers this time, but something much, much older: an ancient sea creature.

Diving for, and finding, a rare sixgill shark was a thrill for everyone. And it seemed to signal an upturn in the fortunes of the trip. Finally *Princess Duda* was in port – not in Messina, but over to the west of Sicily in the harbour at Marsala. Time to load up the 150 cases of gear and head west. Travelling through the crowded towns and along even busier motorways it was difficult to imagine a time when people were just beginning to settle on the shores and islands of the Mediterranean.

## MEDITERRANEAN SUPERHIGHWAY

From these very early settlers grew all the great Mediterranean civilizations. And it was this sea that permitted their extraordinary growth. Usually the sea is an obstacle that keeps people apart. The Mediterranean, with its ease of navigation, smooth waters, natural harbours and abundant island stopping points, was a bridge to bring people together. People were able to migrate, trade and share knowledge. Mediterranean communities became richer, growing culturally as well as economically as they traded with each other and colonized lands across the sea.

> The Mediterranean became a super-highway ... busy with traffic in people and goods.

For the Egyptians the sea offered access to the timber and mineral resources of the Levant. The Phoenicians, hemmed in by the vast mountain ranges of modern-day Lebanon, found it provided a route to expand trade. And it gave the Greeks the opportunity to colonize the islands and coastlines of the Mediterranean and the Black Sea. The Mediterranean became a superhighway, a conduit of skills and experience also busy with traffic in people and goods.

Centuries later, the *Oceans* team is navigating the maze of narrow streets in Marsala to find the harbour and *Princess Duda*. We are heading to the islands of Egadi off the west coast of Sicily, the site of a battle that shaped the history of the entire Mediterranean – a battle between the mighty Phoenicians and a tiny, upstart nation in southern Italy.

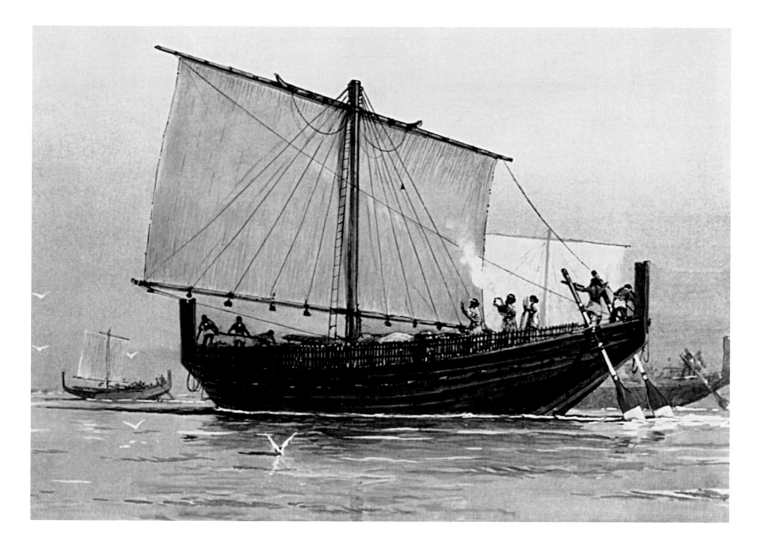

Above all the ancient cultures of the time, it was the Phoenicians who developed the science of seafaring. An enterprising bunch whose ancestors were the Canaanites, they aimed to spread their merchandise across the known world. To achieve their ambition they used their fine native cedar wood to build galleys strong enough to traverse the Mediterranean Sea, powered by sail and oar.

They were peaceful traders, rather than warmongers, interested only in building up commerce and establishing trading settlements. They founded colonies in Cyprus, Rhodes, the Aegean Islands, Sardinia, Tashish, a great commercial colony on the coast of Spain, and of course, Carthage, a city in present-day Tunisia that became a power base in its own right.

> Above all the ancient cultures of the time, it was the Phoenicians who developed the science of seafaring.

As a pre-eminent civilization Phoenicia traded purple dye, ceramics, glass, metals, wine, wood, crops and oil. Phoenician mariners steered by the stars and sun, and probably became early map-makers. They even sold their skills and were mercenaries for others. And it was the Phoenicians who pioneered the use of the alphabet. Our knowledge about

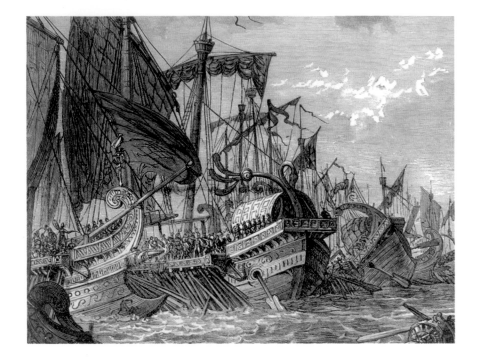

their land-based activities is limited because they undoubtedly kept their records on papyrus scrolls, which have since perished. But there are references to the Phoenicians in Egyptian and Greek records that have survived.

By the fifth century BC Egyptians, Greeks and Phoenicians were occasionally in conflict, but generally rubbed along together and were not unduly concerned about a small republic in southern Italy, based in Rome, which was breaking into the Mediterranean political scene. Yet it was the emergence of Rome that ultimately spelt doom for them all.

## CARTHAGINIAN CATASTROPHE

In the third century BC, Rome was not known as a maritime nation. When war broke out between Rome and Carthage, the later Punic capital, over Sicily in 264 BC, the Phoenicians had every right to believe they would be victorious in skirmishes at sea, as they had larger ships and greater skills. (It was the first of the three Punic Wars – 'Punic' is the Roman term for the Phoenicians – which ultimately led to Roman domination of the western Mediterranean.)

After initial losses, the Romans adopted Punic technology and added an embellishment of their own to their ships. The *corvus* (Latin for raven) was a 6-metre bridge, which ended in a spike resembling a bird's beak. Attached to the prow of a Roman ship, it was swung out and stuck on to the deck of Carthaginian galley at close quarters, allowing foot soldiers to stream aboard.

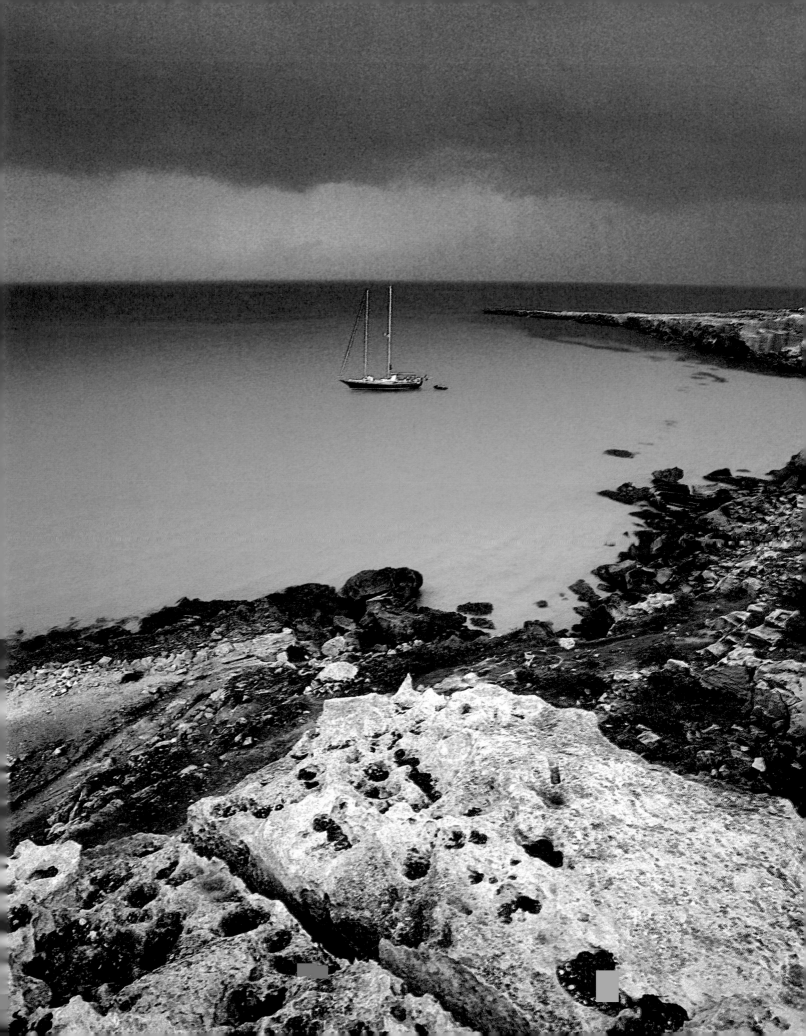

Now superior Carthaginian seamanship could be countered by hand-to-hand combat, at which Roman legionaries excelled.

On 10 March 241 BC, a Carthaginian fleet arrived to relieve the Sicilian port of Lilybaeum, modern-day Marsala, which was under siege by the Romans. But their 170 ships were heavily laden with cargo earmarked for their besieged and hungry comrades. The Romans used the element of surprise, and also the newly developed *corvus,* to triumph. In hours, 50 ships of the Carthaginian fleet were sunk and a further 70 captured.

> In hours, 50 ships of the Carthaginian fleet were sunk and a further 70 captured.

In the face of impending disaster, the rest of the Carthaginian fleet fled when a fortuitous change in wind direction allowed them to flee home to Africa. Denied necessary supplies, the Carthaginian army holed up in Sicily had no choice but to surrender. The resulting peace treaty forced Carthage to give up all claims to the island and pay hefty retribution to Rome. It was a decisive victory, with Sicily becoming the first of many Roman provinces, and may have even changed the course of history by substantially altering the regional power balance.

## WHAT LIES BENEATH?

Diving almost anywhere in the Mediterranean will reveal fragments that tell of its rich history. But incredibly, off the Egadi Islands and beneath 40 metres of water, lies an eerie reminder of the sea battle won by the Romans against all odds those many centuries ago. Wreckage of Carthaginian ships, decrepit but still decipherable despite the ravages of time and tide, have been found on the sea floor.

The first evidence of a wreck was discovered in 1969 by a British archaeologist, Honor Frost. Investigations revealed that the hastily built ship had been sunk stern-first after being rammed by the Romans. It seems the crew abandoned ship, taking their weapons with them, but there was evidence of the supplies it was carrying, including deer, goats, horses, oxen, pigs and sheep as well as olives, nuts and fruit.

> Among the more surprising finds were traces of cannabis …

Among the more surprising finds were traces of cannabis, which the crew may have chewed as a stimulant before going into battle. Suggestions that the hemp plant could have been used for rope have been rejected as there was already rope aboard, made from something entirely different. Not all the crew escaped. A human skeleton, possibly of a Carthaginian sailor, was found trapped by ballast. When the wreck was judged to be at risk it was taken from the sea to be housed in a maritime museum in Marsala, Sicily.

But in 2004 an even greater horde of riches was unearthed on the same site. Local geologist Leonardo Nocitra discovered the remains of more than 25 warships in shallow graves beneath the sand. He began a search after his nephew spotted the outline of what he believed to be a ship while swimming. Given the risk of divers illegally plundering the site, its exact location has been kept under wraps. But the find is a loud echo from the past, from a sea floor strewn with objects from antiquity.

*ABOVE Near the site of the great sea battle the Oceans team found other evidence of human seaborne activity including two anchors: one from a twentieth century vessel and one several hundred years older.*

## TREASURES OF THE DEEP

Diving the crystal waters of the Mediterranean provides other clear snapshots of history. Close to the site of the battle of Egadi Islands are two anchors, one clearly from a twentieth century vessel and one much older, possibly early eighteenth century. Just a bit further on is an even older site, one that speaks of the prosperity of the Roman nation after its Punic War victories.

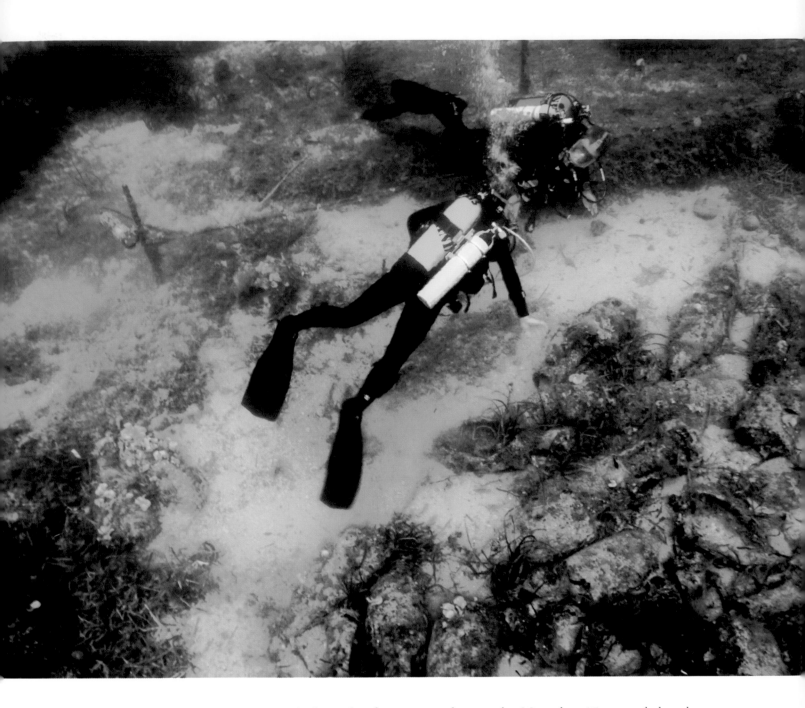

**ABOVE** *Another fantastic dive was to examine the amphorae at close quarters. This booty, more than 2000 years old, presents history at its most exciting. The divers were even able to make out the name Lazio – the makers of the wine carried inside the containers – carved into the necks of some of the pieces.*

And it makes for an extraordinary sight. More than 25 metres below the surface of the Mediterranean lies a mound of amphorae, over 2000 years old. Each of these ancient containers is 1.2 metres long and covers a sizeable chunk of the sea floor. The shape of the amphorae reveals their age and where they came from. They are cylindrical with angular shoulders and long straight handles, generally oval in section and with a collared rim with a longer, slightly flared spike. Their technical name is Dressel 1b.

There are around 50 amphorae, and they are the remains of a vast cargo of over 500, believed to have been carrying Roman wine from southern Italy in the first century BC – or possibly returning with the amphorae refilled with a prized cargo of garum. This pungent fish paste, made from rotting mackerel

and anchovy, was considered a delicacy, particularly among legionaries serving away from home. The graceful amphorae were lined with bitumen to render them waterproof and carefully designed to slot in between each other, to make as efficient use as possible of the space in the hold. Closer inspection reveals a human touch. Carved into the neck of some amphorae is the name of the family who made the wine: the powerful Lazios.

## MODERN-DAY PIRACY

There is a captivating sight inside the police station in the sleepy town of Favignana, on the island of the same name lying off the west coast of Sicily. Among dusty files and paperwork on the shelves, is a small TV monitor relaying a flickering CCTV picture. Every now and then a large grouper floats across the screen, occasionally it's an octopus and sometimes even a moray eel.

But the police are not monitoring sea life. The camera is trained on what remains of the amphorae from the Roman shipment. Over the years most of the amphorae were sold on the black market or brought up from the deep for their ornamental value. Today, in the local bars and cafés of Favignana it's common to find a 2000-year-old artefact among the wine bottles.

… in the local bars and cafés of Favignana it's common to find a 2000-year-old artefact among the wine bottles.

Concern for the wholesale loss of this archaeological heritage has driven the authorities at Favignana to take the unusual step of mounting a guard on the site. Four remote underwater cameras monitor the site 24 hours a day, broadcasting the pictures to the police station and also to the local museum.

A happy spin-off of this security system is that the cameras allow tourists to view the archaeological site without putting it at risk. It's a unique and effective set-up. Since it has been established thefts of amphorae have virtually ceased while visits to the museum have increased.

## THE VANISHING ISLAND

Islands of the Mediterranean have always had strategic value, particularly to countries that border the sea. That's why Cyprus, Crete and Sicily became battlegrounds for Christian and Muslim forces in the Middle Ages, and how the Ottoman Empire flourished, having annexed islands off Turkey and occupied Crete and the Levant.

In recent times, perhaps the most curious of all island-nabbing incidents occurred when a volcanic eruption pushed up a brand-new island off the coast of Sicily. It provoked a major diplomatic dispute, which ebbed only when the island disappeared again, almost as quickly as it came.

During the summer of 1831, Sicily – which itself is defined by the constant rumblings of Mount Etna – was rocked by a series of earthquakes. The tremors damaged homes across the island and were felt from Sciacca on the south coast to Palermo in the north. This time it was not Etna, as the flames and belching smoke erupting from the sea 18½ miles away testified.

Captain Charles Swinbourne, commander of a British navy ship, the *Rapid*, logged what he saw: 'A fire in the distance, in the middle of the sea.' The boiling waters were heaving with dead fish, sailors fainted as a result of dense sulphurous fumes in the air, and a huge column of smoke, ash and flaming projectiles was reported to be rising from the water.

Two weeks after the first eruptions were experienced, the undersea volcano was still ejecting smoke, ash and flaming material which rose to 20 metres above the sea. At Sciacca 34 miles away, the nearest town, events were recorded on 16 July 1831 by the commander of another vessel, the *Anna*, 'Black ash and splinter fall, every 10–12 minutes there are explosions, with ejections up to a league high of large boulders, black in colour by day but red at night, falling near the event.' By now a small crater had begun rising out of the sea. On 17 July (20 days after the eruption started) the mound was 9 metres high. Five days later it had grown to 25 metres and by August it stood at 70 metres high with a diameter estimated at 5000 metres. A new island had been formed.

> … Humphrey Senhouse sailed over from Malta, landed on the still-active island … and planted the Union Jack.

As the volcanic activity died down, the political activity began to heat up. British Captain Humphrey Senhouse sailed over from Malta, landed on the still-active island, braved its noxious fumes and planted the Union Jack. He called the new territory Graham Island, for Admiral Sir James Graham, the First Lord of the Admiralty.

If the action was planned to needle to Sicilians, it worked. Ferdinand II, the Bourbon monarch of the Kingdom of the Two Sicilies, sent a ship to the still smouldering rock. The Union Jack was duly removed and replaced by one in the king's colours. He named the island Ferdinandea in his own honour.

And interest didn't end there. The position of the island, in the centre of the Mediterranean and close to the southern coast of France and Spain, made it irresistible to both countries. The French sent a geologist there, Constant Prevost, who named the island Giulia, for the month it rose from the sea. Spain was gearing up for action too and a diplomatic furore erupted.

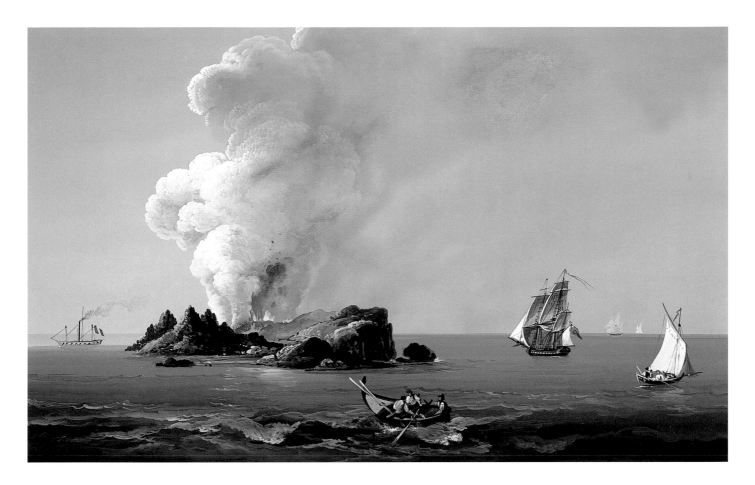

But, before a shot could be fired for the sovereignty of this sulphurous, sputtering cone, it started to sink. The friable igneous rock and ash was swiftly eroded by the action of the waves and, by January 1832, the island had disappeared.

That was not quite the end of this oddball geopolitical story. The submerged island was bombed in 1986 by an American pilot who believed it to be a Libyan submarine. And, after rising levels of volcanic activity in the region at the turn of the millennium, there was a misplaced conviction that the island – and the diplomatic row about its confused ownership – was about to resurface. Two surviving relatives of the Bourbon kings of the Two Sicilies commissioned a marble plaque, weighing 330 pounds, which once and for all, claimed the island for Italy. With ceremony, the plaque was fixed to the underwater island – only to be found a few weeks later mysteriously smashed into pieces. No one knows if it was the victim of fishing gear or vandals.

Ferdinandea is a unique example, but the forces that created this short-lived island off the coast of Sicily are also responsible for the many islands across the Mediterranean. Under its deceptively calm waters are several active fissures and vast submerged volcanoes. Indeed, Ferdinandea itself has very recently (June 2006) been discovered to be only the tip of a much bigger submerged volcano; one with a base covering an area which is larger than the city of Rome and rises higher off the seabed than the Eiffel Tower.

ABOVE *This contemporary painting by Camillo De Vito shows the volcanic eruption that caused the sudden appearance of the island of Ferdinandea.*

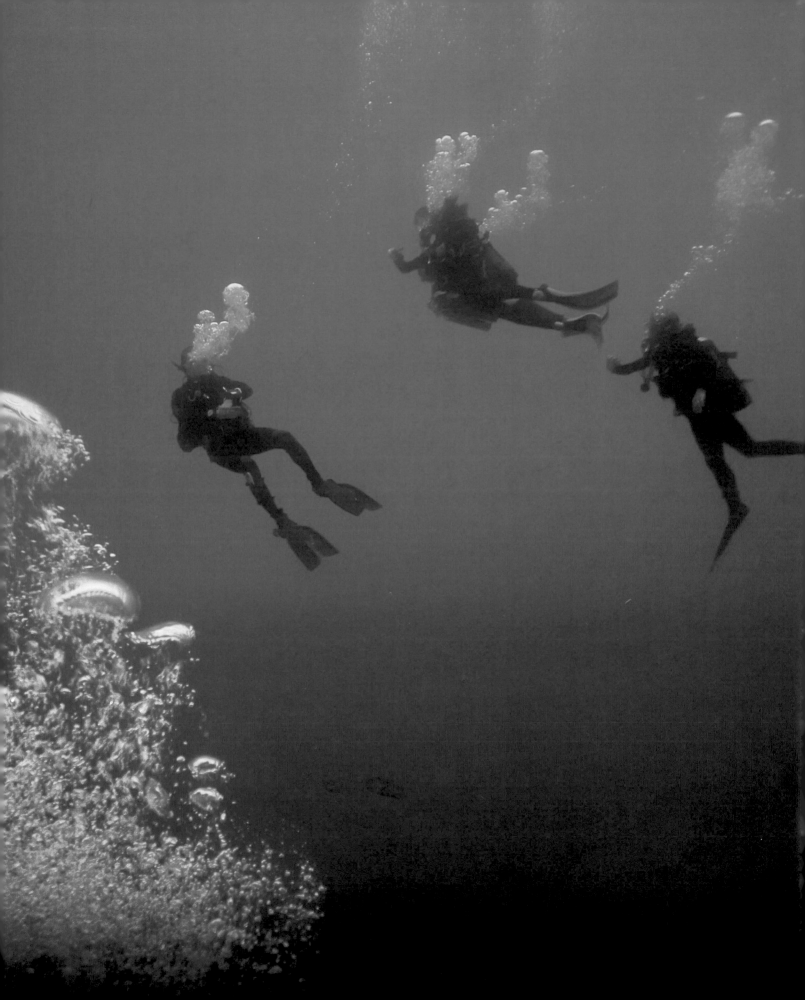

# The Blue-black dive

**I love the feeling of a steaming mug of tea in my hands**, especially at sea in the magic moments just before dawn. The boat's rail was crusty with salt, the heaving seas from the night had left a friendly deep ocean swell, no land was in sight and, with some help from my tea, I was once again thinking how much there is to explore in the world. Ferdinandea was just such a place with its chequered, albeit short, history.

I knew the volcano was down there somewhere but, when I headed into the wheelhouse to check our position, our Russian captain said we would have to abandon the dive as he didn't have any AA batteries. Luckily I'd had the tea, so I was awake enough to realize he meant he didn't have any batteries for his GPS.

The Mediterranean volcano of Ferdinandea rises 400 metres from the seabed, to 8 metres from the surface. It is such a huge sea pinnacle that any reasonable navigator can find it, even with the naked eye. The batteries from my camera made it a certainty. But the trick is getting a good anchorage on such a steep-sided seamount. It's one thing being dragged off the sides of the volcano into safer deep water, quite another to be shipwrecked as you are dragged across the treacherously shallow surface. The area in which Ferdinandea lies is called Terrible Bank on the charts. So we needed to pick our spot carefully. This would have been easier with a breeze as that would have helped us decide which face to go for. As it was, the lazy swell and glassy surface showed no hint of wind so our best bet was to hold position in deep water and dive the volcano summit from one of our small boats.

The dive was beautiful in its simplicity. We descended into that fabulous mid-ocean blue on to a massive black cone. That's it; that's all there was – blue and black. As we got busy measuring the slope angles, collecting lava samples, making temperature readings and taking our photographs I tried to imagine the power of this volcano when it arrived with a head of steam at the surface. It would have been pumping out a massive black smoke plume, and the sea would have been boiling at the newly formed steep black beaches. It must have been an astonishing sight for those sailors back in 1831. And, of course, bemusing to return six months later to find the island had vanished. Formed in the explosion of volcanic ash and mixed with sea water, it remained insubstantial against the force of waves. It simply got washed away, leaving unrequited ambition in its wake.

In contrast to the violence of the geological events and the amusing quirkiness of the political claims, I spent the larger part of the blue-black dive thinking about the rarity of simple surroundings in our lives. It's a setting that attracts me and gives me peace and energy – and I can only get those from deep dives, the polar regions, the sea, in deserts and high in the mountains.

OPPOSITE *The beaches around the Mediterranean, like this one at Durres in Albania, are among the most popular in the world. Experts regard this as a fatal attraction as more people means more pollution. The increasing demand for the fruits of the sea and the subsequent overfishing is also beginning to have a detrimental effect on a number of marine species.*

When these volcanoes erupt, the water pressure limits the force of the explosion while the rapid cooling due to the contact with the water creates a vast drop of cooling lava surrounded by a hard crust – called a lava pillow. As lava continues to erupt the pillow breaks open forming secondary pillows, and gradually a solid island structure is formed. This action formed many of the islands that stud the Mediterranean, such as the Aeolian Islands, Stromboli, Pantelleria, Ponza and Santorini.

## MEDITERRANEAN UNDER THREAT

The growth of civilization on Mediterranean islands and coasts is today the very thing that threatens the sea. Its shores are home to 150 million people and a further 220 million tourists visit each year. The *Oceans* team is travelling to the north coast of Sicily, west of Palermo, to investigate some of the devastating impact that humans are having on this sea.

As a predominantly landlocked body of water, the Mediterranean has a very low renewal rate and is therefore extremely sensitive to pollution. No less than 80 per cent of urban sewage discharged into the Mediterranean is untreated, and agricultural overspill containing nitrates, phosphates and pesticides adds further contamination. In addition, 600,000 tonnes of crude oil are released into the sea each year from shipping traffic.

… 600,000 tonnes of crude oil are released into the sea each year from shipping traffic.

The effect has been devastating with many species now threatened with extinction. That includes the monk seal, the loggerhead turtle and even a species of seagrass. And, while part of the problem is pollution, another is our insatiable greed.

For over 12,000 years, mankind has lived in harmony with the sea, relying on it as a source of food and livelihood. Now that relationship has crossed the line into relentless exploitation that has disastrous consequences for a number of species. Of the 900 fish species found in the Mediterranean, 100 are fished commercially. Each year, about 1.3 million tonnes of fish are caught worldwide and, although it makes up less than 1 per cent of the world's oceans, the Mediterranean is delivering over 10 per cent of its fish catch.

One of the most devastated populations is the Atlantic blue fin tuna. This magnificent cetacean is the largest tuna, reaching more than 4 metres in length, and weighing more than 1430 pounds. Tuna, especially the blue fin tuna, have been part of Mediterranean culture for millennia. On an island off Sicily, there is a cave painting that dates back to 10,000 BC, of a large fish –

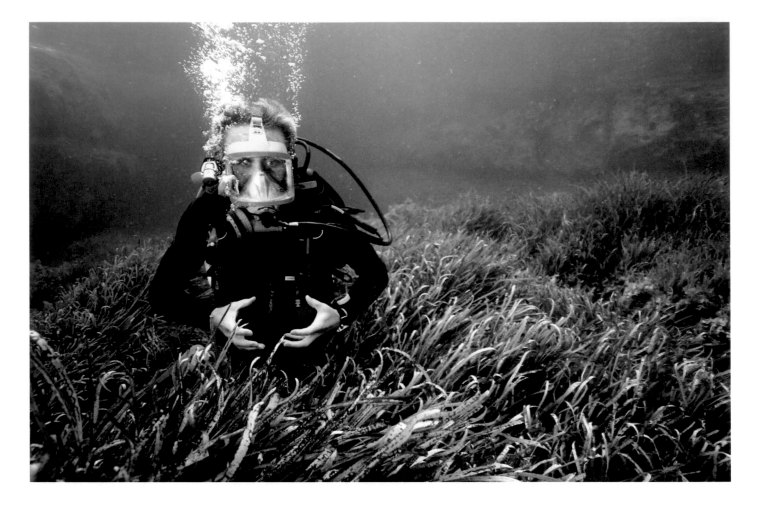

*Untreated sewage and crude oil spillages from shipping traffic are causing havoc in the predominantly land-locked waters of the Mediterranean. Seagrass meadows like this (above), which form the basis of a highly diverse and productive ecosystem, found by the Oceans divers is in danger of disappearing due to this adverse human activity. The loggerhead turtle (right) and the monk seal (opposite) are two species also at risk from pollution.*

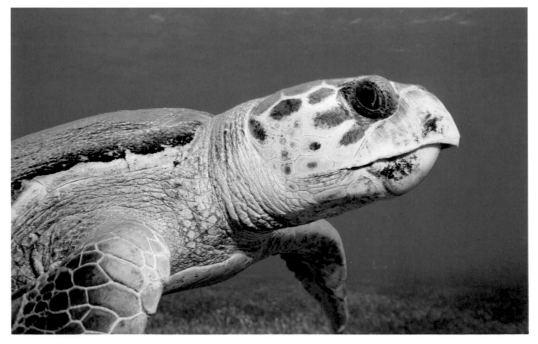

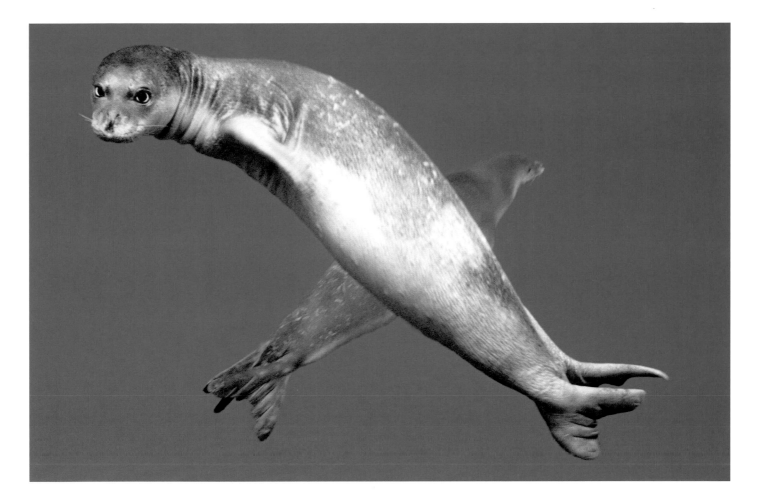

probably a blue fin tuna. The details could not have been drawn by observing the fish while it was in the sea; it must have been landed and it was surely eaten. Pictographs on Egyptian papyrus from 5000 BC show basic fishing techniques while Greek vases from even earlier show fish being cut up in the market. Roman history is redolent with details of trading fish and fish products.

Homer described the fish in the *Odyssey*, which dates from about the eighth century BC, and Aristotle recorded in accurate detail their migration and spawning patterns in 350 BC. The word tuna derives from the Greek word 'to rush'. As they dash around the sea, tuna can reach remarkable speeds, matching cheetahs for pace when they are chasing prey.

For 2500 years they have been a major source of food for Mediterranean people and, for most of that time, there has been no apparent decline in their numbers. But just 30 years ago, that changed. Triggered by the lucrative Japanese sushi and sashimi market, tuna fishing became more intensive. Newly developed purse seines – huge nets that trail behind boats and corral vast numbers of fish – accelerated the catch by 80 per cent.

OVERLEAF *The Strait of Gibraltar – at its narrowest is an 8-mile wide gap between Europe (Spain is on the left) and Africa. At the surface water continually flows eastwards into the Mediterranean from the Atlantic. Outflow from the Mediterranean, which is much more salty, takes place near the seabed, flowing out and down the continental slope, gradually losing its salinity.*

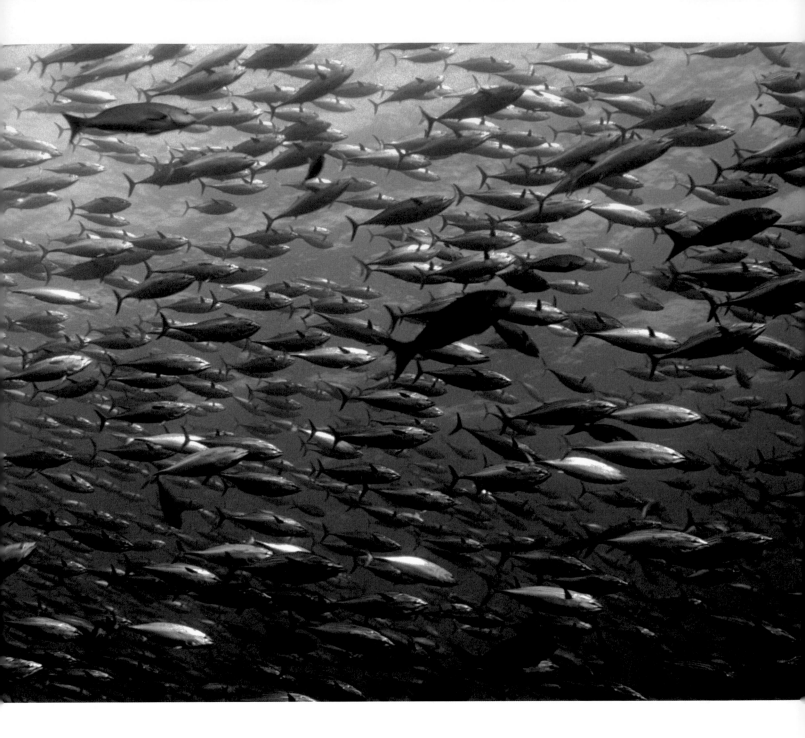

ABOVE *A school of majestic tuna. Blue fin tuna are now endangered and facing commercial and biological extinction.*

OPPOSITE *The Mediterranean has been a source of food for 7000 years as this Greek vase illustrates. Today, intensive fishing is having an alarming effect on its marine life.*

## PLIGHT OF THE TUNA

We have come to Sicily's north coast to investigate an even more worrying development – the advent of tuna farms. From the boat, we can see the tops of vast circular pens on the surface of the water, but diving shows the true extent of these sea cages. The pens are 50 metres across and each contains around 300 or 400 tuna. Live tuna have been slowly dragged in vast nets to these pens, where they are fattened up on oily fish for a few months before being sold. For the divers it's a shocking sight. Trapped in the pens, the vast

numbers of tuna circle endlessly, very different from their natural behaviour travelling across miles of open sea.

In all there are around 40 such farms in the Mediterranean, each with between six and ten large pens. With a single fish bringing in up to £40,000, it is a lucrative business. But the development of these farms has been catastrophic for the species. The pens contain a high proportion of juveniles who will never reproduce and numbers are dropping fast.

In 2003, the International Commission for the Conservation of Atlantic Tuna was set up in an attempt to control the trade, and set a catch limit of 18,301 tonnes per year. However, conservation groups believe that widespread violations involving quotas that are already twice as high as those advised by scientists have led to a continuing collapse in the blue fin tuna population. Tuna farms in the Mediterranean, for example, have a capacity for nearly twice the quota. Today the blue fin tuna, once celebrated by Homer and Aristotle, is classified as endangered and is facing commercial and biological extinction.

It's a story that is replayed time and again in the Mediterranean and the intensive overfishing is having a dramatic effect on the survival of other marine creatures further up the food chain. Colossal numbers of smaller fish are swept up as by-catch by blue fin tuna fishers and discarded. Without easily available amounts of this prey, larger fish and marine mammals are struggling to survive. Dolphin and sandbar sharks are now under threat while turtles are frequently damaged or killed.

Thirty years ago, when Jacques Cousteau made a series of films in the Mediterranean he was fortunate to find a thriving, varied marine environment, with many species unique to this sea. Today, when his grandson Philippe Cousteau dived with us as part of the *Oceans* expedition he found a barren site, devoid of fish, larger pelagics and the abundant marine life that he'd been expecting. The situation has become so severe that the eastern Mediterranean has now been described as a marine desert.

It's a sobering end to the expedition and reveals a much darker picture of the Mediterranean than the balmy holiday destination most of us know. This is the true Mediterranean. The sea that gave us the roots of Western civilization is now reeling under its impact; and the sea, whose very creation was marked by a mass extinction of sea life, is darkened by the shadow of a similar threat.

> With a single fish bringing in up to £40,000, it is a lucrative business.

# THE ATLANTIC OCEAN
## The Sea of Atlas

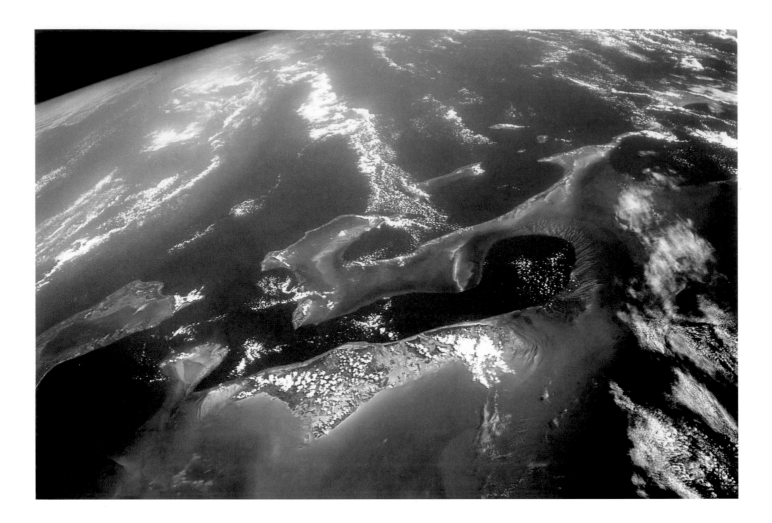

SINISTER AND SINEWY, FIERCE AND PHANTOM-LIKE, sharks are the undisputed rulers of the waves, at least as far as the popular press would have it. There are more than 400 species of shark in the world's oceans. They have swarmed through the seas since before the time of the dinosaurs and are so perfectly adapted to their watery world that they have, broadly speaking, survived unchanged for 400 million years.

Few living creatures inspire fear in the same way as sharks, saddled as they are with a reputation as maneaters, which exaggerates their ferocity and willingness to kill. While sharks have, of course, been known to attack people as they swim, dive or fish, incidents are relatively rare – and deaths rarer still. According to the International Shark Attack File, there were 71 unprovoked attacks by sharks on humans during 2007, with one fatality. Yet, in the same year, 110 people drowned in New Zealand alone, a nation of just over 4 million people. As a matter of interest, there are only a handful of shark species that tend to attack, including the great white, the tiger and bull sharks. Meanwhile, shark deaths suffered at human hands run into millions.

More than just fin, teeth and jaws, sharks fulfil crucially important roles in the various ocean ecosystems where they live. Still, sharks are having trouble shaking off the image of being the oceans' aggressors. Now under

threat in the increasingly humanized seas, they still find refuge and freedom in the 'Shark Eden' of the Bahamas, a corner of the Atlantic Ocean that is particularly appealing to both sharks and humans. The *Oceans* team has travelled here to help make the seas safer for both.

With its waters clean, teeming and blue, most of the Bahamas archipelago – some 700 islands and cays scattered for 500 miles south-east of Florida – remains free of industrial development. More than 40 shark species cruise Bahamian waters, including lemons, great hammerheads, bulls, black-tips, makos, silkies and nurses. Even migrating blues and massive whale sharks pass through.

Perhaps the most common are the Caribbean reef, tiger, bull and hammerhead sharks, making this area a particular hot spot for shark species diversity. This may be due to the large quantity of nutrients brought in by the Gulf Stream, and the protected areas around many of the islands which provide suitable nurseries for the shark offspring. Many give birth in the lagoons where they themselves were born. But this idyllic picture masks the shocking truth – some sharks are at risk of extinction.

> … this idyllic picture masks the shocking truth – sharks are at risk of extinction.

## SHARKS IN PERIL

Up to 120 million sharks are killed each year – mostly through extensive commercial fishing – and the populations of particular species are plummeting. For example, the oceanic white-tip, one of the most abundant sharks just three decades ago, is now critically endangered in parts of its range because of the relentless demand for its fins. So, too, is the scalloped hammerhead shark, again to supply the market for shark-fin soup, a prized Asian delicacy. Also, many sharks are caught accidentally, snagged on the longlines that are part of the vast industry of commercial fishing throughout the Atlantic. Scientists warn that shark populations could be dangerously depleted within a decade and, partly due to the slow rate at which they mature and a relatively low birth rate, some species will vanish entirely.

The *Oceans* team is travelling to the island of Bimini to meet a team of scientists working at the Bimini Biological Field Station – known locally as the 'shark lab' – who are developing a shark repellent, which they feel is a potential species-saving discovery. On the death of a shark a range of marine animals comes in to eat the flesh, but other sharks stay away. Researchers have guessed that the fish corpse is releasing a chemical signal that repels other sharks, like a posthumous warning that danger could still be in the

OVERLEAF *Among the most common species in this area are Caribbean reef sharks. Reef sharks grow up to 3 metres in length. They come to these shallow waters in schools in search of reef fish, rays and crabs on which to feed.*

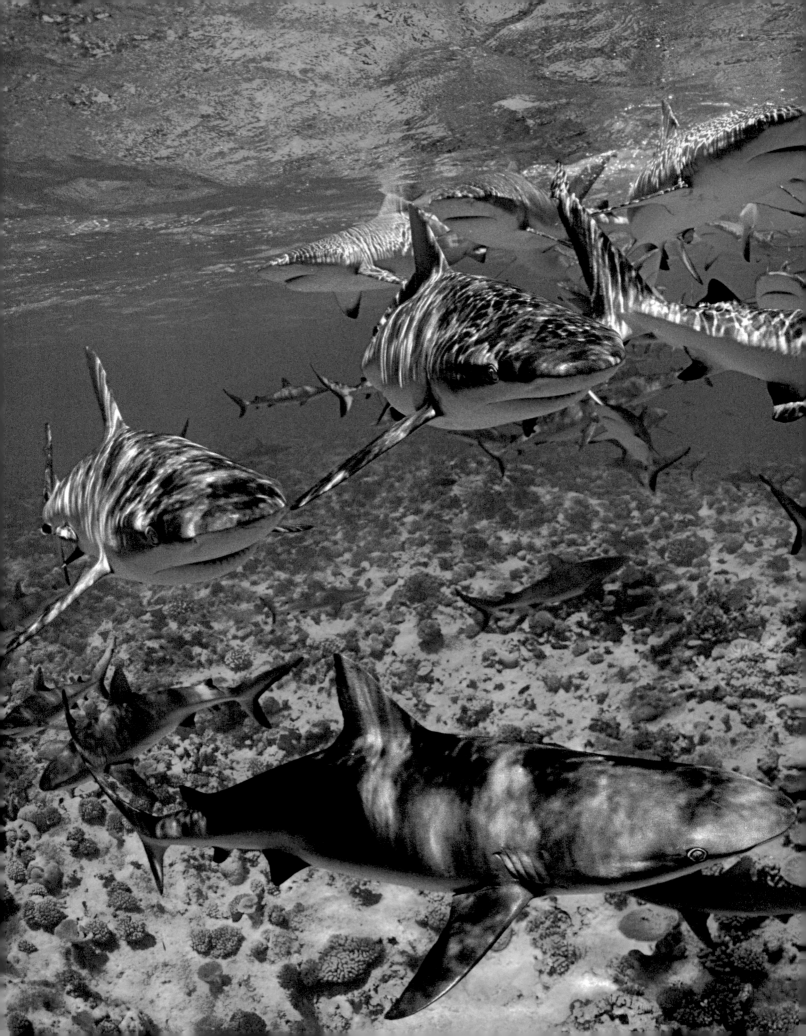

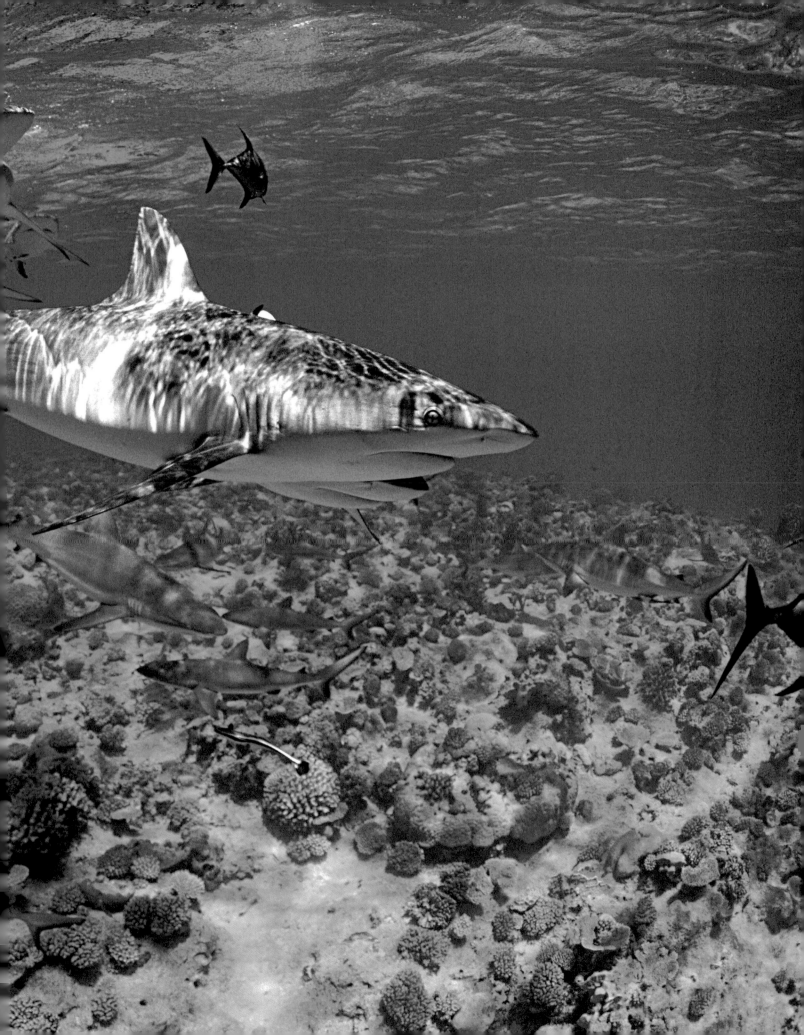

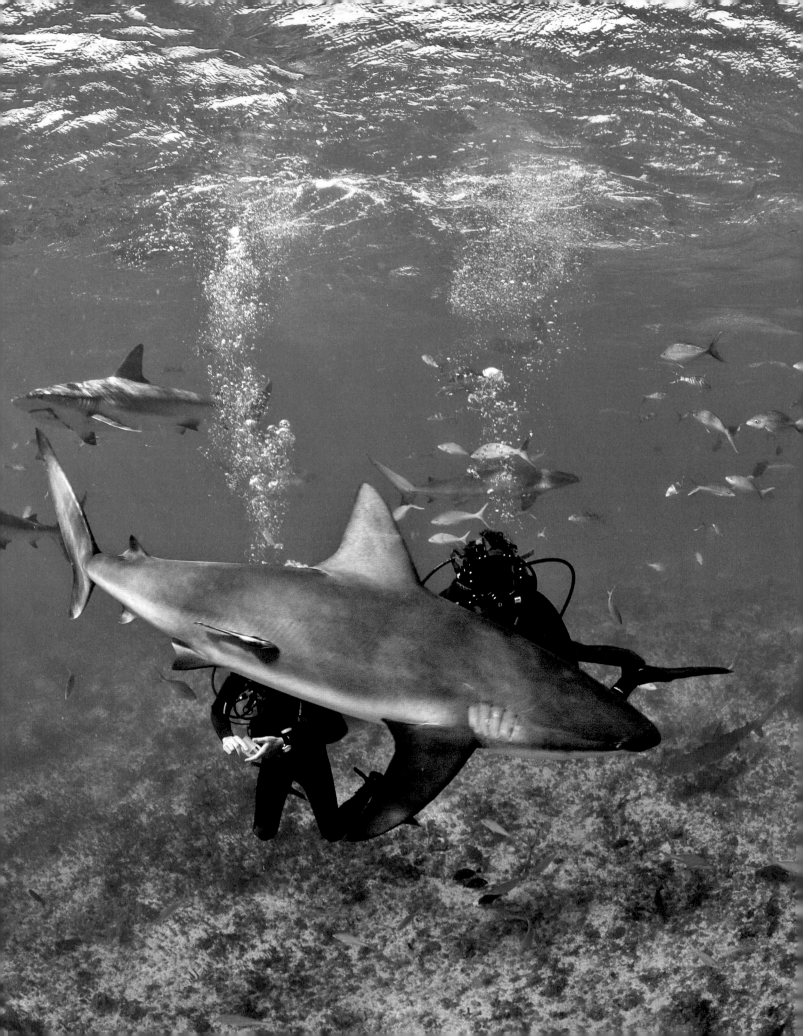

vicinity. Inspired by this, scientists set about trying to mimic the chemical that sparks this automatic response. The team has offered to test this newly created repellent on live sharks. If it works, the 'stay away' scent could be incorporated in suntan lotions and wet suits to avoid sharks mistakenly attacking swimmers.

However, first they will test an electromagnetic repellent, made of metal alloys, which could be used to discourage sharks from getting caught on metal longline hooks. This involves catching a harmless juvenile lemon shark and putting it into a state known as tonic immobility. This is a coma-like state induced by simply turning the shark on its back in the water – not something to be tried at home. Everyone is astonished at the impact of this simple manoeuvre. The shark, previously thrashing about to free itself,

**ABOVE** *Although commercial fishing is decimating some species of shark, many others are killed accidentally, snagged in the longlines and nets of this vast, rapacious industry.*

**OPPOSITE** *Among the most feared living creatures on earth, sharks have an exaggerated reputation as maneaters. Despite this our divers took a while to get used to being surrounded by adult sharks who showed a marked interest in their human visitors.*

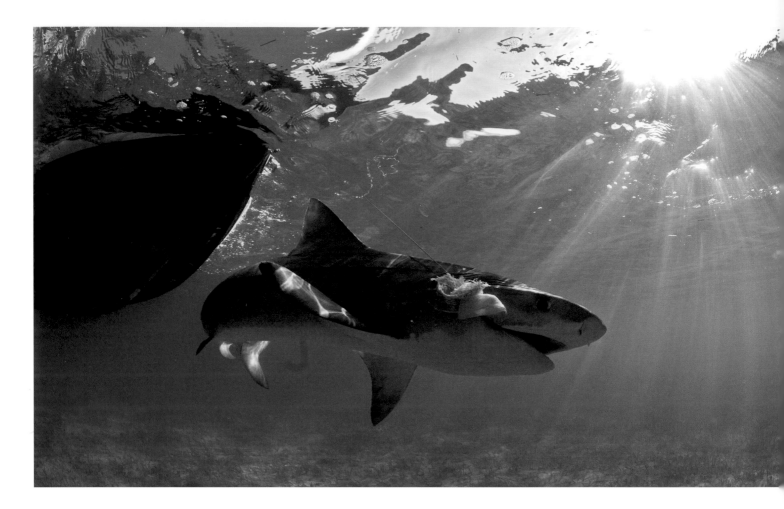

ABOVE *The normal method used to attract sharks is called 'chumming', in which a ball of bait is dangled in the water. It worked wonders when the team wanted specimens on which to try out the chemical repellent.*

becomes still, floppy and utterly unresponsive as soon as it is flipped over. The reason for this behaviour is not fully understood but not even food can wake a shark from this comatose state, giving us a humane way to test the repellent. The electromagnetic repellent is gently brought towards the sensitive electroreceptors on the underside of the shark's snout. The effect is immediate. In an instant the shark wakes up, violently shakes itself free and swims off. The first test is a success.

However, the next test is more dangerous. This time, divers will enter the open sea, surrounded by large sharks, before releasing the chemical repellent in liquid form. The team attracts the sharks in the usual manner – by chumming, that is, by dangling a bait ball in the water. Soon the sea is a boiling mass of sharks in a feeding frenzy. Most are Caribbean reef sharks, but larger tiger sharks have been spotted in the vicinity and are known to come to the research station. Despite the certainty that sharks rarely attack unless provoked, it's a nerve-racking moment as the divers prepare to drop backwards into a sea thronging with large adult sharks, armed only with a prototype repellent.

Under water, the sharks look magnificent, circling the divers smoothly and fluidly. Their wholly hydrodynamic bodies allow a speed and deft manoeuvrability that is awe-inspiring. Occasionally a large shark approaches to 'nudge' a diver and one even takes a testing nip of a flipper. Sharks sense with their mouths and do this to identify anything new in their environment. As more sharks start to display a marked interest in the divers, it is time to test the repellent. Under water, faced with a 2-metre band of circling sharks, it seems unlikely that a squirt of liquid could stop these creatures focusing on feeding. But, as the repellent disperses, the sharks turn and head away. It's a truly amazing sight to see sharks break off mid-meal in a marked response to the chemical. Within moments the sea is empty. The repellent has been impressive and offers hope that, in time, it may provide a way to build a more harmonious relationship with these mighty beasts of the ocean.

> It's a truly amazing sight to see sharks break off mid-meal in a marked response to the chemical.

## PARADISE LOST

When we arrived the Bahamas was certainly living up to its idyllic reputation. The sun was beating down and clear, calm waters lapped against tropical islands. It was easy to forget that these seas are part of one of the most powerful bodies of water in the world. A stark reminder awaited us.

Just days later our boat, *Caribbean Explorer,* pitched and tossed in a huge swell, listing and lurching as the vessel made for a sheltered harbour to sit out the storm. Below decks even the hardiest among the *Oceans* expedition team were groaning in their bunks, watching the vessel roll and tilt in the grip of an Atlantic tempest.

The Atlantic Ocean got its name from one of the Titans of Greek mythology: Atlas. Mentioned by Herodotus in 450 BC, its name means 'Sea of Atlas'. Its scale is vast; it covers a fifth of the earth's surface and is more than six times the size of the US in surface area. It is only outgunned in dimensions by the Pacific. Despite its huge presence, the Atlantic is a relatively young ocean, having formed around 100 million years ago from the break-up of its ancestral supercontinent, Pangaea, from which came the Americas and Africa. The source of the Atlantic's growth is the Mid-Atlantic Ridge, a colossal undersea mountain range, rising 2500 metres from the ocean floor and stretching 10,000 miles from the Arctic to the Southern Ocean. That's four times longer than the Andes, the Rockies and the Himalayas combined.

**ABOVE** *The calm idyll of a typical Bahamian cay, this is Double-Breasted Cay in the Ragged Island chain, often masks the fact that the sea here is part of one of the most powerful bodies of water in the world.*

It's a powerful ocean renowned for its storms, surging tides and violent winds. The highest tides in the world are found in the Bay of Fundy, which separates New Brunswick from Nova Scotia. During certain times of the year tides can dwarf a three-storey building.

It is dark when *Caribbean Explorer* finally makes it into the lee of an island and the storm shows no signs of abating. Hurricane winds are forecast for the next few days and the unexpected violence of the weather has put the entire expedition in jeopardy.

## WILD IS THE WIND

Billowing winds and mountainous waves are the flipside of the picture-postcard Bahamas. That's because there's a lot going on here. The unique geology of this archipelago drives the most powerful and fastest current in the world – the Gulf Stream.

It originates in the Gulf of Mexico but it is in the Bahamas that the Gulf Stream gains its real power. Between the islands of the Bahamas and the

coast of Florida the ocean forms a narrow channel, bordered by hard, calcium carbonate rock. As the warm waters come up from the south, the entire output of the Gulf of Mexico is forced through this 60-mile-wide channel. Around 3 billion cubic feet of water per second – that's 15 times the flow of Niagara Falls – is squeezed through the gap. It acts much like a gun barrel, propelling the warm waters out into the rest of the ocean with mighty force and forming the warm Gulf Stream.

With so much power behind it, the stream is driven up the eastern coastlines of the United States and Newfoundland and across 5000 miles of Atlantic Ocean. Once it reaches the middle of the North Atlantic, the current splits in two with the northern stream crossing to Europe. All along the northern route the Gulf Stream water continues to release heat and moisture to the atmosphere, making the climate of the region it passes through warmer and wetter. The amount of heat it holds is prodigious, enough to supply the whole planet's energy needs 100 times over. When it releases heat around the countries of northern Europe it dramatically changes the climate, raising air temperatures by as much as 10 degrees Celsius, and allowing palm trees to grow in western Scotland, at latitudes which otherwise would be frozen for considerable parts of the year.

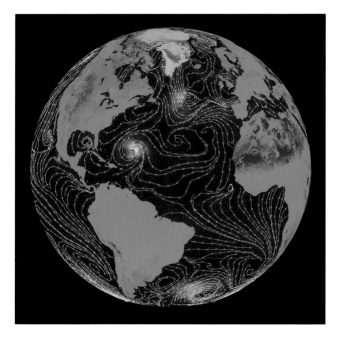

The southern part of the Gulf Stream hits West Africa and recirculates back to the Caribbean Sea, combining with it to form the North Atlantic subtropical gyre. And this also plays a crucial role, preventing the tropics from overheating by moving warm water away from the equator.

Apart from changing the climate across much of the planet the Gulf Stream also acts as an ocean highway, carrying plant spores, animal larvae and even adult organisms over huge distances. And, as the *Oceans* team discover, it was also a highway for civilizations – bringing people thousands of miles to form settlements in new worlds.

After days of delay, waiting for the storms to pass, there are finally signs that the worst is over. Our goal is to explore this part of the Atlantic, to discovers something of what makes this ocean perhaps the most influential on our planet. The morning dawns clear, and the sea has regained its bright blue sparkle. There is time to marvel at the sheer abundance and variety of sea life.

**ABOVE** *This NASA QuikSCAT satellite image shows the weather systems and wind patterns at work in the Atlantic Ocean at any given time. The orange circles indicate hurricane force storms; purple indicates medium strength winds while the lighter winds are blue and wind direction is indicated by the white arrows.*

## CORAL REEF PREDATORS

Among the fabulous species that throng the Atlantic there are some unwelcome visitors. Recently, a deadly invader has arrived, threatening the natural fish stocks and decimating the ecosystems along the western edge of the ocean. The next mission of the trip is to assess the damage it is wreaking.

The invader is the beautiful but deadly lionfish species. These delicate fish have fins that have been adapted into flamboyant, fan-like structures that are frilled around the edges, making the fish appear much larger than they actually are. But a fragile appearance belies their true nature as these are some of the most poisonous creatures in the sea. Along their backs is a row of spines, loaded with venom. The sting kills many marine creatures instantly and causes humans intense pain, redness and swelling. Indeed, though a lionfish sting is rarely fatal, there are stories of fishermen who would rather drown themselves than suffer the agony of the lionfish barb.

… a fragile appearance belies their true nature as these are some of the most poisonous creatures in the sea.

But the danger posed by the lionfish in the waters around the island of Grand Bahama is not their venom, but the fact that they are here at all. Lionfish are native to the Indo-Pacific Ocean and, outside aquariums, are rarely found elsewhere. In the 1980s a lionfish was spotted in the Atlantic, thousands of miles from its native environment. How it got there was a mystery. The African and American continents act as a barrier to any movement between oceans, and it would be impossible for a tropical animal like the lionfish to swim around the tip of Africa as the water is far too cold. By 1995 there were more sporadic sightings. Perhaps the lionfish had been caught up in ballast as container ships plied their trade across the seas, and dumped as the ship reloaded in the Atlantic, but a more likely suggestion is that a few lionfish were released in Biscayne Bay from a Florida sealife centre which was destroyed by Hurricane Andrew in 1992. Either way, by 2000 lionfish were being spotted in their hundreds, and it is now estimated that there are over a million in the Bahamas alone.

This population explosion is due to two factors. Hundreds of miles from their native sea, they have no natural predators. Also, there's abundant food because their small prey are completely unaware that this new neighbour is a dangerous killer and take no evasive action when the lionfish approaches.

Lionfish are one of the main predators in many coral reefs, active hunters who ambush their prey with outstretched, fan-like pectoral fins. Whole fish, up to three-quarters of their own size, are routinely found in the stomachs of lionfish. On this reef, the divers are astounded by the sheer quantity of lionfish and the seemingly suicidal behaviour of their prey. Lionfish are

usually nocturnal hunters but in one daytime dive the team witnessed several rare scenes of lionfish hunting and killing prey.

The results are devastating. Lionfish are voracious hunters and, as a result, native populations of reef fish around the east coast of America are being decimated. In this favourable environment, numbers of lionfish are increasing exponentially, helped by their unique reproductive mechanism. They produce floating balls of eggs that can travel vast distances, allowing for greater dispersal. Now, lionfish are found all along the western seaboard of the Atlantic, from the Bahamas up as far as New York.

Difficulties created by invasive species like the lionfish are not restricted to this part of the Atlantic. Worldwide, there is a growing environmental issue as alien species are inadvertently transported into new environments, resulting in the loss of native species and reduction in biological diversity at a rate that ranks only marginally below problems like habitat destruction, a degraded environment or rampant disease.

The divers are in a sombre mood as they gather for dinner that evening, all too aware of how suddenly fragile ecosystems can be tipped into disaster. This area has shown the power and influence of the giant ocean, but has also highlighted the impact that modern life is having on this vital ecosystem.

ABOVE *The beautiful but deadly lionfish are renowned hunters. They only arrived in the Atlantic in the 1980s but are now decimating native populations of the reef fish on which they feed all along the ocean's western seaboard.*

# Cave diving

**'Oh yeah – you were the guy I gave a hell of hard time to in 1981** because you were so cocky. You thought you were invincible.' So said Wes Skiles, our cave-diving cameraman, as he remembered training me years ago. Luckily I have matured. I am 27 years older and, theoretically, commensurately wiser. And these days Wes is so laid-back that at the start of the cave dive he fell asleep in the water and dropped the camera. We were together again to explore an underwater cave complex with the agenda of trying to understand better how sea levels have changed over time.

Now we stood at the uninviting entrance to Dan's Cave on the island of Abaco. Entrances to flooded caves never look pleasant but still I am drawn to them. This one was a crescent-shaped pool about 4 metres long and a metre wide surrounded by dead trees, poison oak and mud. Bleak though it appeared, it was the only way into about 37 miles of beautiful flooded caves that hold evidence of past sea-level changes.

Tooni, the *Oceans* team marine biologist, and I trust each other and dive well together. And when the dive conditions are challenging we just get better. I was really happy to have Tooni as my buddy on this cave dive as there would be no room for error.

We had stirred up the silt at the entrance so we descended to 20 metres in almost zero visibility. After the halocline (the interface between fresh water and sea water) cleared, visibility was better and we continued down to 25 metres and entered the cave system proper through a cavern that was so big our lights could not reach its end.

I enjoy the thrill of going where most people have never been and of being tested in an extreme environment. There is no room for error in cave diving. The diving skills and techniques that I take for granted when I'm at depth in the big blue or cruising along a colourful reef have to be firmly dialled-in. So it means that from the moment the dive planning and preparation begins I start to enjoy a clear, focused state of mind. And by the time I among the confines of the cave I am so tuned-in to the dive that it seems almost effortless. Short of being an astronaut, cave diving has to be the most exciting way of exploring our planet.

As we moved further into the cave I could see the stalactites and stalagmites that are familiar to all cavers. They can only be formed in air so this proves that these deep caves must have been dry at some point. We swam on through beautifully formed pillars, some in almost impossible shapes. I had to stop a few times just to figure out how they were created. It's in the Bahamas that the theory of underwater cave formations was proved. And it was a great feeling to see them for ourselves.

The dive was a long one and meant we could not ascend directly to the surface. So below the entrance pool we hovered at 6 metres in zero visibility for 16 minutes on a decompression stop to out-gas our nitrogen build-up. Ascending without the stop would have lead to decompression sickness or the 'bends'. Stops like this feel endless. However, the time went quickly as in the ascent to the stop I had been caught in a tree and spent the entire time in complete darkness trying to get out of its tangling limbs.

Short of being an astronaut, cave diving has to be the most exciting way of exploring our planet.

## A SUNKEN TREASURE

Two centuries ago the Atlantic Ocean was coping far better with its exposure to human activity. Then, our interest in the Atlantic was largely centred on crossing it. The Atlantic was the first ocean to be traversed by both ship and plane, and it forged a special relationship between the nations of either side of it, as our next dive was to show.

Both the American War of Independence in the late eighteenth century and the battle of the Atlantic during the Second World War used this vast ocean as both a battlefield and a transportation system for supplies and ammunition. It has also been host to a small number of forgotten wars, which have had important historical implications. For our next dive, we were hoping to identify a wreck, foundered on the coral reefs of Conception Island to the north of the Bahamian archipelago.

The War of 1812 was between Britain and its colonies and the newly independent United States. It began after British attempts to impede American trade with France resulted in a series of restrictions that the United States contested as illegal under international law. The major goal of the 'war hawks' in the western and southern states was aggressive territorial expansion. Their intent was to drive the British out of North America and the Spanish out of Florida, and to assert, once and for all, US control of the continent.

When the war ended after three years 1600 British and 2260 American troops had died but no territory was lost or gained by either side. It was, in effect, a draw.

Yet it was a war that changed much between the United States of America and Britain. From then on, Britain would never fail to regard the United States as a sovereign state. For many historians, it is this war that marked the final and decisive phase of American independence.

One of the last remnants of the war is the wreck of HMS *Southampton*. On 27 November 1812 the British frigate was bound for Jamaica towing the USS *Vixen*, which it had captured in battle a few days previously. Before midday, land was sighted. It was identified as Conception Island, and a course was ordered that would steer the ship well away from the shoals shown on the chart. However, further unmarked reefs eluded the crew and punctured the sides of the boat, filling the hull with water faster than the pumps could remove it.

It is thought that the skeleton of the ship lies just off Conception Island in the Bahamas, very close to Southampton Reef, which was named after the ill-fated warship. Few people know the exact spot of the ship's final resting place but we had heard of a possible location from a local amateur historian. The team will sail

… after three years, 1600 British and 2260 American troops had died but no territory was lost or gained …

through these treacherous waters on a mission to prove that these remains, as yet unsurveyed by a professional archaeologist, are indeed those of HMS *Southampton*.

After a difficult few hours of negotiating the jagged coral heads surrounding Conception Island, we moor at a location near enough to drive the smaller RIBS over the jutting reef. As the divers descend the water column, a huge cannon is immediately spotted protruding from underneath a vast brain coral. Measuring its length shows it matches the dimensions of the *Southampton*'s cannons, as listed in the original plans for the ship. Gradually more cannons are spotted, some camouflaged by crustaceans, others clearly visible on the sea floor. Nearby, two anchors with the distinctive V-shaped arms that are typical of British anchors made at that time, as opposed to American anchors with rounded arms, indicate that this is surely our ship. Further cannons are found strewn over the reef, interspersed with cannonballs and ballast rocks. A rum bottle is hidden beneath some sediment, and further on we find part of a pane of glass, probably from the window of the captain's cabin.

It is an amazing dive, a window on a forgotten war. For the team, who have identified the lost remains of the *Southampton*, it's an exhilarating triumph.

**BELOW** *The colonial war of 1812–15, between Britain and its colonies and the newly independent United States, used the Atlantic as its battlefield. This aquatint,* Capture of the Argus, *illustrates a scene that would have been familiar to the sailors on HMS* Southampton *when it engaged and captured the USS* Vixen *a few days before it was wrecked in November 1812.*

**OVERLEAF** *An aerial view of the Exuma island chain, the historic home of the Lucayan Indians who settled here from South America about 1000 years ago.*

## A LOST CIVILIZATION

ABOVE *This lithograph by M.F. Tobin entitled* First Sight of the New World *depicts Christopher Columbus arriving at the Bahamas in 1492. The exact point of his arrival at these islands is still a matter of debate.*

Throughout the trip, we've come to see just how dependent we are on this vast ocean. It drives our climate, our trade and economies, and it holds our history too. The sea carries stories of our past, preserved for millennia below the waves. Halfway through the expedition we are heading north, hoping to uncover the story of a lost civilization.

About 1000 years ago, the first settlers on the Bahamian islands arrived by boat. The Lucayans had ridden the Gulf Stream's 'express highway' from South America to establish colonies on the islands. Their name derives from the Arawakan Indian words *Lukkunu Kaíri* meaning 'island men'. They share a common ancestry with the Taino societies of Puerto Rico, Haiti, the Dominican Republic, Cuba and Jamaica, from whom they separated in about AD 600 when they began to colonize the Turks and Caicos Islands and the Bahamas. By 1492, when Christopher Columbus arrived in the area, they were living in well-established communities on these islands.

Living primarily off the sea, these peaceful people were skilled potters, carvers and boat-builders. They spun and wove cotton into clothing and hammocks, which they traded with neighbouring communities. The Lucayans, however, had no idea of the wheel, did not use metals for tools, and had no written language.

Religion played a pivotal role in their society. Lucayans worshipped various gods who were thought to control the rain, sun, wind and hurricanes. But their strongest mythology was connected to the ocean. They believed that blue holes – the deep shafts leading to water-filled caves that puncture the islands – had powers of creation. According to legend, the sun, the moon and the Lucayan race came from these sacred caves. And so, when Lucayans died, they were ceremonially returned to them in a ritual burial, through a rock gateway into the afterlife.

The *Oceans* team sailed to Grand Bahama, at the northerly end of the island. It has a number of deep blue holes and the team will dive inside these to look for signs of ancient burial sites. The caves were formed from the erosion of calcium carbonate, which created vast underground caverns rather like giant pieces of Swiss cheese, which became flooded with seawater.

> According to legend, the sun, the moon and the Lucayan race came from these sacred caves.

As the team begin to penetrate one of the caves, it isn't long before another world unfolds. In a vast cathedral cavern beautiful stalactites surrounded by water hang from a ceiling, rather like the vaulted ceiling of an underwater palace. Occasionally, glorious streams of sunlight reach into the depths from openings in the roof of the cave, lighting up the sparkling crystalline rocks. It's a strikingly spiritual place.

We are hoping to find some evidence of the Lucayan burial rituals. Searches like these usually yield only trace evidence, or maybe fragments of artefacts. So the team are absolutely delighted when they discover, nestling deep in a crevice of the cave wall, a human skull. On closer inspection, its forehead appears to be broadly flattened, a strong suggestion that it belonged to a Lucayan. When a Lucayan baby was born its parents would strap a board to the child's forehead so that it grew flatter, in a custom similar to Chinese foot binding. The Lucayans considered a flat forehead a sign of beauty and strength.

> … they discover, nestling deep in a crevice of the cave wall, a human skull.

This flattened skull may have been placed here more than 1000 years ago and, since it was alone rather than in a communal grave, it probably belonged to a tribal dignitary. Up from the crevice there is a narrow opening in the cave roof. Through this the body was probably lowered into the depths of the blue hole. Along with the excitement of the remarkable find, the divers spend a few moments reflecting on the lamentable loss of an entire race.

For these gentle people, idyllic island life was not to last. Spanish gold hunters followed in the wake of Columbus, and began shipping many Lucayans out to work as slaves in the gold mines of Hispaniola. The remainder were forced to dive for pearls. In effect, the Lucayans were worked to death. Those who resisted were

killed, while the rest died from European diseases or committed mass suicide. Within a generation the entire Lucayan population of around 50,000 was wiped out, leaving few traces behind it. The Spaniards then sailed away leaving the islands deserted. Now the only testimony to this civilization lies deep in the blue holes, in the grip of the Atlantic Ocean.

## THE AIR THAT WE BREATHE

The Atlantic Ocean is home to billions of marine creatures in an array of ecosystems. On the rocks and reefs live colourful sea anemones, sponges and corals. In the shallow waters of the continental shelf, before the seabed drops away to the ocean depths, there is familiar marine life, such as crabs, shrimps and molluscs, as well as many varieties of fish, octopus and squid. Further out in the depths are dolphins, seals and sharks. Faced with this profusion of plant and animal species, it is hard to imagine a time when the oceans were toxic environments almost entirely devoid of life. But they were noxious and inanimate until the era of the stromatolite. This unlikely hero of earth's story looks like a rock but is actually a bacterial city that breathes out oxygen, which eventually sweetened the seas.

> This unlikely hero of earth's story looks like a rock but is actually a bacterial city that breathes out oxygen …

Around 550 million years ago stromatolites were the most populous organism in all the oceans of the world. Now there are only two places left on the planet where they can be found: the super-salty waters of Shark Bay in Australia and the tide-scoured channels near Lee Stocking Island in the Bahamas.

The *Caribbean Explorer* sailed for a day before reaching Lee Stocking Island, which sits on one edge of the huge calcium carbonate platform that holds up the Bahamas. Huge drop-offs plunge down the side of the platform to depths of many thousands of metres. As a result, there are large upwellings which make sea conditions particularly treacherous. This is a hostile place with constant wave action and the swirl of ocean debris, and very few organisms can survive. Except, that is, for stromatolites.

At first sight there appears to be nothing in the water except wispy clumps of seagrass and unremarkable lumps of rock. But there's more to these rocks than meets the eye. They are, in fact, composed of thousands of primitive microbes called cyanobacteria which create domed rocky structures – stromatolites. The bacteria live in gooey mats on the top surface of the structures, trapping fine sediments carried across them by tidal currents. The mats are made opaque by the sediments so that the microbes move upwards, seeking sunlight. In this way, layer after layer is cemented to produce cup-like shapes.

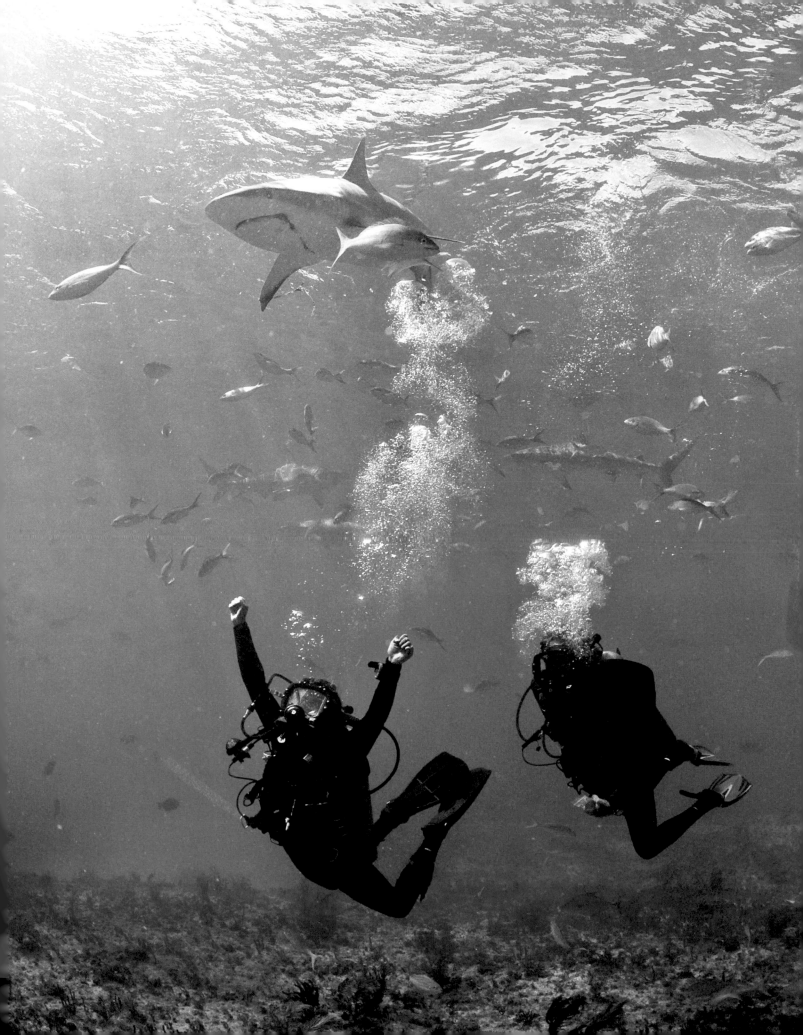

ABOVE *Stromatolites are unlikely heroes, but these rock-like organisms produced the oxygen that eventually detoxified the seas and turned them into hospitable habitats for countless marine species.*

From around 2.5 billion years ago, these were the only creatures that could endure the extreme environments found in earth's first oceans. The cyanobacteria are closely related to primitive extremophile bacteria, which can cope with highly toxic chemicals like hydrogen sulphide at close quarters. They also secrete a type of 'sunscreen' on the surface of the stromatolites, which would have protected the microbes from the sun's powerful radiation.

But their greatest legacy to the planet was that as they respire they produce oxygen. From 2.5 billion years ago, stromatolites put oxygen into the seas and the atmosphere. About 550 million years ago oxygen levels reached what they are today. This was enough to both oxygenate the deep ocean and displace the sulphur bacteria, which were previously widespread. The stromatolites transformed the toxic seas into hospitable habitats for millions of species. With a combined photosynthetic activity greater than the world's rainforest canopy, they are the reason for our oxygen-rich atmosphere.

New organisms evolved that used oxygen as a source of energy. These 'oxygen-loving' organisms began to dominate the oxygen-rich seas, and gradually evolved

into myriad forms of marine life. Fossil stromatolites have been found in sedimentary rocks of all continents. They have been an important focus for palaeoecologists – those who study the early evolution of life – while other scientists use fossil stromatolites to reconstruct ancient physical environments. For these studies, observations of modern 'living' stromatolites are crucially important for a proper interpretation of the ancient fossils.

Thanks to the humble stromatolite the Atlantic is now one of the world's most productive seas. The most fertile areas for fishing include the Grand Banks off Newfoundland, the shelf area off Nova Scotia, the Bahama Banks, and Dogger Bank in the North Sea, and the major species of fish caught commercially are cod, haddock, hake, herring and mackerel. The ocean is hugely influential commercially. Besides its major transportation and communication routes, it also offers abundant petroleum deposits in the sedimentary rocks of the continental shelves.

## THE BLACK HOLE

Without the stromatolite none of this is likely to have occurred. But what was it like in the years before the advent of the stromatolite? Bizarrely, there is one place where you can still experience an ancient, alien ocean. The team is about to head to the island of Andros, south of Grand Bahama and north of Cuba, for possibly one of the most memorable dives ever undertaken.

> … there is one place where you can still experience an ancient, alien ocean … the Black Hole at Andros.

The team plans to investigate a remarkable phenomenon. The Black Hole is a perfectly round sinkhole that plunges 47 metres into the soluble limestone – the sedimentary rock that makes up the Bahamas archipelago. Isolated from the rest of the ocean it is an eerie and unique marine environment. But it is the life forms in this sinkhole that make it such an extraordinary place.

The Black Hole was first seen in 1985 by veteran cave diver Rob Palmer. His initial thought was that it was formed by meteor impact, due to its perfectly round shape. But it is now thought that the hole formed from the surface downwards. Puddles of rainwater gathered on the surface and gradually became deeper, to be colonized by bacteria that produced acid as a waste product of their carbon metabolism. This acid dissolved the limestone, leaving a perfect circle, which over time and after the action of many billions of bacteria, has grown to nearly 50 metres deep. From the surface it is an uncanny sight; the still waters appear pitch black and distinctly ominous.

Hardly anything is known about the microscopic animals in the Black Hole, and only one research team has ever dived it before. Our team plans to descend into the acidic depths, taking probes to measure temperature and oxygen levels.

# The dive of a lifetime

**I should have seen it coming** – you can't travel back in time 3.5 billion years without being flippin' uncomfortable.

My first sight of the Black Hole from the helicopter brought the familiar feelings of excitement and anticipation. I love those moments. Part of me is just bursting to get to it while a voice in my head is working out risks and how to manage them. The Black Hole on Andros Island is a one-off. Nothing like it exists anywhere else on earth. That alone makes it a great diving expedition. I'd heard that the hole was about 50 metres deep with a strange layer at about 18 metres that keeps the top and bottom waters isolated. We planned to dive through this layer and see what happened on the other side.

From the start it was clear this was going to be a stretch. The site is only accessible by helicopter. The area around the hole is a cross between Yorkshire limestone karst scenery, a mangrove swamp and a nightmare tangle of poisonwood. The rock edge of the hole has formed into a brittle honeycomb with razor-sharp edges.

The first part of the dive felt like many freshwater dives – cool, clear, green-tinted water with us cruising down a steep rock on the descent. We soon lost sight of the wall and then, as expected, we came on to the top of a dense brown layer that looked exactly like a muddy bottom. It moved in thick clouds. We slowed to study it and immediately felt the water get hot. Not pleasantly warm, but unhealthy-get-out-of-there hot. Within a few seconds visibility went to zero. The only way I knew my torch was on was to hold it against my mask. I held the front of the camera and pulled it to my mask so that I could describe the experience and keep us all together.

I was almost overwhelmed by a sudden blast of the smell of rotten eggs, which made no sense. You usually can't smell anything under water as your nose is inside the mask.

**BELOW, LEFT** *Watched by team members, Paul Rose launches himself into the Black Hole on the island of Andros.*

**OPPOSITE, LEFT** *The cameraman swims into position in clear water just below the surface ready to film the rest of the team.*

**OPPOSITE, RIGHT** *In the heart of the Black Hole: zero visibility, blood-red water and the most hideous smell on earth.*

In this case I could smell the bacteria because the chemicals were absorbed into my skin and I smelled them through my sinuses. I was being permeated with chemicals. I kept reminding myself that this layer was made of hydrogen sulphide but I couldn't remember the level of toxicity. My overwhelming feeling was that I just had to go deeper.

In a few seconds we entered an even smellier layer that was blood red – almost purple. I did not want to hang around here but was drawn into experiencing it for as long

> ... the chemicals were absorbed into my skin ... I was being permeated with chemicals.

as possible. We continued our descent and, at 22 metres, finally made it through to clear, completely black water which was reassuringly familiar – just like a normal night or cave dive. That was until I looked up. The 'ceiling' was black with bright green holes, where we had come through it, surrounded by the strange red-purple layer underneath.

I realized that the water we were exploring was what all of our seas were like 3.5 billion years ago. The black water with its dead feeling is a long way from the beautiful oxygen-rich, life-giving oceans we have now.

There was no avoiding it. We had to go back up through the layer and I needed to experience it again just to check that I was right about the assault on my senses. Sure enough, the visibility went to zero in the red-purple, smelly super-hot layer, which was followed by the green smelly layer and then the wonderful cool, clear life-giving fresh water. I raised my arms in joyous triumph as we enjoyed the slow ascent in clean water.

I felt a bit odd after the dive and I spotted John, our safety diver, throwing up in the weeds. Tooni had a headache and Mike, the cameraman, had a sore throat. It wasn't until late that evening that we all began to feel good again. There are even some longer-term effects – my hair has gone a weird colour. Was it worth it? You bet. It was a dive of a lifetime that took us back to what the sea was like 3.5 billion years ago.

The sudden temperature spike at around 18 metres, obvious to the divers even through their wet suits, occurred as they entered a metre-thick layer of bacteria. But that wasn't the only oddity. Suddenly the water turned a bright, almost psychedelic red-purple. The layer of microbes is so dense that it absorbs nearly all the sunlight entering the hole. By reflecting only a small amount of the longer wavelengths, the microbes cause the intense red-purple colour. This is what makes the hole appear black on the surface. The bacteria here are so dense that they would weigh about 5 tonnes if they were dried out. They are able to photosynthesize using sunlight to produce energy. However, the water deep inside the Black Hole has virtually no oxygen dissolved in it, which is vital for photosynthesis to happen. So, the bacteria have evolved an ingenious way to harness the sun's energy by using sulphur in place of oxygen and producing acidic hydrogen sulphide as a waste product. In high concentrations, hydrogen sulphide is toxic and the concentrations produced here are overwhelming. The characteristic 'rotten egg' smell of the sulphurous by-product is so intense that not only could the divers 'smell' it through their skin, but on the surface, too, the stench was unmistakable as their air bubbles carried the gas up to the surface. As the divers stayed in the layer, the toxic acidic gas started to irritate their skin, causing stinging, itching sensations. This was potentially dangerous and the surface safety team monitored the situation carefully.

> Suddenly the water turned a bright, almost psychedelic red-purple.

Still, the divers were determined to see what was beyond the bacterial layer so they descended even further. Under the layer the team were in the pitch black. They shone a torch up on to the underside of the microbial blanket to see globules of bacteria raining down on them. The temperature also dropped dramatically when they moved out of the sulphur-bacteria layer above, rather like being plunged into a cold-water pool. This is because no sunlight can penetrate through the bacteria mat, so the lower lying bacteria adapt to this by using the heat energy from chemicals in the water instead of the sun. The readings confirmed that the water is completely devoid of oxygen.

The environment inside the Black Hole is as hostile as it gets. With no oxygen or sunlight, very little life can thrive. And this is what our planet's oceans would have been like when they first formed around 3.5 billion years ago. From around 3.5 billion to 2.5 billion years ago the earth's atmosphere was oxygen-deficient. Although some photosynthesizing bacteria were producing oxygen, volcanic gases were reacting with it so quickly that very little accumulated in the atmosphere.

> The environment inside the Black Hole is as hostile as it gets.

Sulphur began to gather in the ocean and, in this oxygen-free sulphur environment, only oxygen-intolerant sulphur-bacteria could survive, much like the bacteria found in the Black Hole. By diving in this unique place the *Oceans* team

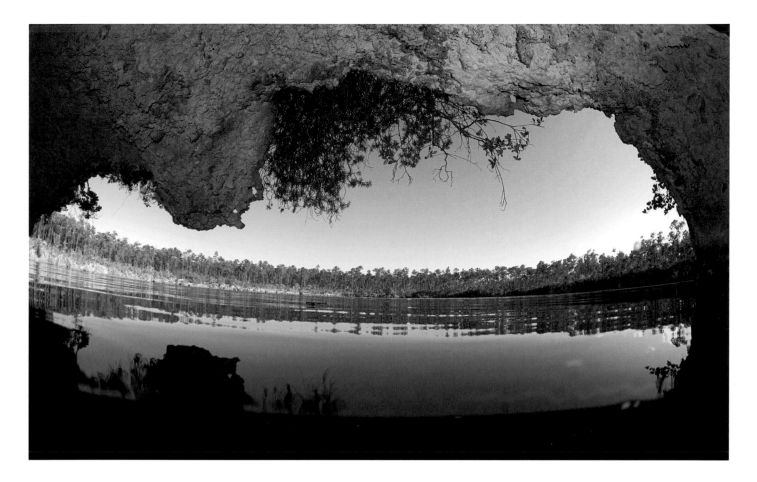

dived back in time to discover what might have lived in our oceans when they first formed. Now they know it to have been a toxic, black, virtually lifeless void, colonized by nothing except patchy mats of red-purple bacteria.

Despite the thousands of dives they have accrued between them, none of the divers had ever seen a marine environment like this anywhere else in the world. This was a hazardous dive, and we retrieved the divers earlier than planned because of safety fears. But even so this unique dive came at a price. After prolonged exposure to the toxic chemicals, one diver was severely ill, brass fittings on the dive equipment had become tarnished and the hair of the team leader had turned an odd shade of gold.

In the dying light of a tropical sunset, sipping beer and mojitos, the team reflected on what has turned out to be an unforgettable trip. For the British and the American on the boat the Atlantic is the most familiar of all the world's oceans, and one that is easily taken for granted. But even in this relatively small corner, we have witnessed the potency and influence of this mighty ocean.

The storms that dogged the beginning of the expedition, and the massive power of the Gulf Stream, speak of the Atlantic's crucial importance in shaping the world's weather and climate. Its trade routes, fisheries and natural reserves have made it a giant in world commerce, and as a highway linking continents and peoples it has played a major role in shaping our history. As the sun slips below the horizon of this mighty, vast sea, it feels appropriately named – as a Titan.

*ABOVE In stark contrast to the Black Hole the Bahamas are also home to a number of Blue Holes. These water-filled caves – found both on land and offshore – were formed during several ice ages but unlike the Black Hole are filled with regular sea water. Diving here is much more pleasant and they are a major attraction for divers in search of rarely seen tropical marine environments.*

# THE SEA OF CORTEZ

## The World's Aquarium

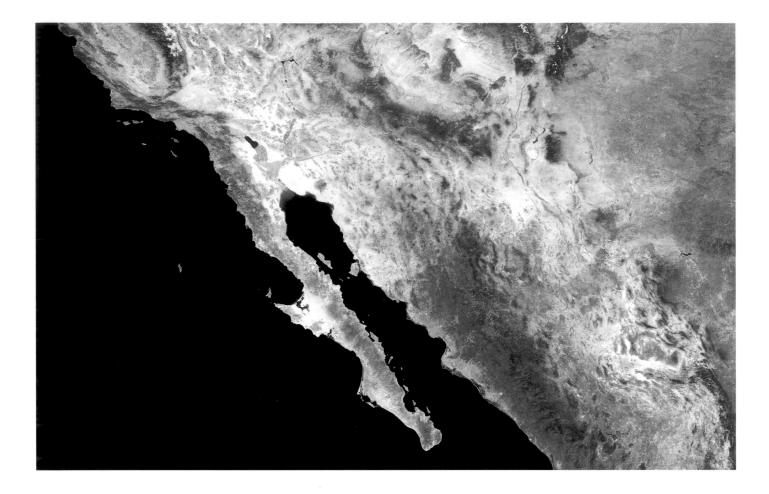

ABOVE *A satellite image of the Sea of Cortez – the thin strip of ocean between the Californian peninsula and Mexico.*

PREVIOUS PAGE *A sperm whale dives in the sea that contains the highest diversity of large whales in the world.*

AS GLOBAL WATERS GO, the Sea of Cortez at first sight appears distinctly unprepossessing. A skinny strip of sea between the Baja (pronounced ba-ha) California peninsula and mainland Mexico, it is a mere 99½ miles wide and only 995 miles long. It has neither the majestic power of the Atlantic nor the vast scale of the Pacific.

On the face of it, it is an unlikely destination for a global ocean expedition. But it was this rather modest sea that delivered one of the rarest sightings of all the *Oceans* expeditions.

The expedition had not set out to break new ground. The goal of this trip was simply to investigate the extraordinary profusion of marine life found here. This small stretch of sea contains one-third of all earth's marine mammal species, and 800 different species of fish, not to mention the highest diversity of large whales in the world. Jacques Cousteau (1910–97) called it the 'world's aquarium' and writer John Steinbeck (1902–68), who wrote a lyrical account of his time here working as an amateur biologist, claimed it was 'ferocious with wildlife'.

This unique environment was, of course, an irresistible lure for the *Oceans* team whose aim was to investigate the secrets of this abundant, thriving mass of marine life. We witnessed whale behaviour that was by any standards a zoological coup. Unfortunately, this triumph was set against a

backdrop of the discovery that the ecologically vital Sea of Cortez is in turmoil and under threat.

Our expedition set off from the crowded harbour in La Paz in the height of the Mexican summer. The reek of fish hung heavy in the intense, stinging heat and the air crackled with the residual energy of a hurricane that had passed through the day before.

The harbour was a jumble of boats. Open fishing boats called pangas, crudely finished in brightly coloured fibreglass, bobbed alongside sleek yachts. On the scale ranging between panga and super yacht, the expedition boat was firmly in the middle, a former research vessel called *Sea Escape*. Once loaded, and to the deafening thrum of what seemed like the region's noisiest generator, the expedition set off to explore the marine riches of the Sea of Cortez.

## RICH CHEMICAL SOUP

The prolific life in the Sea of Cortez is partly the result of the mighty geological forces that formed it. Five million years ago the massive tectonic plate under the Pacific moved away from the North American continental plate, ripping off the Baja peninsula and southern California from the mainland. As it moved, travelling 200 miles north, it left behind a deep gulf. Pacific water flooded into the gulf and the Sea of Cortez, also called the Gulf of California or the Vermillion Sea, was born.

*BELOW The Sea of Cortez was formed five million years ago when the Pacific plate moved westwards ripping the Baja peninsula off the North American continental plate and opening up a deep gulf that filled with water.*

ABOVE *Hydrothermal vents like these release rich ocean 'fertilizer' into the waters here, which help attract and feed the huge variety of marine life.*

OPPOSITE *Huge sunfish are indigenous to the area. These giants, which are said to resemble a fish head with a tail, can grow up to 3 metres in length.*

Today, the Sea of Cortez is still growing, widening by 5 centimetres per year along the southern extension of the notorious San Andreas fault line, which runs out of California and fractures the planet's surface below the water. The whole area is geologically highly active, its movement creating cracks in the sea floor that plumb deep into the earth's crust.

Normally, cracks in the earth's crust are found in the deep mid-ocean ridges, many thousands of metres down on the sea floor, but in the Sea of Cortez they are found in a shallow basin, just off the coast, only 5 metres below the surface. This provided a rare opportunity for the *Oceans* team to investigate this unusual phenomenon. Under water, the first sign of the vents is not a sight, but a sound – a crackling, popping hiss. Soon its source becomes apparent. All around, over an area that measures under half a square mile, streams of hot bubbles billow out of the sea floor, raising the immediate water temperature to around 80° Centigrade. This is a hydrothermal vent; a crack in the earth's crust reaching right into the molten magma towards the core of the planet. Water seeping in is warmed to many hundreds of degrees and is gradually forced back up to the surface through miles of sediment on the sea floor. As it rises it absorbs a rich cocktail of minerals and nutrients: calcium, magnesium and iron, which are released into the sea. This is the unique, rich 'ocean fertilizer' that feeds the life here. Chemical-synthesizing bacteria flourish around the vents, visible as thick coloured mats covering the rocks, and fish of all kinds are thriving on the plentiful food source. This, combined with the nutrient-rich cold California currents that flow through the Sea of Cortez, has turned this small sea into an ocean oasis.

Fish of all shapes and sizes abound here; angelfish, damselfish, grouper, parrotfish, stonefish, wrasse, snapper and moray eels are just some of the hundreds of different fish swimming in this sea. Giant manta rays, up to 7 metres wide, are found here, as are vast sunfish, the heaviest known bony fish in the world, which can weigh up to 5000 pounds. Other resident species include California sea lions, fin whales, an endangered porpoise – the vaquita – and cannibalistic Humboldt squid.

Five of the world's seven species of sea turtle migrate here: leatherback, loggerhead, hawksbill, olive ridley and the Pacific green turtle – also known,

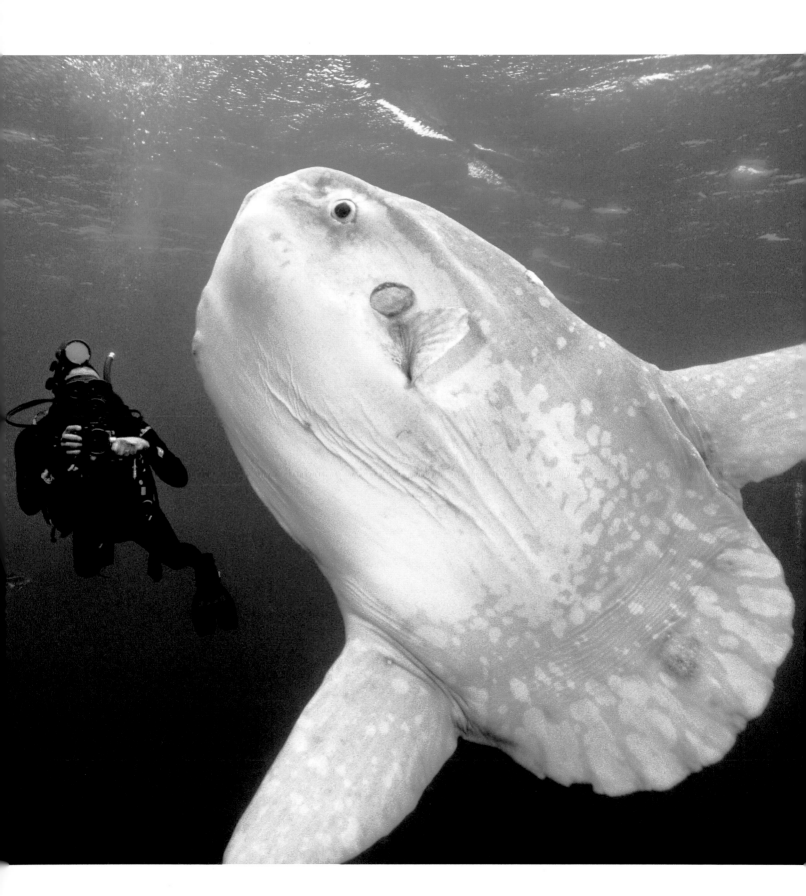

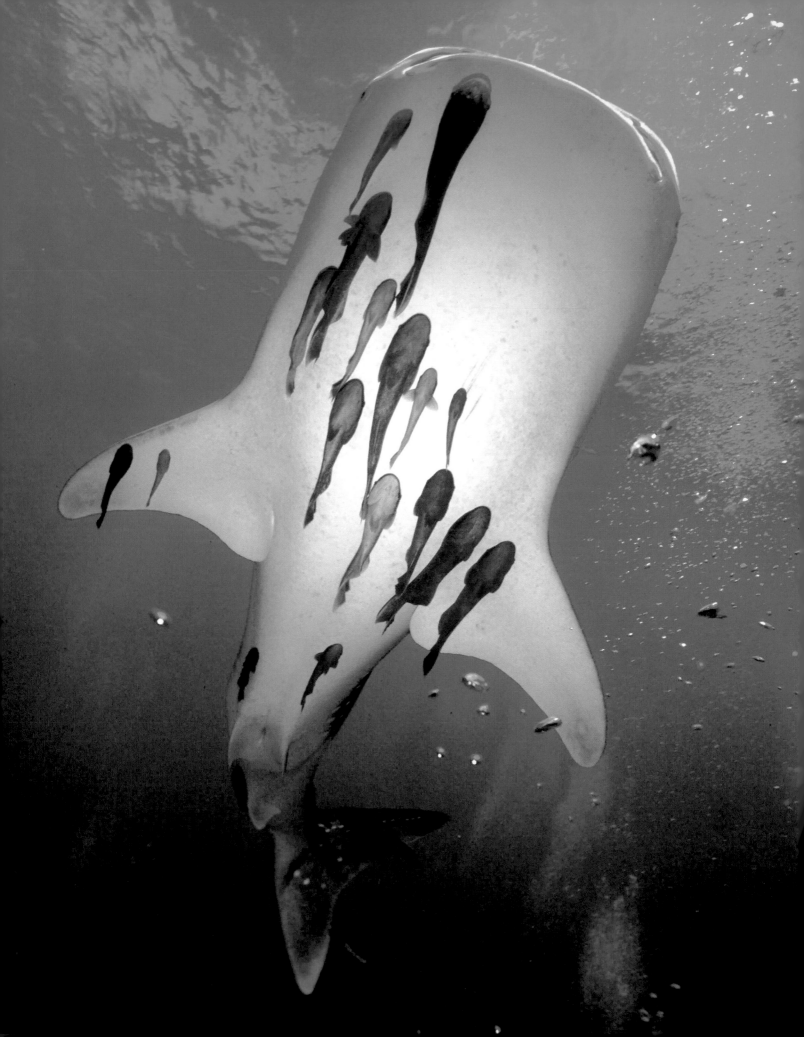

rather confusingly, as the 'black turtle'. Other visitors include whales and whale sharks, pods of dolphins and elephant seals. The California gray whale completes the longest migration of any mammal by spending a few winter weeks each year in breeding grounds here before returning to the Bering Sea 5000 miles away. More species of whales and dolphins feed and breed in the Sea of Cortez than in any other part of the world. Overall, nearly 900 fish species and 34 species of marine mammals swim these waters, and more than 800 of the sea's marine and coastal species are found nowhere else in the world.

OPPOSITE *Whale sharks are migratory visitors here, usually in September or October, to feed and breed. They are often accompanied by ramora, or sucker fish, who hitch rides on these gentle giants and keep them clean of parasites.*

## THE SHARK AND THE SNAIL

And right at the top of the food chain, the apex predators, are the sharks. At least, that's how the script always used to read. But that's old news today. For the last 20 years or so the most deadly killers have been mankind and it is sharks who have all too often been the prey.

Man had fished the waters here for centuries, with few far-reaching effects. Then came the era of commercial fishing, with gill nets and then drift nets scooping up everything small and enormous from this diverse habitat. Sharks were frequently the victims of the tuna fishermen.

But then the demand for shark fin soup in the increasingly wealthy Far East put a different complexion on the issue. When a fin weighing just over 2 pounds can fetch between $50 and $100, it comes as no surprise to learn that commercial shark fishing has become so intensive. The practice of slicing off the fins and throwing the shark back is illegal in Europe and the United States. Although it is not illegal in Mexico it is heavily discouraged, but we saw signs that it is still happening here. It's impossible to say just how many sharks are killed worldwide. One estimate out of Hong Kong, where many of the fins are landed, says the number is between 26 million and 73 million each year; others suggest it is over 100 million.

For the last 20 years or so the most deadly killers have been mankind …

By the time the Sea of Cortez was added to the UNESCO list of World Heritage Sites in 2005 it was already sorely depleted of its fish and marine mammal populations. The next mission for the *Oceans* expedition team is to investigate how critically overfishing and the ravaged fish stocks have affected the scalloped hammerhead shark.

There are nine species of hammerheads, so called because the long, flattened lobes projecting from the sides of their heads resemble a flattened

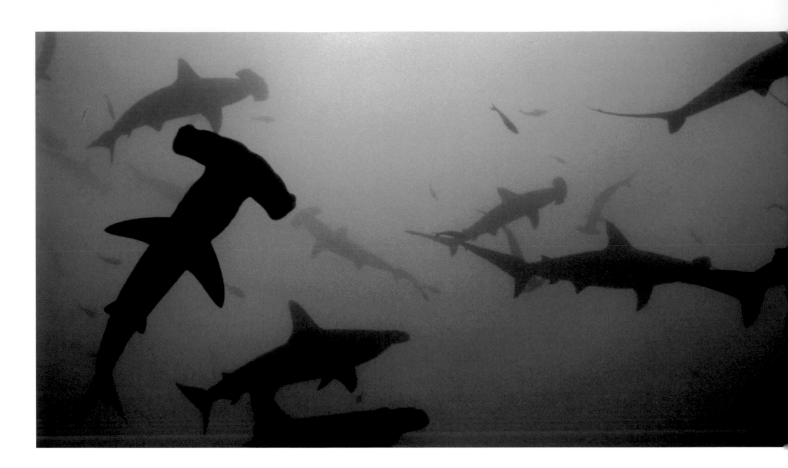

hammer. The 'hammer' is, in fact, a highly complex organ containing both olfactory organs and highly developed electroreceptors. The nostrils are located near the outermost tips of the hammer and have specialized grooves that channel scent-bearing water to the nostrils. By having their nostrils mounted far apart, hammerheads may be able to sample a wider portion of the water column giving them increased acuity – a kind of 'stereo sniffing'. Hammerheads are often the first sharks to arrive at an area where fish offal is being dumped overboard, suggesting that their sense of smell is particularly well developed. Question marks still exist about hammerhead behaviour as they are notoriously tricky to observe.

**… they can even locate prey buried under the silt of the sea floor.**

The hammer also houses the specialized electroreceptor, called 'ampullae of Lorenzini'; the ampullae are distributed over the entire undersurface of the hammer and are acutely sensitive to electromagnetic fields, including the weak bioelectric aura that surrounds every living creature. Hammerheads often swim very close to the seabed, swinging their strange T-bar heads in broad arcs to sense this minute electrical field. Using this mysterious sense they can even locate prey buried under the silt of the sea floor.

It's this electromagnetic sense that draws them to the Sea of Cortez. Thanks to its volcanic past, the sea is dotted with large seamounts; undersea mountains typically formed from volcanic rock, mainly basalt. This basalt is rich in magnetite (ferrous-ferric oxide), the most magnetized of all naturally

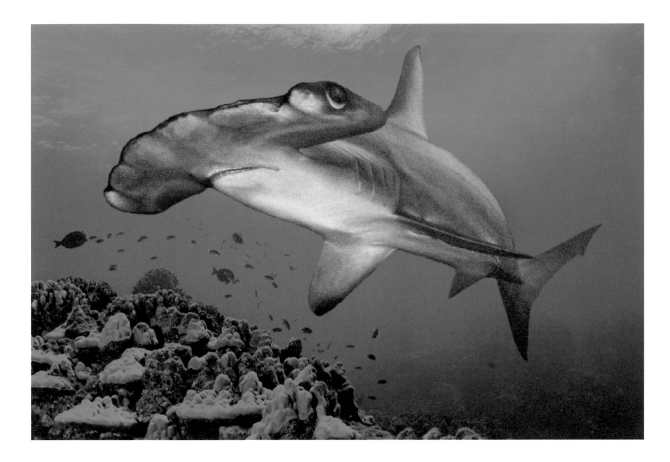

occurring minerals, so seamounts emit a strong magnetic field. Traditionally, seamounts have been a rich source of food for sea life. The hammerheads' sensors can detect minute changes in magnetic polarities, enabling them to find seamounts from many miles away. As a hammerhead swims it moves its head from side to side, scanning the water for a signal. It's like a shark GPS system, mapping the ocean highway.

Just decades ago, huge schools or 'shivers' of hammerheads would congregate around these large seamounts, drawn by both the magnetic field and the array of fish found here. Hammerheads are one of the few species of shark known to congregate like this, and they do so solely during the daytime. At night they disperse in order to hunt. One suggestion is that the hammerheads use the magnetic dipole of the seamount as a navigational tool, a landmark on their migration route northwards through the Sea of Cortez. Whatever the reason, the mounts in the Sea of Cortez have always been one of the places in the world to see vast shivers of hammerheads, numbering up to 500 sharks in a group.

The *Oceans* team is planning to investigate the current health of the population by diving at a particular seamount known as a hammerhead congregation point. Technically it is a complex dive. El Bajo seamount lies 40 metres below the surface and, because hammerheads are frightened off by the air bubbles of normal scuba gear, the dive will have to be done with silent, bubble-free re-breathers.

**ABOVE** *The population of scalloped hammerhead sharks in this area has been seriously depleted in the last 30 years due to overfishing.*

**OPPOSITE** *In the past huge schools or 'shivers' of hammerheads would congregate around the large seamounts of the Sea of Cortez. However, these are now rare as this fascinating species is fast disappearing from these waters.*

# Re-breathers

**My career as a diver spans 40 years** and during that time I have wasted most of my air. This is not because I wasn't working or having fun under water, but because for almost all of my dives I have used SCUBA equipment – Self Contained Underwater Breathing Apparatus. This is the kit invented in 1942 by Emile Cagnan and Jacques Cousteau that involved divers carrying high-pressure cylinders of air on their backs. You can easily spot scuba divers in the water because of the stream of exhaust bubbles that follow them and when you are using scuba gear it's hard to get really close to the fish because of these noisy bubbles. The instant you exhale, the fish dart away. And that's not all – most of the precious air in the diving cylinder is wasted in the bubbles.

Scuba gear is what most divers use these days – it's pretty simple to use and maintain, is safe and reliable, and just about everyone uses it when learning to dive. But if you want to get really close to marine creatures, spend hours under water, engage in underwater warfare or live in space, then you need a CCR – Closed Circuit Re-breather unit. That's because, unlike scuba divers with their tell-tale bubble trails, CCR divers emit no bubbles at all – so it's a completely silent and incredibly efficient way to dive. It works by allowing the diver to reuse his or her exhaled air by scrubbing it clean of carbon dioxide and adding small amounts of oxygen. Divers using CCR still carry cylinders, but they last a great deal longer and instead of a diver's time under water being measured in minutes, it can now be measured in hours.

And there are also other benefits in using a CCR unit. Because it gives you a perfect breathing gas for your depth there is much less chance of getting either nitrogen narcosis – high-pressure nitrogen affecting the brain and giving deep divers a dangerous semi-drunken/high feeling – or decompression sickness, when high-pressure nitrogen is absorbed into the body on long, deep dives resulting in joint and nerve damage, aka 'the bends'.

So if you want to dive long, deep and silently you should always opt for a CCR. It's worth mentioning that it takes some getting used to. It's not surprising; after all, how many pieces of equipment do you have that come off the shelf ready to use at depths of down to 100 metres, or have instructions that say, 'Warning. This equipment can kill you without warning'?

**ABOVE** SCUBA *co-inventor Jacques Cousteau (top), and Paul Rose with a* CCR *unit.*

**OPPOSITE** *Scuba's tell-tale bubble trail.*

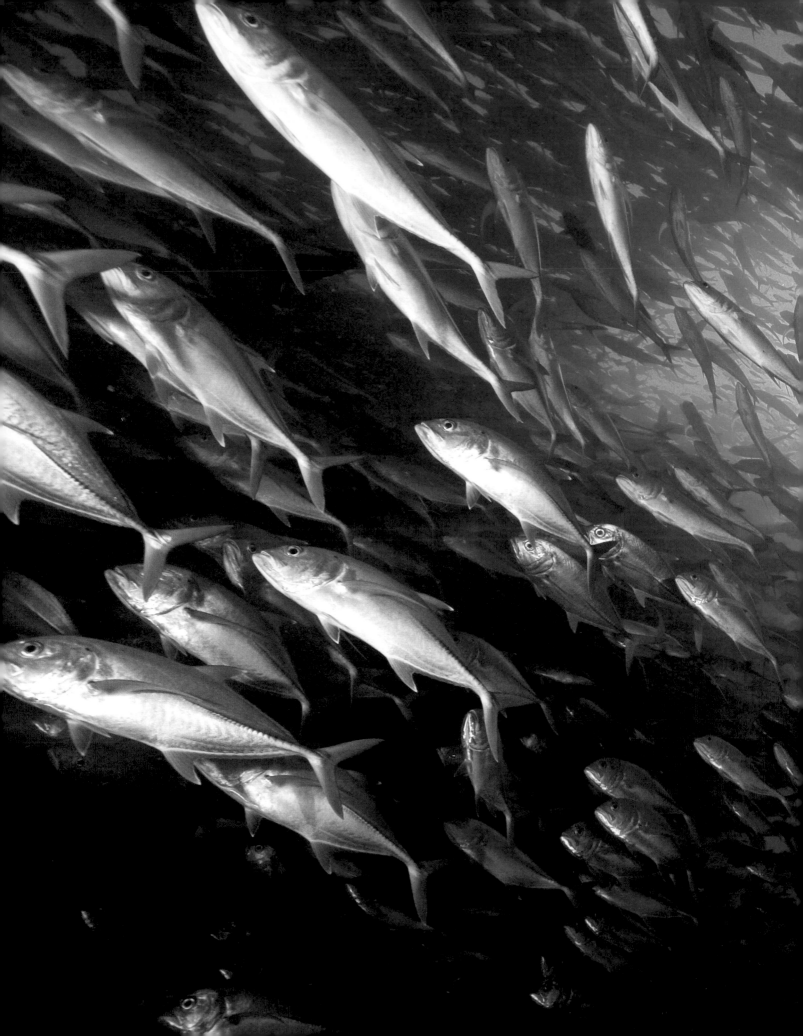

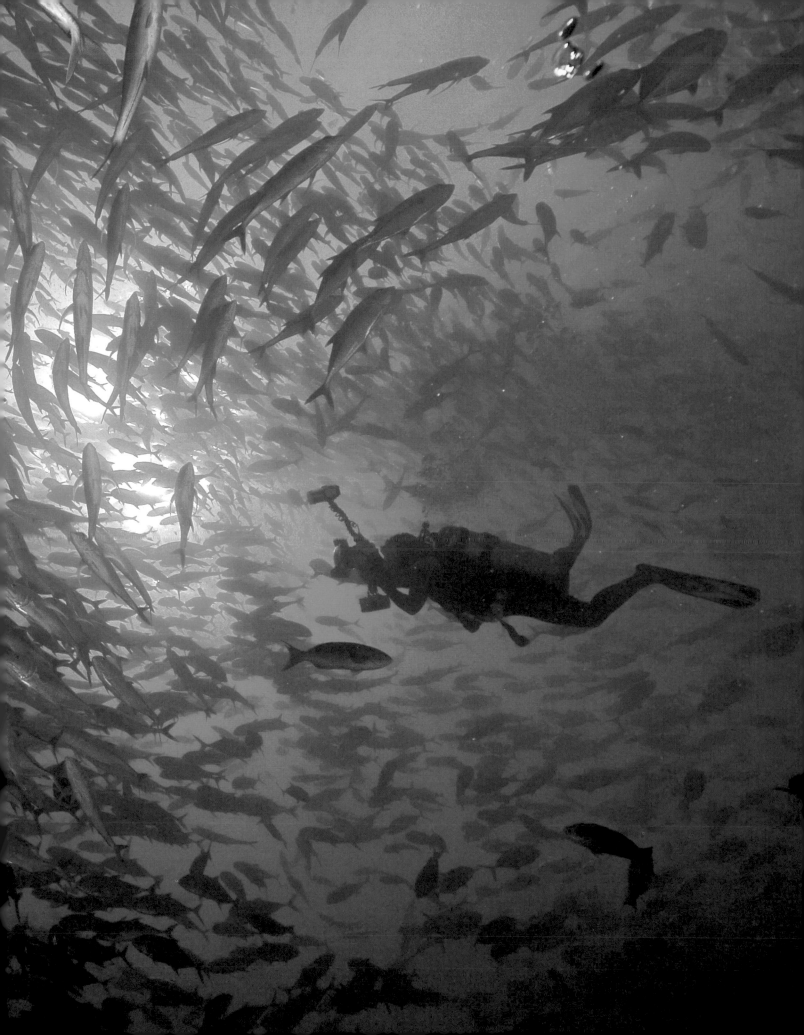

**ABOVE** *Moray eels. waiting with gaping mouths for passing prey.*

**PREVIOUS PAGES** *One of the team's divers observes a shoal of jacks circling with balletic precision. This behaviour is a source of much debate but thought to be a defence mechanism against predators.*

Deep below the surface, the seamount rises from the distant ocean floor. It is a vibrant, rich, fascinating place. Myriads of small fish flit in shoals between the algae that grow on its sides. Shoals of jack and golden snapper circle with coordinated precision. A writhing mass of rainbow wrasse are mating, white puffs of sperm and eggs mixing and merging in the sea. Tucked under a jutting rock, a row of moray eels, mouths agape, trap unwary prey. Finally, there are two species that are clear signs that this is hammerhead territory: stingrays and round, brightly coloured barber fish. Stingrays are a favourite prey of hammerheads while barber fish are small cleaning fish that service the sharks, cleaning parasites off their bodies.

The water is clear, the fish are abundant. The conditions are perfect for hammerheads. However, spotting hammerheads requires Buddha-like patience. These are some of the fastest and most agile of the great sharks. The flattened hammer acts as an aerofoil, giving lift and manoeuvrability, while the flat belly and triangular trunk are perfectly streamlined for speed.

There is no point trying to hunt a hammerhead. The art is to float quietly and silently in the current and be prepared to linger.

Hanging on to the seamount, the diver waits and watches, hopeful that a scalloped hammerhead will swim by. A sea lion looms up and dives quickly away; a grouper floats past in leisurely fashion. Hours pass but no hammerheads appear. Dive after dive, it's the same story. Despite ideal conditions and the perfect location, there are no hammerheads to be seen.

It's a stark indication of the impact of the fishing industry here. Schools of hundreds of hammerheads are now reduced to rare, isolated individuals. Today, hammerheads are facing annihilation and these sharks, once so abundant, are now disappearing from the Sea of Cortez. It seems questions about the species may never be answered.

As the team prepares to weigh anchor and sail on, there's a poignant find; a last reminder of the plight of the hammerhead. Lying on the shore is a bleached white skull, mouth gaping, and the unmistakable flattened bone of the hammerhead, lightly covered with sand.

If sharks vanish from the Sea of Cortez the trade may switch to snails. A sea snail that yields valuable ingredients for the voracious pharmaceuticals industry is found here. But harvesting it is no mean feat. The cone mollusc is singularly the most toxic living thing beneath the waves.

They might not be as fast and furious as the Humboldt squid or thrash and snatch like a shark, but underestimate these slow-moving snails at your peril. They are found on the sandy bottom in relatively shallow waters and their shells are highly prized. But, unusually, they can defend themselves effectively. They're full of one of the most deadly poisons known to man, and a single sting is toxic enough to kill up to 70 adults. Moreover, there's no anti-venom. If you are stung, death is almost certain. So pity the snail's small prey on the ocean floor. It fires a harpoon-like tooth into its victim in 0.001 of a second, and through this it injects its deadly toxins. Next it swallows its quarry whole, sucking it up like a piece of spaghetti.

The toxins in the snails are now being used to develop a range of painkillers more powerful than morphine. Despite the fearsome reputation of sharks, their loss to the world's seas in general, and the Sea of Cortez in particular, will be mourned by many. But if the diminutive molluscs of the sea are exploited into obscurity, few of us will be aware of their plight and fewer still will care.

Schools of hundreds of hammerheads are now reduced to rare, isolated individuals.

… one of the most deadly poisons known to man and a single sting is toxic enough to kill up to 70 adults.

# Seri Indians

**Travelling from the village to the dive site** with the Seri diver and his father, the village shaman and boat owner, was memorable for all the right reasons. The shaman sang us a traditional blessing. He had a beautiful clear voice, which rang out above the racket of the outboard engine with no effort. When he finished the air was punctuated with a powerful few minutes of silence, with the turbulent waters of the Canal del Infiernillo (Canal of Hell) and the backdrop of the Sonora Desert seeming to glow in receipt of his haunting song.

It seemed an ideal start to my first experience of a unique commercial, cultural practice. Fishing for scallops with the Seri is an event that remains etched on my soul. Not for them the latest in aqualung technology – not even a hard hat or a mask. Instead, they rely on air being pumped from the vessel on top of the water through a tube to a regulator, which the diver holds in his mouth. It's the same diving technology that predominated from the 1800s until the 1950s.

Having air supplied from the surface to a diver below started in the nineteenth century with hand pumps. The support team on the surface had the job of cranking the pump constantly. If it stopped, the diver died. The deeper the diver went the more air he needed, so the men on top had to pump faster. The most common signal was the diver pulling three times on his rope, which meant 'more air'. Disaster would inevitably strike when the diver fell into a deep hole and the frantic team on the surface could not keep up with his demands for more air. Then nature would take over and his entire body could be forced into his brass helmet. It's a cautionary tale told on every diving course, and plenty of old hard-hat divers have stories of near misses and the shoulder bruises to prove its truth.

These days, surface supply diving rigs are very efficient but they can be expensive. So the Seri Indians have made their own. By using a small petrol engine, a car paint-sprayer compressor, a very long garden hose, an old beer keg, lots of ingenuity and no shortage of bravery, the Seri are able to fish for their community.

It was a relief to arrive at the dive site, despite the delightful diversion of the cultural singing, but the rough ride through steep waves and strong currents had loosened the wooden plank holding the dive rig, which meant I had spent the past two hours hanging on to the engine and compressor so they didn't get washed overboard. Our Seri diver was ready to go in a flash, so I started the engine, checked his air supply was working, gave him the thumbs up and he dived below. In his weighted boots, he was on the bottom in about two minutes. As I got ready to join him the beer-keg air tank began to leak, hissing, and blowing out masses of air. The shaman casually handed me a plastic bag and some string and went back to smoking at the stern. I did my best to plug the leak by wrapping the bag around the keg, then tying the string round and round to seal it. But it was still hissing. 'No problem,' shouted the shaman. 'He'll be fine! In you go.'

**ABOVE** *Diving gear remained primitive for many hundreds of years. This diver, at the turn of the twentieth century, still had his air supplied by hand pump.*

**OPPOSITE, TOP** *Despite having little equipment Seri divers work efficiently collecting scallops around Tiburon Island every day of the year.*

## They are one of the few indigenous people in Mexico who have never been conquered by invaders.

The currents make this water murky. Visibility was only about 2 metres, so I followed the diver's garden hose from the surface and swam down until I bumped into him. His work rate was staggering. He ran along the bottom until he found scallops, then knelt, yanked them out with his metal hook, stuffed them in his bag and ran on again at an amazing pace.

He works for about two hours, down to 25 metres deep, twice a day, every day of the year. If you put those figures into a dive computer or a dive table you'll soon see that this man will have decompression sickness – the bends – not to mention the effects of breathing air from his old paint-sprayer compressor, the oil from which will probably coat his lungs with an irreversible layer of fine oil that is highly likely to lead to lipoid pneumonia. One good thing; he now has a filter for his air so he doesn't breathe in impurities like dust and sand any more.

The name by which the Seri are known, *Kumkaak*, means 'the people'. These nomadic hunter-gatherers of Mexico, renowned for extraordinary endurance, are one of the few indigenous people who have never been conquered by invaders. Conquistadors, Jesuit priests, the Mexican government and entrepreneurs were met with varying degrees of ferocity. Now only about 420 Seri remain, down from about 5000 in the seventeenth century and 2000 in the 1890s. This is the result of imported diseases rather than warfare.

The effective removal of all fish in the sea forced the Seri to find new money-making ventures. They made craft goods for the tourism industry, which meant moving off their ancestral land of Tiburon Island – which became a game reserve in 1965 – to camps on the mainland. Granted exclusive fishing rights to the scallops in the area by the Mexican government in 1970, they earn income by selling access rights.

The Seri regard the leatherback turtle as a sacred embodiment of their ancestors. Traditionally, if one was inadvertently captured they held a four-day ceremony to protect it, building a shelter, painting powerful motifs on its back, and singing and dancing. One ceremony took place in 2005, but no others had occurred for about 20 years, because leatherback turtles are now rarely found in the northern Sea of Cortez – they are one of the world's most endangered marine turtles.

**RIGHT** *The leatherback turtle, regarded by the Seri as a sacred embodiment of their ancestors, is one of the world's most endangered species of marine turtle.*

## ARRIVAL OF THE EUROPEANS

*Sea Escape* heads north. The sea is flat, the sunset golden. The cacophony of seabirds has ceased and peace is settling like a blanket as the night falls. Only the insistent roar of the generator breaks the stillness of the evening.

Humanity has enjoyed a complex relationship with the Sea of Cortez. From earliest times, people have lived along these shores, using the marine riches as a source of food and livelihood. Indigenous people lived in harmony with the sea, seeing themselves not as exploiters of its harvest, but as its custodians. Today, only one of these indigenous communities survives – the Seri Indians.

For the Seri Indians, the key to their relationship with the sea was stewardship. It housed the spirits of their ancestors and was a sacred place to be nurtured and sustained. That respectful relationship was blown apart when Europeans discovered this narrow sea in the sixteenth century.

The Spanish conquistador Hernan Cortez (1485–1547), for whom the sea is named, accidentally came across it while exploring the Mexican coast of the Pacific Ocean in 1536. At the time Cortez was stung by perceived insults from the Spanish monarchy, hungry for more than the Aztec Empire that he had already claimed in their name. But his experiences in Baja California fired his enthusiasm for exploration once more. He returned to Europe with tales of untold riches – pearls by the handful that could be simply lifted off the seabed.

> Soon, another rich commodity was discovered – a prize worth more than gold itself.

Trading routes were quickly established, and thousands of galleons plied the Manila route between Europe and the Sea of Cortez. Soon, another rich commodity was discovered – a prize worth more than gold itself. Its lyrical name is guano but it's otherwise known as bird or bat droppings. With its abundant marine life, the Sea of Cortez was a magnet for seabirds like the blue-footed booby, frigate birds, the brown pelican, egret and ten different species of gulls, and the many islands that dotted the sea were covered in guano, baked in the dry sun and built up over thousands of years to layers 30 metres deep. Guano is rich in phosphorus and nitrogen. At the time it was valued both for fertilizer and in the manufacture of gunpowder.

In the nineteenth century this unlikely commodity was rediscovered as a powerful economic lever. Indeed, guano was so effective at increasing crop yields that demand went through the roof. Europeans raced here to mine the smelly, white-capped islands in the sea. The most isolated of the islands, San Pedro Martir, even became a penal colony, with the prisoners sentenced to gather guano. The trade brought industry where none existed. It expanded

empires, made companies rich and exploited both the local population and the marine environment of this tiny sea. The traditional approach of the Seri Indians, as custodians of this rich resource, was lost in the face of commercial imperatives.

Today, the complex ecosystems in the Sea of Cortez are in constant flux as human activity impacts on every aspect of the rich sea life. Pollution from agrochemicals and urban waste is threatening the coastal marine habitats, and 39 marine species in the sea are classified as endangered or threatened.

As we've already established, overfishing is rife and it's not limited to sharks such as the hammerhead. Shrimp, snapper, tuna, grouper, sea bass, marlin and sardines are all being devastated by the vast fishing industry here. For every pound of shrimp netted, another 10 pounds of marine species are killed then simply discarded.

The fishing industry is triggering one of the most dramatic changes in the balance of sea life here. As numbers of the larger, vertebrate fish fall, there are fewer predators to keep the invertebrate species in check. Now, in several of the world's oceans, the invertebrates are taking over, becoming the dominant species. It's the invasion of the ctenopods, invertebrate marine creatures such as jellyfish, squid and octopus. And nowhere is this more extreme than here in the Sea of Cortez.

**ABOVE** *Tiburon Island (tiburon is Spanish for shark) is the largest island in the Gulf of California. Once the ancestral home of the Seri Indians it is now a nature reserve. The island, home to a huge community of seabirds, is still covered in guano, once a valuable commodity used both for fertilizer and gunpowder.*

## THE INVASION OF THE CTENOPODS

*Sea Escape* reached Loreto, halfway up the sea, to survey the main site of the invasion but, in the morning light, there was little evidence of it. However, as night falls, the sea transforms. Instead of calm, clear waters, the sea is alive with literally hundreds of huge, voracious Humboldt squid. They take their name from the Humboldt current which runs through the east Pacific Ocean, but they are also known as jumbo squid or, among the local fishermen who fear them, *diablos rojos* – red devils.

> The Humboldt is the Terminator of the squid world.

The Humboldt is the Terminator of the squid world. The squid can reach up to 2 metres long and weigh 99 pounds. The huge head, or mantle, is surrounded with feeding tentacles, each one studded with suckers for grasping prey. Each sucker contains sharp barbs, which the squid uses to pierce the flesh of prey and drag it to its mouth. These squid are aggressive hunters and, although their main diet is small fish, they have been known to attack sharks, each other and even, so they say, local fishermen, trapping them in their powerful tentacles and ripping them with their barbed suckers.

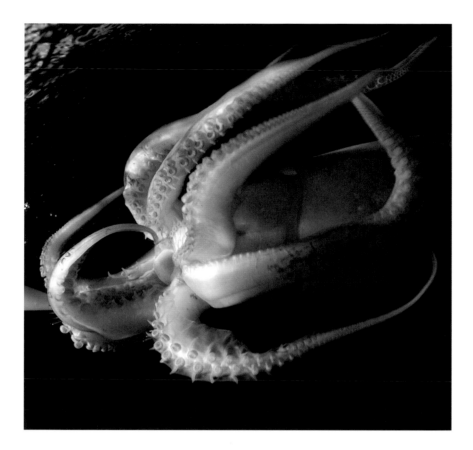

OPPOSITE AND LEFT
*Humboldt squid, which
grow up to 2 metres long,
are known to local fisher-
man as* diablos rojos *– red
devils. They have barbed
suckers on their tentacles
which pierce the flesh of
their prey. These aggressive
creatures have been known
to attack sharks and even
fishermen.*

Swimming at speed the Humboldt could match the coyotes that roam the nearby deserts. They have even been known to fly. In a bid to hunt food or escape predators they are able to propel themselves out of the waves by expelling water from their bodies.

And there's evidence that they are becoming more cunning. Recent research suggests that the Humboldt are communicating with each other and hunting in packs. All squid can emit light and the Humboldt change colour rapidly from maroon to ivory and all shades in between, the colours pulsing like a strobe. The variation and changes in frequency of the pulses strongly suggest that this is a form of communication. As the squid pulse at each other, they seem to be working co-operatively as a pack, to herd and trap shoals of prey.

Recent research suggests that the Humboldt are communicating ... and hunting in packs.

During the day they maintain depths of at least 70 metres, making research and any observation of their behaviour all but impossible. Only at night do they rise near to the surface, and then they are at their most intimidating. Elusive, perhaps, but not rare as they arrive in great numbers and are hungry for flesh.

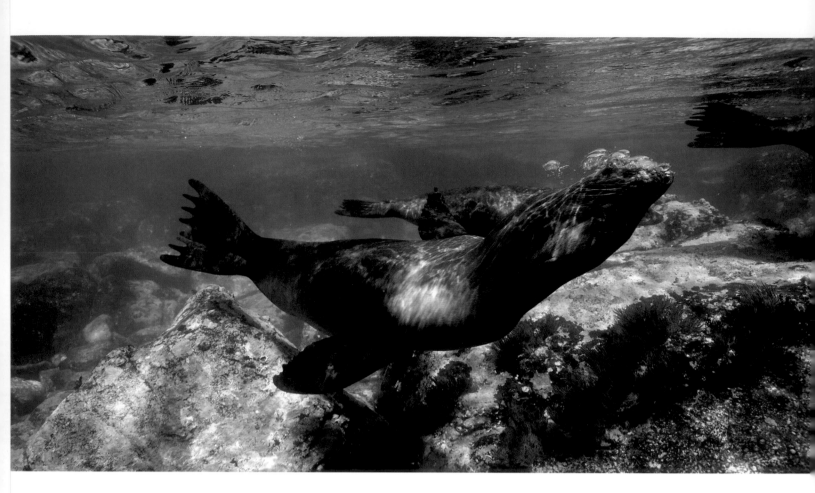

ABOVE *Sea lions communicate in a number of ways including blowing bubbles to attract the attention of other members of the colony.*

were under threat as stocks of the deep-sea fish they feed on were reduced. Now the explosion in the squid population has provided an alternative, abundant source of food. Squid are now the whales' main diet, and as a result the population here is beginning to recover. The expedition is heading for the guano island of San Pedro Martir, a favoured whale haunt, to see if they can locate, and dive with, these magnificent creatures. It's the highlight of the trip, a dive every member of the team is looking forward to despite the awesome bulk of the whales next to spindly divers.

As it turned out, it was to be even more spectacular than they could ever have anticipated.

But the sperm whales are still few days' sail north, and now, the expedition team has a colony of energetic, highly intelligent sea lions to investigate. Californian sea lions, as the name implies, are native to this area. They are the most common of all the pinnipeds (meaning 'winged feet') and here in the Sea of Cortez their numbers reach around 23,000, scattered in colonies all along the coast of the sea. So smart are sea lions they are often trained to perform in circuses, marine parks or zoos. Indeed, they are so intelligent and nimble that they have been trained by the American navy to help protect ships in hostile waters, by 'clamping' enemy divers. The animals are trained to swim behind a diver approaching a ship and attach a clamp, which is connected to a rope, to the diver's leg. Navy officials say the

sea lions can get the job done in seconds and the enemy doesn't know the clamp is attached until it's too late.

But sea lions, too, have been affected by overfishing, as stocks of their staple food (mostly sardines and mackerel) are depleted. All along the sea, some sea lion colonies are struggling – but not all. Against the trend, some are thriving, adapting well to human and industrial intrusion. One in particular is on the island of Los Islotes, where nearly 100 sea lions congregate. They are highly social animals, and extremely vocal. The booming, bass bark of the males can be heard for many miles across the sea. In fact, the large domed skull that gives the male sea lion its characteristic appearance is thought to act as an echo chamber and to increase the resonance of these mighty barks.

Sea lions, along with walruses and true seals, evolved from a bear-like ancestor about 23 million years ago, during the transition from a warmer to a colder climate. They are large creatures; males grow to 2.4 metres and weigh 275 pounds, while females are much smaller, reaching only 99 pounds. Ungainly on land, they become powerful, streamlined torpedoes in water. Their front flippers rotate to propel them forward and they are deft manoeuvrers and extremely fast. At full tilt, a sea lion can reach swimming speeds of 25 m.p.h.

> At full tilt, a sea lion can reach swimming speeds of 25 m.p.h.

Under water, their playful, friendly nature is evident. Juveniles rush at the dive team, then rapidly retreat: an invitation to play. Occasionally an older male keeps both the young sea lions and the divers in check by blowing a stream of bubbles as a warning.

Sea lions dive to feed, catching their prey on the move. They normally depend on commercially important fish but as these stocks are low there are signs that some colonies, like the one on Los Islotes, are learning new feeding patterns. This remarkable adaptation was discovered by the analysis of sea lion scat, or faeces. Excreted in the scat are the undigested bones of fish, and of these the fish otoliths or ear bones can be used to identify the species of fish eaten. What has emerged from this rather unglamorous research is that unlike other colonies in the sea, these sea lions are diving deeper to catch deep-water fish such as lanternfish, or deep-water sea bass, as their main diet. This is unusual behaviour, as these are not usual sea lion prey, but these fish are not commercially important so they provide a plentiful source of food for the sea lions. What's more, it seems that this colony is passing on the new knowledge to their young. Sea lion pups are taught to dive to these new depths as soon as they are old enough to forage for themselves. It's a remarkable example of adaptive behaviour and just another example of the ongoing cycle of change happening here in the Sea of Cortez.

*OVERLEAF Despite their size – male sperm whales can reach up to 16 metres in length – sightings are rare. But when you see one… it's worth the wait.*

## DANCE OF THE LEVIATHANS

Finally *Sea Escape* arrives at San Pedro Martir. The island looks spectacular, its white-capped rocks sparkling in the sun giving it an ethereal appearance quite at odds with the distinctly earthy stench of the guano that creates the glistening white mantle.

This is one of the best places in the world to see sperm whales, as it's a popular breeding ground and resting place on their long migration across the oceans. Some female sperm whales have been tracked here from the Galapagos Islands, a journey of over 2360 miles. In fact, the Sea of Cortez attracts a vast diversity of whales: fin whales, blue whales, pilot whales, killer whales, humpback whales and great whales are all found here. Congregations of so many huge mammals make the rich, fertile protected waters of the Sea of Cortez unique.

Although sperm whales are drawn here and the populations are stabilizing, even so sightings are rare and relatively little is known about these majestic creatures. The *Oceans* team hopes to find surface spots and to check on the health of the population, adding significantly to the relatively small amount of scientific data about sperm whales.

> Sperm whales are able to last for up to two hours under water on a single breath.

One of the problems in studying sperm whales is that they rarely stay at the surface. They are the longest breath-holders of all mammals, able to last for up to two hours under water on a single breath. As a result they are able to dive to astonishing depths. They are the deepest diving of all earth's creatures and have been tracked 3000 metres below the surface. These leviathans are the largest of all the earth's carnivores, with males reaching a vast 16 metres in length. They inspired the legend of Moby Dick and terrified sailors for centuries. However, despite their considerable size, finding them in the endless miles of open sea is no easy task.

But, while it may be difficult to *see* sperm whales, it is a lot easier to hear them. Whales use a complex language of clicks to locate one another, communicate and mate. Different click patterns are used for each of these different purposes. A pattern of regularly spaced clicks, called 'usual' clicks, are used to locate their prey in the vast depths of the ocean. Shorter bursts, known as 'creaks', seem to be contact communication used to signal the whales' presence to other whales across vast distances. Slow, deep clicks seem to be a predominantly male 'language', probably used for mating. These are immensely loud, exceeding 230 decibels and equivalent to a rifle shot fired 1 metre from the ear. Recently, researchers have begun to understand how the whales are able to make such powerful sounds that they can be heard

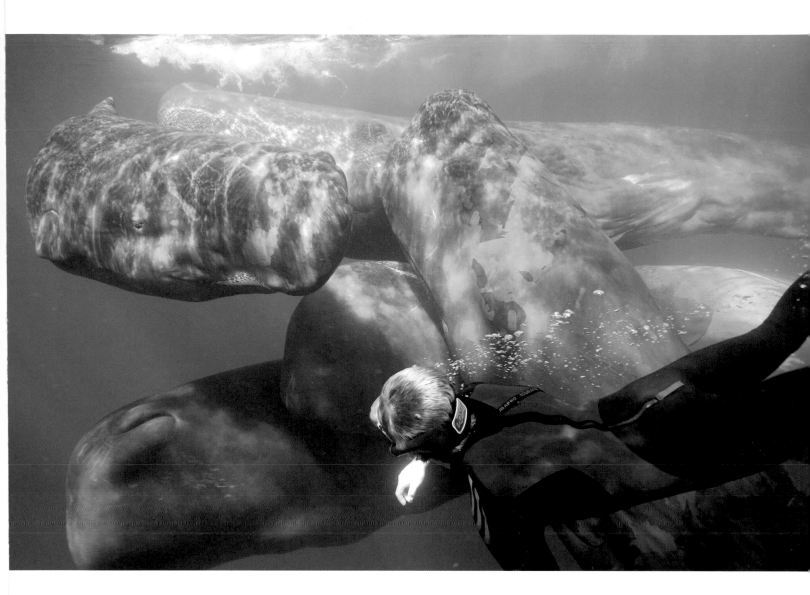

over 34 miles away, through the water. On top of their skull, sperm whales have a unique organ, called the spermaceti organ. It's filled with a milky white, semi-liquid wax which early whalers mistook for sperm – hence the whale's name. But it is actually a powerful sonar organ, whose highly variable muscle sheath allows the whale to create powerful, and variable, sound waves that resonate in the vast head of the whale before being projected.

Using underwater directional hydrophones it is possible to identify the location of the whales, and start to track their movement. Once close, the whale song is easily distinguishable under water by divers, a symphony of overlapping clicks. To the untrained ear this chaotic sound seems like mindless babble, but scientists have identified something fascinating in this complex whale language. As well as the patterns of clicks, sperm whales use codas, repeated rhythms, when they are communicating with one another. These codas are highly individual and seem to be much richer in meaning than the functional clicks. By comparing the codas of different clans of whales, the researchers have discovered that each clan has its own coda 'dialect'.

**ABOVE** *The group of socializing sperm whales which included males, suggested that this area is an important breeding ground.*

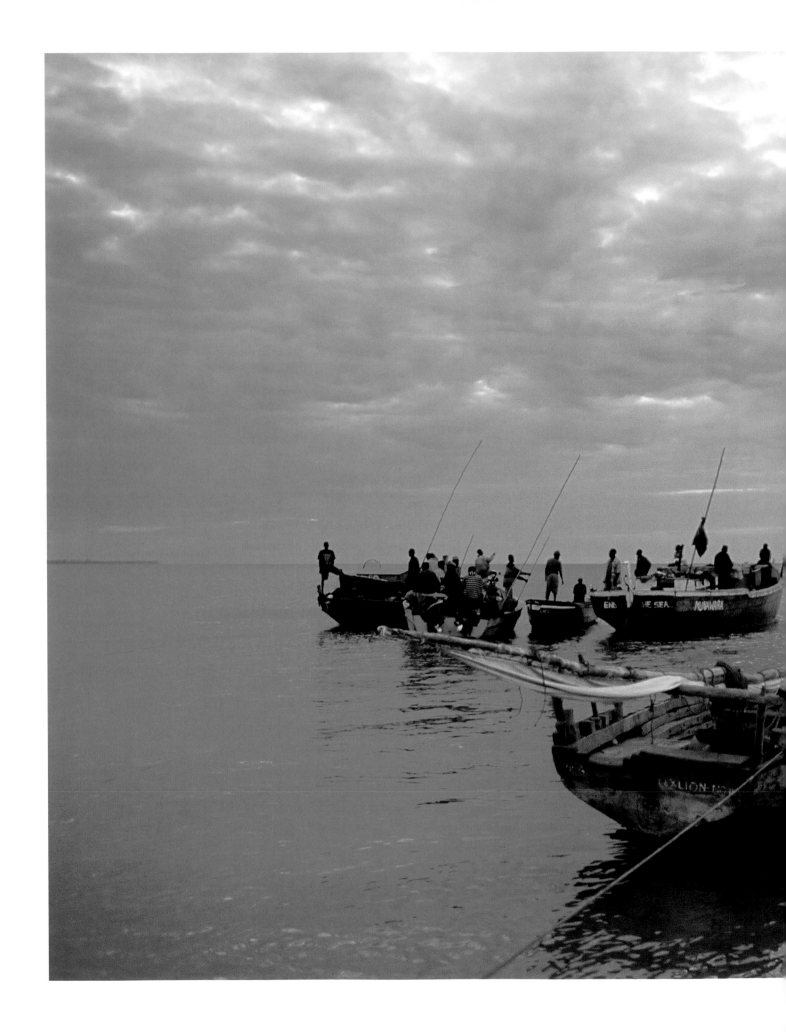

# THE INDIAN OCEAN

## Stillness and Storms

**PREVIOUS PAGE** *Sunset at Stone Town, Zanzibar, and fishermen are out in force. It was the sea that first attracted settlers to this area.*

**RIGHT** *This NASA satellite image shows South India, the northern end of Sri Lanka and the Bay of Bengal, an area that produces severe cyclones.*

**OPPOSITE** *This computer generated image shows a topographical view of the Indian Ocean, it is the temperature differences between the sea and the surrounding land masses that cause the cataclysmic weather systems that characterize this contrasting ocean.*

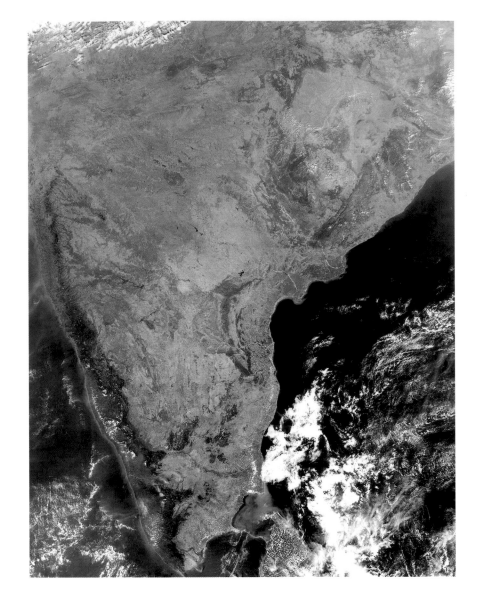

ITS NAME ALONE CONJURES UP A PICTURE of exotic, bath-warm waters turned turquoise in the shallows by day-long sunshine. Indeed, this is a seductive jewel of an ocean nestling between Asia, the Middle East and Africa with sapphire depths that harbour rare and enigmatic creatures, dramatic sea monuments and vibrant, vivid reefs. But that is only one side of the story.

Ebbing and flowing over 25 million square miles, the Indian Ocean is the third largest on the planet. It is fringed by some spectacular beaches – think Seychelles, Goa, Maldives – and vast swathes of the world's population. And it was these densely populated areas that were devastated by the Boxing Day tsunami of 2004 which claimed the lives of an estimated 275,000 people and left countless thousands of others homeless, jobless and destitute. The catastrophe was caused by an undersea earthquake off the Sumatran coast, measuring a colossal 9.1 on the Richter scale and lasting for as long as ten minutes, dispatching waves from ocean to shore at speeds of 500 m.p.h. and at the height of city office blocks.

The Indian Ocean is not only subject to earthquakes but is also scythed through by one of the most powerful currents on earth, the Agulhas current. This and others like it have carved lands, destroyed ships and driven calamitous storms across the planet. To sum up, this seascape is by turns a place of sunshine and cyclonic rain, of stillness and storm, of extraordinary beauty and bone-chilling terror. The *Oceans* expedition has come here to explore the extreme contrasts of this powerful ocean, and to unravel its rich and complex legacy.

*... a place ... of extraordinary beauty and bone-chilling terror.*

When the team arrived at the port of Dar es Salaam, Tanzania, it was thronging with people. Shrieks of seabirds pierced the throbbing heartbeat of loud African music. Market traders shouted their wares, nearly drowned out by the groaning of dock machinery. The rich aromas of coconut oils, pungent spices and cooked fish hung like a cloud in the sea air. Along the harbour, at the end of a long walkway, stood *Kairos*, a sturdy and workmanlike boat that would be the team's cramped home as they explored the farthest reaches of the Indian Ocean. From the perspective of the boat's small cabin, the task ahead seemed immense.

We were to bob around an ocean that has fashioned islands and coastal lands, which supports 30 million people on its shores, is oil-rich, is crisscrossed by trade routes linking east and west and has currents that drive climate and weather patterns all over the world. More than any other ocean, this sea has shaped humanity's history and, furthermore, is driving our future.

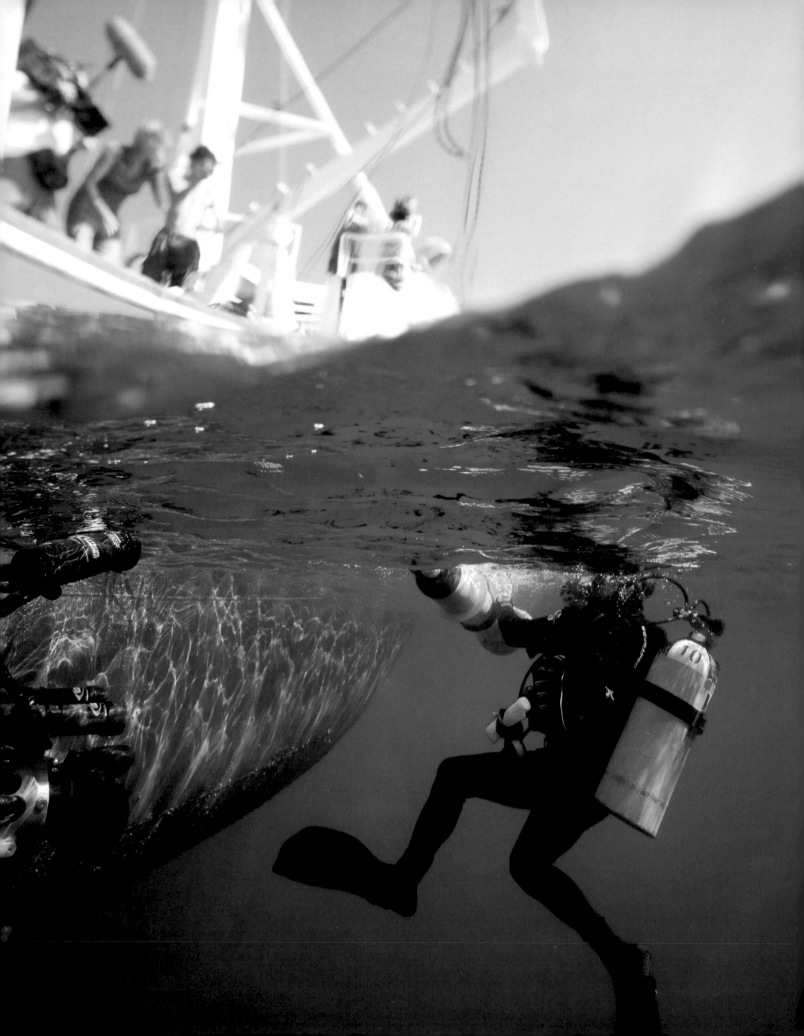

## FORCE OF THE CURRENTS

At the top of our list is an investigation into the massive force of the Indian Ocean currents which, perhaps more than anything, define its role. It's only recently that scientists have begun to understand just how important these currents are and knowledge is still limited. One of the problems is the difficulty of monitoring a complex three-dimensional environment deep below the surface of the sea and thousands of miles from land. But the *Oceans* team is about to play a part in changing that. We had been asked to take part in an international project designed to build a detailed 'real time' picture of the oceans in action. On the deck of *Kairos* is a long wooden box and inside is a state-of-the-art, robotic ocean-monitoring buoy, the latest addition to a network of 3000 similar buoys dotted throughout the oceans of the world. The cylindrical buoy, called an Argo float after the classical hero Jason's ship, is designed to dive to a depth of between 1000 and 2000 metres, drift at that level with the current and record temperature, salinity, depth and position. After ten days it propels itself to the surface and transmits the information by satellite to a receiving station before descending to complete its next ten-day cycle. Profiling floats like this have been in action since 2000. Within a few hours of launch, this rather insignificant looking buoy will begin sending data to scientists 5000 miles away in Liverpool, England, giving them a detailed picture of the currents and conditions in this part of the Indian Ocean.

If it's successfully launched, that is. Once the float is activated the team has precisely six hours to reach the remote deep-water location where it is to be sunk. There, the 2-metre-long float weighing 55 pounds needs to be dropped by deck crane to a diver waiting to guide it into position, 10 metres below the surface, ready for its first descent. It's a challenging manoeuvre. In deep, featureless waters divers can become disorientated and dive down instead of up towards the surface, with disastrous consequences.

It's a huge relief when the team watch the Argo float successfully disappear out of sight into the depths of the Indian Ocean on its first descent, to begin a recording career likely to last for at least four years and 150 cycles. The data the float sends back is not just of academic interest. The oceans and the atmosphere are inextricably linked. Throughout the world, the Argo armada of 3000 floats can measure the impact of global climate change and predict extreme weather, like the devastating 1998 El Niño, typhoons or hurricanes. In the Indian Ocean, the data can predict droughts and details of the wet seasons including how heavy the rains will be, and where and when they will fall.

OPPOSITE *Paul Rose waits to guide the Argo float into position. A deck crane on the* Kairos *drops the float so that he can guide it as it dives to begin a four-year cycle of recording.*

… the Argo armada of three thousand floats can measure the impact of global climate change …

## CATACLYSMIC WEATHER SYSTEMS

Powerful monsoons that sweep across the tropics are caused by the difference in temperature between the sea and neighbouring land masses. A newly identified see-saw system, the Indian Ocean dipole, can cause cataclysmic weather. This complex, oscillating system was only identified in 1999 but its effects have been traced back through the coral record for over 10,000 years. In the positive phase of the dipole, sea surface temperatures in the west of the ocean are higher than in the east. This increases convection currents in the west and drags rain across to the lands there, causing severe rain and flooding in East Africa and the Middle East. At the same time,

Indonesia, on the eastern side of the ocean, is starved of rain, causing droughts and forest fires. In its negative phase the dipole system reverses, bringing drought to Africa and torrential rains to Indonesia.

Just one day after the successful launch of the Argo float the team experiences the full might of the Indian Ocean weather systems. A tropical storm breaks. Strong winds whip the sea into a spume-topped frenzy. Then the rain comes down in torrents, the downpour sluicing the deck of the *Kairos* leaving water pouring relentlessly from the canvas sun cover. The rain has a curiously calming effect on the sea, flattening the cresting waves into gentle, stippled undulations. The team is en route to the island of Pemba, 50 miles off the African coast. Pemba is one of three islands off Tanzania, along with Zanzibar and Mafia Island, collectively known as the Zanzibar archipelago or the Spice Islands. Navigating the treacherous currents of the Indian Ocean is tricky at the best of times. In 45-knot winds, it's nearly impossible. But it's a graphic reminder of the power of this sea and its currents around these isles.

Pemba is the oldest of the islands, formed around 10 million years ago. It rose from the depths of the sea as a result of seismic activity and is now a mini subcontinent in its own right, sitting on the edge of the African continental plate. Above sea level it lives up to its Arabic name, 'the green island', as home to around three million clove trees. Around its perimeter the submerged landscape plunges into an 800-metre abyss, leaving sheer walls totally exposed to the force of the ocean. It's here that the best ocean architecture can be seen. These spectacular cliffs are decorated with crevices and overhangs sculpted by the southern equatorial current as it barrels across the Indian Ocean and swirls around the Zanzibar archipelago.

ABOVE *This satellite image shows the cyclonic storm Sidr, which hit the Bay of Bengal in 2007, producing winds of over 80 m.p.h.*

OPPOSITE *Soft coral grows in abundance on the sheer underwater cliffs of the vertical reef at Pemba.*

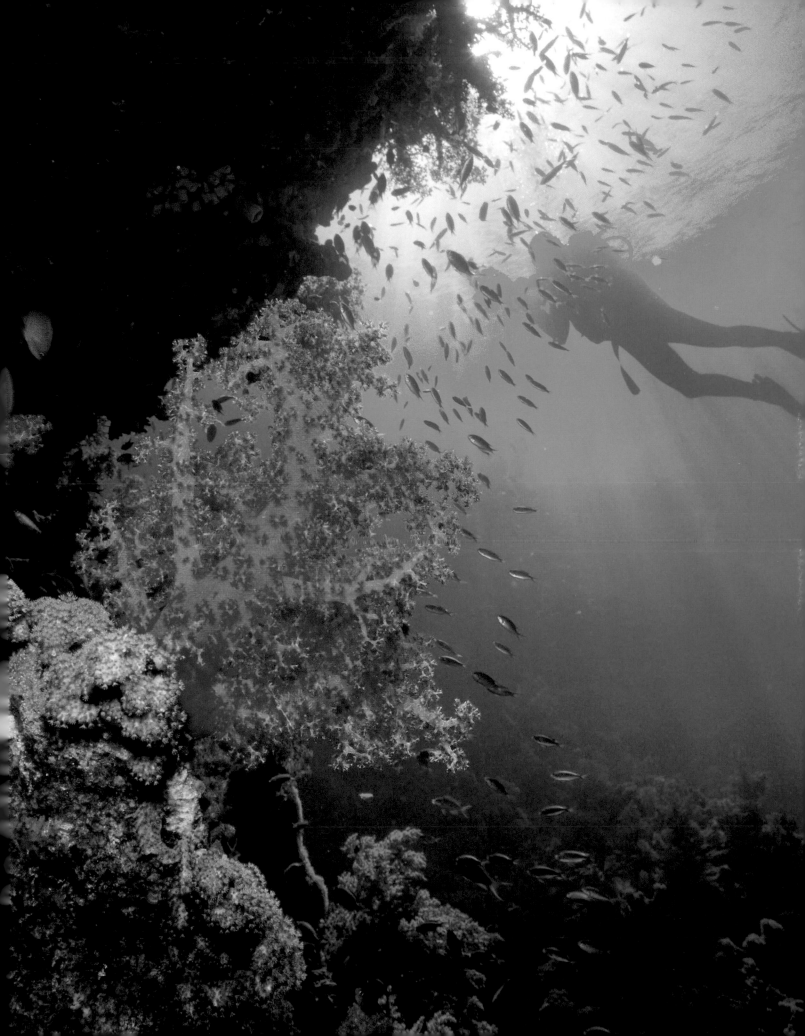

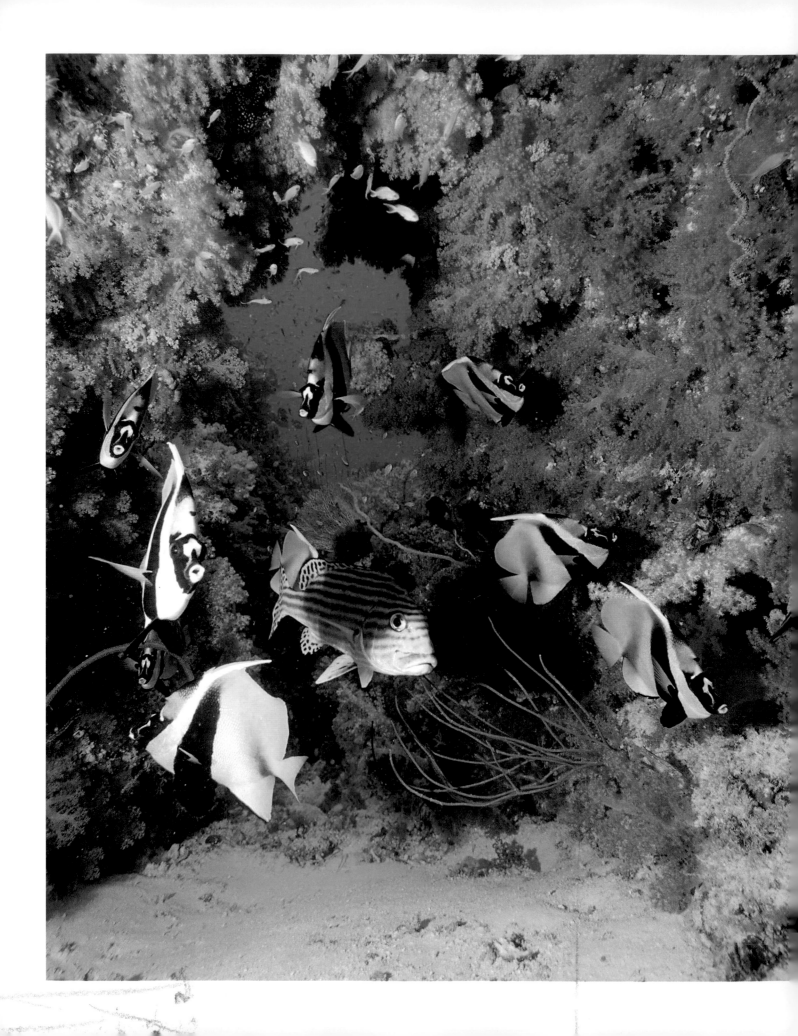

## UNDERWATER SEA CLIFFS

The next mission for the *Oceans* team is to investigate one of the most dramatic features of this unique underwater seascape – a massive fissure carved deep into the face of the rock.

The sea is flat and featureless on the surface, and it's hard to envisage the sheer variety and drama of the seascape below water. Across the planet, our oceans hide mountain ranges higher than the Himalayas, trenches and ravines to rival the Grand Canyon, active undersea volcanoes that spit glowing lava, and even vast natural falls where sand, not water, plunges over ridges to fall 2000 metres into the deep.

The underwater sea cliffs at Pemba are at least as stunning as any found on land. Diving down the wall, the divers are struck by two things – the strength of the current and the abundantly busy sea life. A mass of colourful sea anemones crowds the rocky outcrops and moray eels, scorpionfish and hinged shrimp hide under the overhangs. Spectacular fish can be seen: razorfish; leaf fish, named for their shape and for an uncanny ability to remain motionless in the current; snowflake soap fish; brightly coloured titan triggerfish, and even the huge hump-headed wrasse, which can reach 2 metres in length and has the fascinating ability to change gender from female to male in adulthood. Rarer species such as dwarf lionfish and flying gurnards can also be found here.

As a tropical sea, the Indian Ocean is not known for its prolific aquatic life. But, just here, the ocean currents bring cold, nutrient-rich water up from the depths and create an oasis-like attraction for passing fish.

Buffeted by the current, the divers are pulled along the wall until they spot the opening – a gaping crack extending several metres into the rock. This vast fissure has been carved by the sea, the power of the current eroding the limestone rock to form the crevasse. The fissure is impressive but inside there is something more stunning: a breathtaking display of coral. Partly protected by the walls of the channel, the fissure has become a vertical reef, a bright hanging garden of soft corals, brain coral, dark green tree coral, forests of whip coral, barrel sponges and huge flat tablets of plate coral, growing outwards from the fissure walls. Vertical reefs are rare and to see one deep inside the base of an island is exceptional.

In Swahili the word for 'rock' and 'coral' is one and the same. In reality this couldn't be further from the truth. While rock is inert, coral is very much alive. Indeed, most corals are not just one species but two: part flora, part fauna – a fully functioning albeit diminutive ecosystem in their own right.

> … mountain ranges higher than the Himalayas, trenches and ravines to rival the Grand Canyon …

**OPPOSITE** *Though the Indian Ocean is not known for the abundance of its sea life, the underwater cliffs at Pemba are an exception to the rule. Here, the currents bring cold, nutrient-rich water up from the depths and create an oasis for passing tropical fish.*

**OVERLEAF** *A spectacular view of sea life on the reef off the Glorioso Islands, near Madagascar, which shows a range of tropical fish including sweetlips, fairy basslet and fusilier fish.*

OPPOSITE *The most flamboyant sea slug in the world: the Spanish dancer, so named because of it bright red 'skirt' that waves in the sea currents.*

Coral polyps are tiny animals, related to sea anemones, which secrete a stony cup of limestone (corallite) around themselves to form a skeleton. But living within the tissues of the polyp are single-celled algae called zooxanthellae. It is these algae that give the coral its distinctive colours, as the photosynthetic pigments of the plant show through the clear tissue of the coral.

And this is a mutually beneficial relationship with the flora, or algae, bringing far more than just colour to the coral. By day, they photosynthesize, harnessing the energy of the sun to generate nutrients, oxygen and carbon compounds for the coral and supplying as much as 90 per cent of its food. In return, the fauna, or coral, provide the zooxanthellae with a safe place to live and a steady supply of carbon dioxide to complete their photosynthesis.

At night, things change. The feeding tentacles of the coral polyp emerge, reaching out in the darkness to capture passing zooplankton with stinging cells called nematocysts. The fissure where the coral is sited provides an ideal feeding position. The current brings waves of microscopic plankton directly to the coral; like pizza delivery in an oceanic context.

In the hours of darkness the reef is an extraordinary sight. The coral appears to suddenly come alive as other nocturnal creatures emerge to forage. The *Oceans* team is hoping to spot one of the most flamboyant: the biggest (and brightest) sea slug in the world. The Spanish dancer is from a branch of molluscs correctly called nudibranch, from the Latin *nudus* meaning naked and *brankhia* meaning gills. It can reach up to 40 centimetres long, and cruises the reef at night to feed on other invertebrates including sponges, soft corals, or even the feared Portuguese man o' war jellyfish. Most remarkably, it changes colour as it 'flies' through the water waving and flashing its bright red 'skirt' like a flamenco dancer, hence its name.

So the slow-growing coral feeds at night in its animal guise and by day as a plant, which allows it to compete against the much faster-growing macro-algae that inhabit the same environment.

> … whether … coral is a carbon sink or a carbon source is a hotly contested issue.

With its unique make-up it's not certain whether, overall, coral spends most of its time in 'plant' mode, extracting carbon dioxide from its environment, or chiefly respires like an animal and therefore is producing carbon dioxide, increasing global warming. So, whether the world's coral is a carbon sink or a carbon source is a hotly contested issue.

What is not debated, however, is the critical role of coral reefs themselves. Reefs act like underwater rainforests, giving life to the surrounding ocean by oxygenating the waters and providing a habitat to support a vast range of fish and other life forms including, indirectly, mankind. The expedition is about to explore the role of this sea in shaping the history of the lands around it.

## THE SUNKEN CITY OF RAS KISIMANI

It's early morning, and the *Kairos* has pulled into Stone Town harbour to gather supplies for the rest of the trip. Stone Town, on the island of Zanzibar, is a World Heritage Site because of its fascinating architecture, which blends African, Islamic, Indian and European influences. Alive with traders, the market is a profusion of colours, noise and overwhelming scents of spices. The activity on land echoes the bustling life of the coral reefs at sea, and indeed it was the sea that drew the earliest inhabitants here. Surrounded by plentiful food and supplies, the first settlers came not to the African mainland but to the Zanzibar archipelago, islands that were abundant in spices when their value was akin to gold.

Between the seventh and thirteenth centuries AD the islands were settled by Bantus from Africa, and Arabs and Persians from the Middle East, and quickly became a thriving hub for traders along the African coast. These groups formed the Swahili people and culture, from the Arabic word for coast: *sahil*.

By the end of the first millennium one of the chief settlements was a town on the southern tip of Mafia Island, called Ras Kisimani. It grew to be an important medieval Arab town settled by Shirazi traders (ethnic Persians)

ABOVE *Traditional dhows are still built and used by fishermen around the Zanzibar archipelago. The team used such a vessel to begin the search for the sunken city of Ras Kisimani.*

OPPOSITE *Once in the area of the potential site, the team adopted more modern technology for their search, using underwater scooters to cover a wide area of the sea floor.*

who harnessed the monsoon winds to drive their trading ships up and down the East African coast.

Today, however, Kisimani is an empty stretch of sand, the once thriving town swept away by a devastating cyclone in 1872. Now, the only remnants of its glorious past lie submerged in the open sea.

Travelling by dhow, the traditional wooden craft that are still built and used here, the team heads to the potential site of the sunken city to search for archaeological remains. There is a huge area to explore so the divers have underwater scooters, allowing them to cover a wider area on each tank of air.

At first there is nothing to see but scattered clumps of seagrass on the sandy sea floor. But after an intensive search one of the divers spots a small piece of pottery. It's red burnished stoneware, typical of the local pots and clear evidence of the settlement. It was an exciting find but it was just the start. All around the site there is broken stonework, rubble and blocks of solid masonry from the houses and temples of the ancient city. Most seem to date from later occupation in the nineteenth century when the cyclone tore off the headland and plunged the entire city into the sea.

As the team searches further another piece of pottery is revealed. It is a glazed fragment, with its delicate blue and green pattern clearly visible, a piece of celadon ware that is not local to the area but has been brought in from the east, probably from China. Initial dating puts it at the fifteenth century, which is later confirmed. And a little later an even earlier piece of pottery is found: Persian sgraffito ware, from around the thirteenth century.

It's a rare piece of evidence of the heyday of Ras Kisimani, when it was one of the most significant coastal civilizations of Muslim city-states. This

was a time when the rulers and merchants built mosques and palaces, minted coinage and imported pottery and other goods from most of the known world – including China. At the time Europe was only just emerging from its cultural backwater at the start of the Middle Ages.

Ras Kisimani was inhabited by a mix of Africans, Arabs and traders from elsewhere in the Indian Ocean, principally the Persian Gulf regions. All were drawn to the riches that Africa had to offer: ivory, gold and spices – especially cloves, which were more valuable, pound for pound, than gold. These riches drew in Europeans in the wake of the Arab and Persian settlers.

By the end of the fifteenth century, the Portuguese explorer Vasco da Gama (1460–1524) arrived at the Spice Islands. He was surprised to find a developed society with thriving trade, a monetary economy, wealthy merchants and sheiks. Within a few years, the Portuguese fleet returned and took control of the region, a rule that lasted two centuries. At the heart of this protectorate was the slave trade, controlled for centuries by Portugal and condoned by every other major power and ethnic group.

> … spices – especially cloves, which were more valuable, pound for pound, than gold.

In the nineteenth century, even after slavery was made illegal (in 1807 in Britain) between 10,000 and 30,000 African people per year were shipped as slaves from the Spice Islands. At Ras Kisimani the trade continued until the immense force of nature put a stop to it. The cataclysmic cyclone that tore off the headland and destroyed the town arrived just a year before slavery was finally outlawed in the region. Now all that remains of the rich history of Ras Kisimani are a few sunken remains, protected and preserved by the sea.

The story of the storm is preserved here in the heart of the coral. Coral grows at a rate of about 1–3 centimetres a year, adding to its calcareous outer skeleton. This forms annual growth rings in the coral, rather like tree rings. And, like trees, coral can survive for hundreds of years, forming a living record across centuries. By taking a core from the coral and analysing the growth in each year, scientists can both identify extreme weather events of the past and predict future events. Part of this analysis is done by viewing the thin 5-centimetre-diameter cores under ultraviolet light. In this light clear, fluorescing bands are visible, showing yearly growth. In a year with high rainfall or soaring temperatures, skeletal calcification of the coral is low and therefore growth is limited. These cores ultimately record massive weather events in the Indian Ocean, like the the cyclone that swept Ras Kisimani into the sea, the devastating 1998 El Niño and the impact of the newly discovered Indian Ocean dipole.

> … coral can survive for hundreds of years … a living record across the centuries.

## DANGEROUS WATERS

The Agulhas current is the second fastest in the world, and its complex and unpredictable flow patterns make it the most dangerous to navigate. For centuries, this current prevented European explorers rounding the cape at the tip of Africa. When Portuguese explorer Bartholomew Dias (c.1455–1500) became the first to do so in 1486 he called it the 'Cape of Storms'. Later, Portugal's King John renamed it the Cape of Good Hope to reflect the optimism of travellers who had rounded it and were heading to the rich trading areas beyond. Even now it is dangerous and difficult to navigate. It's why the waters further south are some of the most unexplored in the world.

And that is the next destination of the expedition. we are leaving the exotic Spice Islands and heading south, to the remote waters off the coast of Mozambique where the team aims to investigate the world's largest colony of manta rays, giants of the deep with wingspans of up to 8 metres.

The largest population of manta rays ever recorded numbered over 600, just offshore in Mozambique's southern waters. These enigmatic gliders are the largest of all rays. But, unlike their close cartilaginous cousins the sharks, mantas are not predatory. Bar the odd small fish and krill they feed almost exclusively on plankton.

Mantas often feed at the surface on small zooplankton by funnelling them into their mouths with specialized head fins – called cephalic fins – that unfurl into scoops. When these fins are rolled back up into a non-feeding position they look like devilish horns.

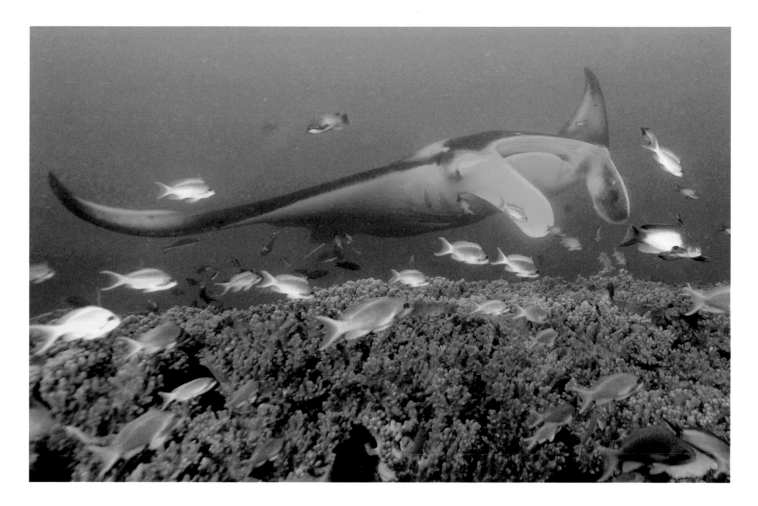

Fishermen and early divers called manta rays 'devilfish' and who could blame them? They move fast and have accidentally swum into ships' ropes, anchor lines or even into hard-hat divers' air hoses. Rays can't swim backwards so, when they get tangled, they just try to power forwards, thrash around and often leap clear of the water. There are old stories of mantas drowning divers, and towing fishing boats out to sea before crushing them.

Mantas must eat a huge amount of plankton to survive and tend to congregate in fast-flowing, nutrient-rich waters. The Indian Ocean currents off the Mozambique coast curl around a headland and concentrate the plankton into a relatively tight area, making it an ideal feeding ground. But that's not the only attraction. Below the surface, an ocean reef has formed into a unique ecosystem centred on the rays – a cleaning station.

All fish carry unwanted hitchhikers, usually parasites. Mantas depend on the reef's 'valet' service available at cleaning stations. Here, different 'cleaner' fish feast on parasites and dead tissue off the larger fishes' skin. This artful symbiotic relationship provides food and protection for the 'cleaners' and considerable health benefits for those being serviced. There is one overwhelming criterion for a manta cleaning station – a strong current to enable the manta to remain stationary while still passing fresh oxygenated water through its gills. The sites are mostly found at the top of reef walls.

**ABOVE** *The waters to the south of Mozambique are home to the largest population of manta rays in the world. These huge fish feed almost exclusively on plankton. They congregate where the ocean currents ensure that the plankton is concentrated in a relatively small area.*

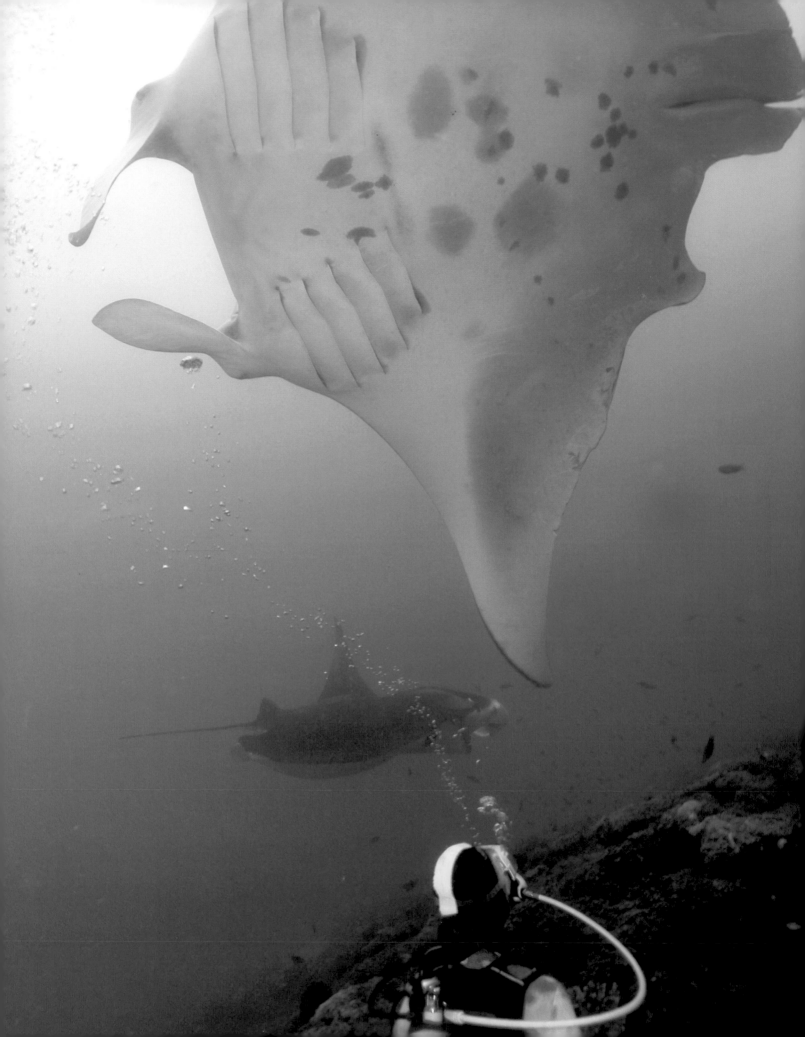

# The 'Cleaning Stations'

**The only way to truly understand** the astonishing relationship between the mantas and the 'cleaner' fish is to dive the 'cleaning stations'. I hoped this would be a relatively easy task. But there is nothing straightforward about the coastal waters of Mozambique. Rough seas and difficult currents meant we had to leave our dive boat and use inflatable boats, launched from the beach, through the surf zone and out to the reef.

The plan for the dive was simple: find an area that could be a cleaning station and just wait for some action. So I spent a couple of dives hanging on to the reef in the current wondering if I was in the right place. The reef was animated – soft corals swaying to the current and the ocean's surge, clown fish darting in and out of their safe anemone haven, beautiful but poisonous lionfish drifting past me in the current, the sounds of parrotfish crunching at the hard corals, schools of brightly coloured jacks flying past, the silhouettes of turtles above me, all contributing to that wonderful feeling of life on a healthy tropical reef. No rays – but no shortage of things to see.

Then, on my third dive I suddenly noticed all the reef life around me changing – and fast. Some reef fish just disappeared while the 'cleaner' wrasse and butterfly fish all came further out from the reef fissures. The whole character and atmosphere of the reef had changed. And a moment later the first of the mantas arrived. As they swooped into the reef it was hard at first to get a sense of scale, but once they closed in and cruised close to me I could clearly see they were an impressive 7 metres in length.

The mantas came up from deep water and formed a holding pattern close to the surface as they queued up for the cleaning station area. There was a ranking system in place so that the larger mantas got serviced first. On this particular reef there was one huge manta we called the albino, who was completely white. This exceptional manta was over 8 metres long, and when he came in for a clean, all the other mantas left.

By traversing the reef I soon discovered that each section acts as a separate cleaning station with different types of 'cleaner' fish specializing in different parts of the manta. At the first stop, blue streak wrasse went into the mouths and gills, then the mantas moved on to the second stage where the sergeant majors cleaned the head area, and moon or saddle wrasse cleaned the parasites off the mantas' backs. It was an amazing experience to see these huge mantas flying in to the reef, swooping over my head, complete with different reef fish attached to them.

Manta rays are known to have the biggest brains of all fish. And scientists have discovered that their brains are especially enlarged in areas responsible for smell, co-ordination and hearing. I wouldn't be at all surprised to find they have a special brain section dedicated to perfect grooming.

About 80 per cent of the mantas in this area were female and most were pregnant. With their young inside them they cruised the deep ocean, looking just like undersea flying saucers. Nobody has ever seen mantas give birth or nurse. A great deal about these wonderful creatures is yet to be discovered and I left the water happy indeed that, once again, a dive into the mysteries of the ocean threw up more questions than it answered.

> Manta rays are known to have the biggest brains of all fish.

As the mantas gather at the cleaning station, it becomes apparent they are being attacked by more than parasites. Almost every manta has one or more shark bites on its rays. No one knows why sharks in this region attack the mantas, but they do, repeatedly. Unlike any other population of mantas in the world, over 70 per cent here have shark injuries.

> Almost every manta has one or more shark bites on its rays.

Rays' eyes are at the ends of their heads, giving them amazing stereoscopic vision but it means they have a blind spot behind their wing tips. So the shark bites are always at the very back. But if so many are being attacked by sharks, why is the population so vibrant? The answer could be the last piece in the puzzle, because at the station there are fish that are specialized to concentrate on wound cleaning. Butterfly fish are seen dressing the mantas' wounds, allowing them to recover more quickly and preventing infection.

This is a unique environment: a specialized cleaning station that is part wash and brush-up, part A&E, combined with a powerful current that allows the mantas to stay at the station for long enough to get a thorough clean-up.

## SIRENS OF THE SEA

Not all species in the Indian Ocean are thriving. One of the rarest and most fascinating of those at risk is the dugong, a mysterious creature that has authored legend. This sea cow is a herbivorous marine mammal; indeed, it is the only fully aquatic herbivorous mammal. Between 2–3 metres long, dugongs have tapered bodies that end in a deeply notched fluke, or tail, and short forelimbs of rounded flippers. The myths of mermaids and sirens are thought to be based on sightings from a distance of these creatures, perhaps exacerbated by the teats on the front of their bodies, near their front flippers, and their habit of swimming on their backs suckling their young while holding them with one flipper. Christopher Columbus reported seeing three 'sirens' in the ocean off Haiti in January 1493. 'They came quite high out of the water,' he wrote, but 'were not as pretty as they are depicted, for somehow in the face they look like men.'

Dugongs are related to elephants, having evolved from a common ancestor and now, with manatees, belong to the scientific order of Sirenia, a nod to the folklore that decreed that the songs of creatures that were half-woman, half-fish lured passing ships on to rocks.

Today it is these 'mermaids' rather than ships that are in peril. Once populous, the numbers of these fascinating creatures are rapidly declining. In many parts of the world dugongs appear to have vanished completely, and here

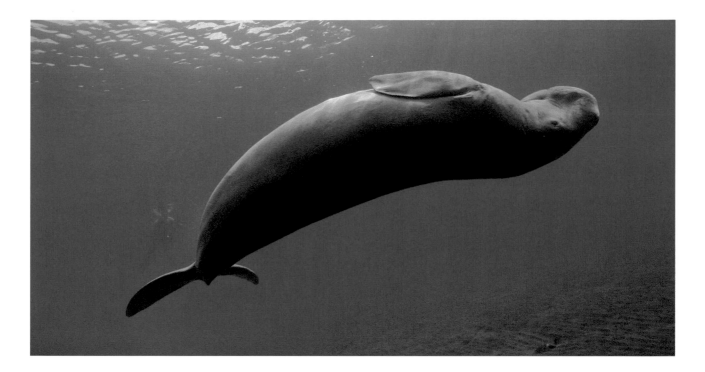

in the Indian Ocean the picture seems equally bleak. The expedition is heading to the Bazaruto archipelago, about 9¼ miles off the coast of Mozambique, to investigate the very last sustainable population of dugongs in the entire western Indian Ocean.

In the early African dawn, the islands of the archipelago are breathtaking. Rising up out of the Indian Ocean, these barrier islands are made up of vast sand dunes: monumental mountains of sand up to 100 metres high that dwarf everything around them. These, the highest sand dunes on any barrier island system in the world, are formed by the power of the Indian Ocean.

The strong currents that characterize the Indian Ocean swirl southwards in giant eddies, 62 miles wide, that gather up and transport vast quantities of sand. These same currents sweep across the ocean and crash into the steep continental shelf of Mozambique, dumping the entire cargo of hundreds of tonnes of sand in one narrow area. Day after day, the sand builds up to form the huge mountains. Then the monsoon winds take over, sculpting the dunes into statuesque peaks.

Although the barrier islands are just a few miles wide they separate, as their name suggests, two very distinct marine habitats. On the seaward side there are ideal conditions for a barrier reef – warm waters, refreshed by nutrients brought up from the depths by the strong currents of the open sea. On the landward side, the environment is more akin to swamps or marshes; sandy, shallow, sediment-rich waters that allow profuse growth of seagrass.

Seagrass is the dugongs' only source of food and the beds off Bazaruto Island are a known grazing spot, so it was here that the expedition was hoping to spot them and document their health. Ideally the team wanted to spot dugongs in a group, as this would indicate a more sustainable population.

ABOVE *A dugong or sea cow swimming gracefully on its back.*

OVERLEAF *Related to elephants, early sightings of these creatures were probably reponsible for the myth of the mermaid.*

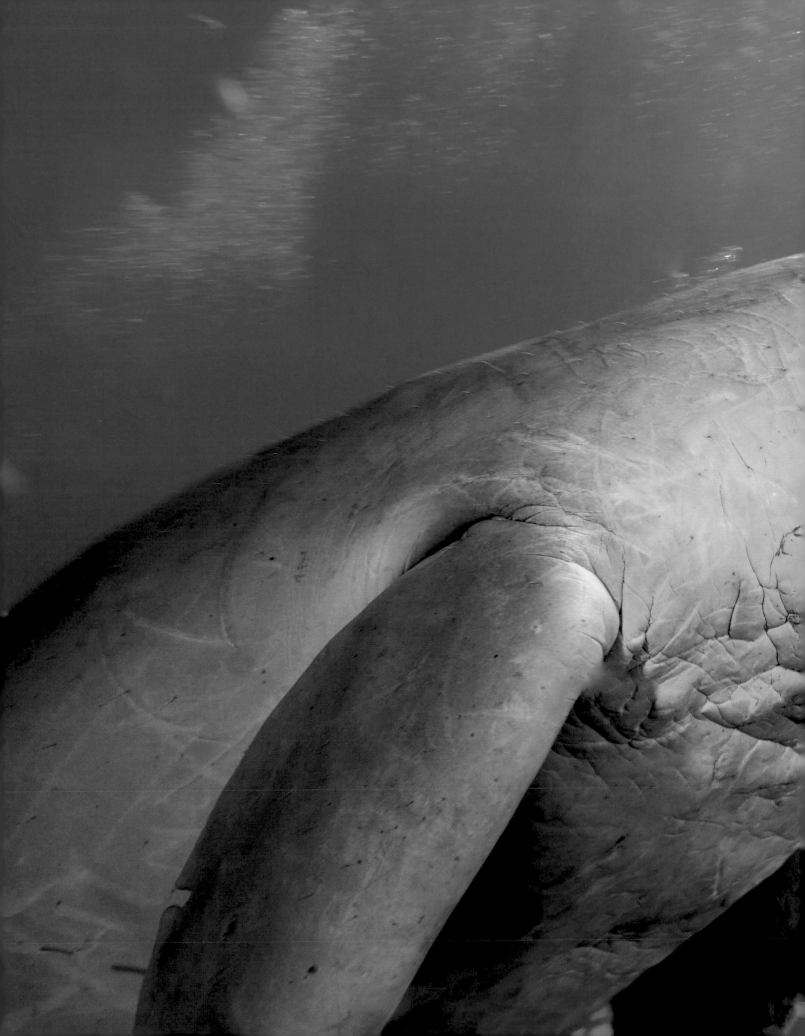

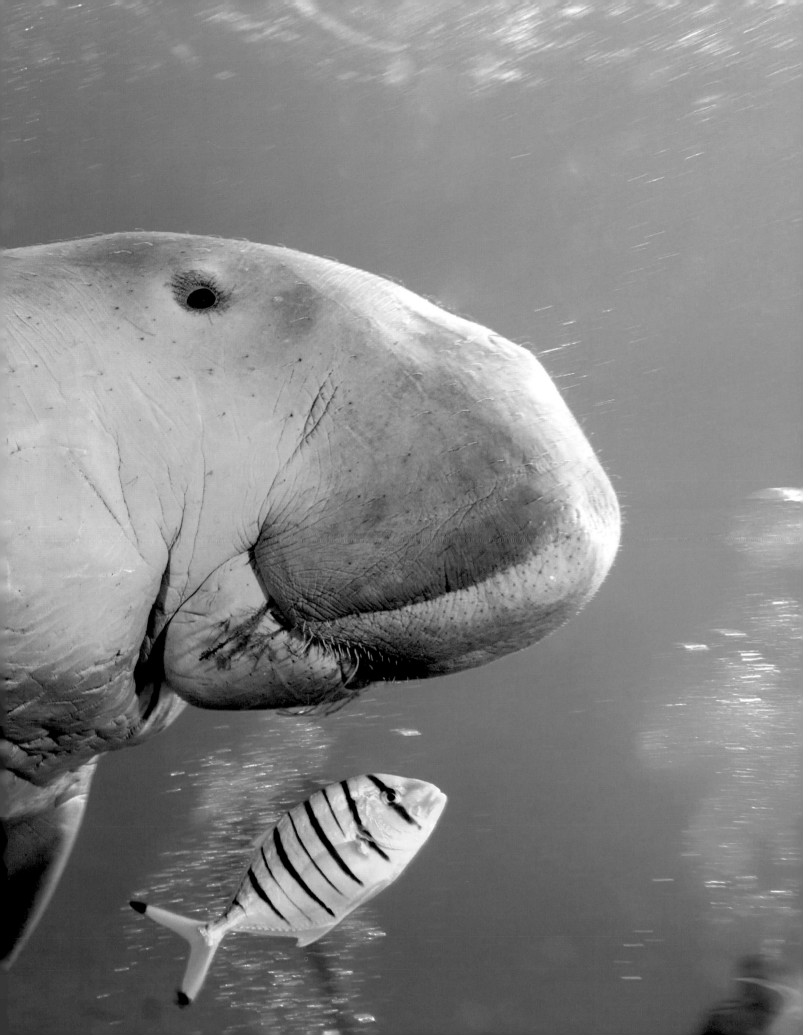

The plan was to take a low-flying plane and scan the area from the air, while a boat waited in the vicinity ready to head towards any sightings. The search would be made more difficult by the fact that dugongs are notoriously shy, easily stressed and quick to dive at the sound of an engine.

Dugongs do not swim fast over long distances, and tire easily if chased. It is thought that their metabolism stays in low gear so that seagrass alone can sustain them. On top of that, their flesh reportedly tastes delicious, making them attractive prey for whales, sharks and crocodiles. Humans once hunted them for meat, hides and oil, but today, most populations are protected by law. Hunting, though, is only one cause of their decline. The destruction of seagrass habitats has been a significant factor, as has entanglement of these slow-moving animals in fishing nets. Nor do dugongs do much to help themselves, having an extraordinary low reproductive rate. Females do not reach sexual maturity until ten years of age, and even then only give birth to a single calf, every three to seven years. Females therefore tend to produce only one calf in a lifetime – and do not give birth at all if food is scarce. As a result, even the slightest reduction in the survival of adults has a devastating impact on the sustainability of the population. Dugongs are on the International Union for Conservation of Nature (IUCN) vulnerable list and the Bazaruto archipelago is believed to be the next place where they will become extinct unless urgent action is taken.

> Females ... tend to produce only one calf in a lifetime.

The team's search for dugongs is hampered by the weather, which is now almost routinely poor. Storms blowing in make it impossible to launch the plane, and even when there is a break the sediment stirred up in the sea makes it impossible to see anything under water. Also, shortages of fuel mean there is only time for a few short air reconnaissance trips. But on one of these two dark smudges are spotted in the water below. Dugongs! And, even more excitingly, a mother and a calf. The boat follows the direction they are travelling in, aiming to steer round them in a wide sweep and drift without motors into a position that allows a closer sighting.

Finally, there they are. Not just the mother and her calf, but a group of five, swimming gracefully through the water. From observation the animals appear healthy, and the sighting of the calf indicates that food is plentiful. It is a special moment for the team, seeing these rare creatures in their natural habitat for perhaps the last time. But the health of this group gives a ray of hope that there is still time to protect the population here, to allow this legendary creature, this secret siren, to survive.

At the end of the day a glorious sunset transforms the ocean. Recent storms are forgotten in the golden stillness, with the sea calm and serene in the sky's fiery glow.

# Riches on the Seabed

**Perhaps the real relationship between mankind and the sea** is wrought in the wrecks that litter the floor of this ocean. Currents, not mermaid song, inspire its deadly power. Many ships have been swept along the currents or caught in the changing winds, to founder on the reefs or rocks below the surface. The sea has taken many thousands of lives and many more thousands of tonnes of cargo over the years, but now people are taking some of it back. Modern-day salvagers plunder the riches of sunken treasure.

**ABOVE** *Paul Rose dives down to the wreck of the* Paraportiani, *a victim of the powerful East African coastal current in 1967.*

These days the bounty is more likely to be the bronze of a propeller rather than gold or silver doubloons, but the plunder is still controversial. To archaeologists, wrecks are valuable sites, preserving a moment in time, an archaeological resource that exists nowhere else and can reveal untold riches in terms of understanding our past. For local salvage operators, it's a way of exploiting the sea, no different from the exploitation that has always been used to provide a livelihood.

The *Paraportiani* was carrying a full cargo of wheat from Romania to Jeddah on what should have been a routine 1800-mile passage. But in 1967 the Suez Canal was closed during the Arab-Israeli war and that meant her only option was a 12,400-mile passage out of the Black Sea and across the Mediterranean into the Atlantic, to pass down the west coast of Africa, around the Cape of Good Hope, up into the Indian Ocean and finally north into the Red Sea.

I can imagine the wheelhouse on the night of 25 October 1967 as the captain of the *Paraportiani* and his officers worked out their position. The long voyage had taken its toll on the 40-year-old ship and among the broken equipment was the radar. Without its magic eye, the captain only had a sextant and compass. And because of overcast skies he had not had a good sun sight for an accurate sextant fix for days. He could not even take the safer route of going way out to the east into more open waters as the ship was by now desperately short of supplies and water. So he was committed to taking her in to Mombasa to resupply.

The wheelhouse would have been as dark as possible with all white lights extinguished, the compass, depth finder and charts lit by dim red lights in an effort to preserve delicate night vision. A crewman lighting up a cigarette in sight of the wheelhouse would have been severely chastised. It would take fully 20 minutes to restore the night vision damaged by the flash of his match.

Unknown to the men of the *Paraportiani* they were being forced towards land in the grip of the powerful East African coastal current, reaching speeds of 5 knots. Features on the sea bottom did not offer any clues that they were approaching land as there is no gentle slope leading to shallow waters. Instead, Pemba Island sits at the top of the continental shelf with water depths going from deep ocean to shallow reef in an instant.

The combination of bad weather, their uncertain position and the force of the current could only equal disaster. And so it was that the ship ran up hard on to the Panza Reef at the southern tip of Pemba Island.

Her radioed distress call was answered by the Mombasa signal station and relayed to the Kenyan navy at Mtongwe who deployed two patrol boats to attempt a rescue. In the meantime 19 of the crew had taken to the lifeboats and rowed ashore where they were arrested by the Green Guard, a local Pemba militia unit. During the arrest one of the crew was shot for refusing to hand over a case of Scotch whisky he had rescued from the ship. At the same time the Kenyan navy sent a boat to the *Paraportiani* to bring the remaining crew ashore – they, too, were arrested. The confusion was all made good later when the crew were taken to Mombasa, the shot crewman was treated and the whole crew was repatriated to Greece.

Unlike the *Paraportiani* our dive boat was fully equipped with the best navigation equipment, including up-to-date paper charts, electronic charts, detailed current information and an array of back-up electronics. We also had powerful engines and perfect weather. But even so, it was too dangerous for us to anchor at Panza Reef, so we stood off in safer, deep water and ran our dive boats over to the wreck.

The great East African coastal current was ripping across the *Paraportiani* so we had to drift-dive her. That is, enter the water upcurrent from her position and let the current drift us along the wreck. We dropped on to the reef and flew towards the stern. She is a beautiful wreck. Mostly intact, the collapsed hull and twisted steel are a testament to the power of the Indian Ocean's currents. As we whizzed around her we ducked behind companionway doors, the boilers and any good-sized object to stop ourselves drifting off, and when we did stop the current was so strong that I could feel my mask vibrating. Our exhaust bubbles went sideways instead of straight up to the surface.

We let go of the ship's rail and, accompanied by hundreds of fish, continued our underwater high-speed flight down the port side and over the mast, which was lying across the hull with the top pointing out to the deep shelf. We scuttled behind the rudder to rest by the propeller, its massive four blades giving us a calm eddy in the current. We saw the locals had been salvaging bits of the wreck. They had taken some relatively easily available valuable pieces, such as brass portholes, and had been trying to cut through the massive propeller shaft. If they were successful the propeller would sell for a small fortune.

As we surfaced my last sight of the wreck was the huge shaft, partly buried deep in the seabed, half cut through, and a large collection of lifting tackle left in place by the local salvors. I thought it was great that the Pemba Island villagers were salvaging some of the ship. It looked like a relatively sustainable and environmentally friendly livelihood. The island is not wealthy and the sale of those wreck pieces could keep a community going for years. My co-diver Lucy, on the other hand, was deeply concerned that the salvors were destroying the site. She felt their salvage activities were part of a problem that encourages looting of vessels of all ages and great historical value.

We left the wreck to its uncertain future – archaeological site or source of income?

… the current was so strong that I could feel my mask vibrating.

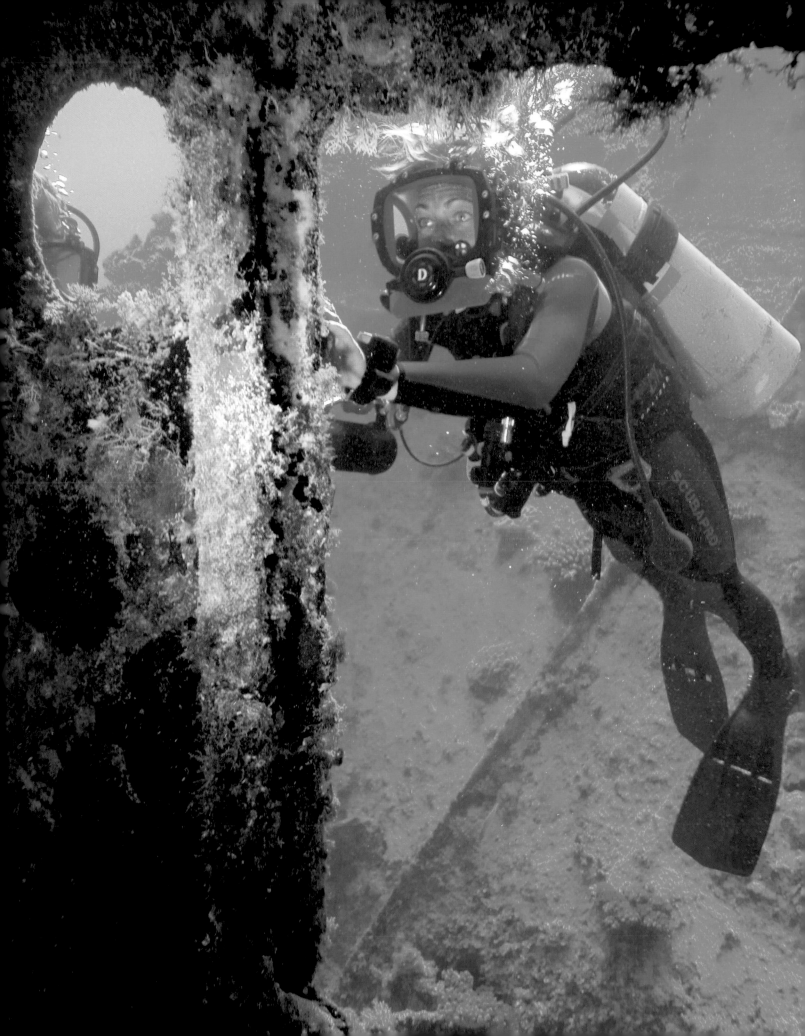

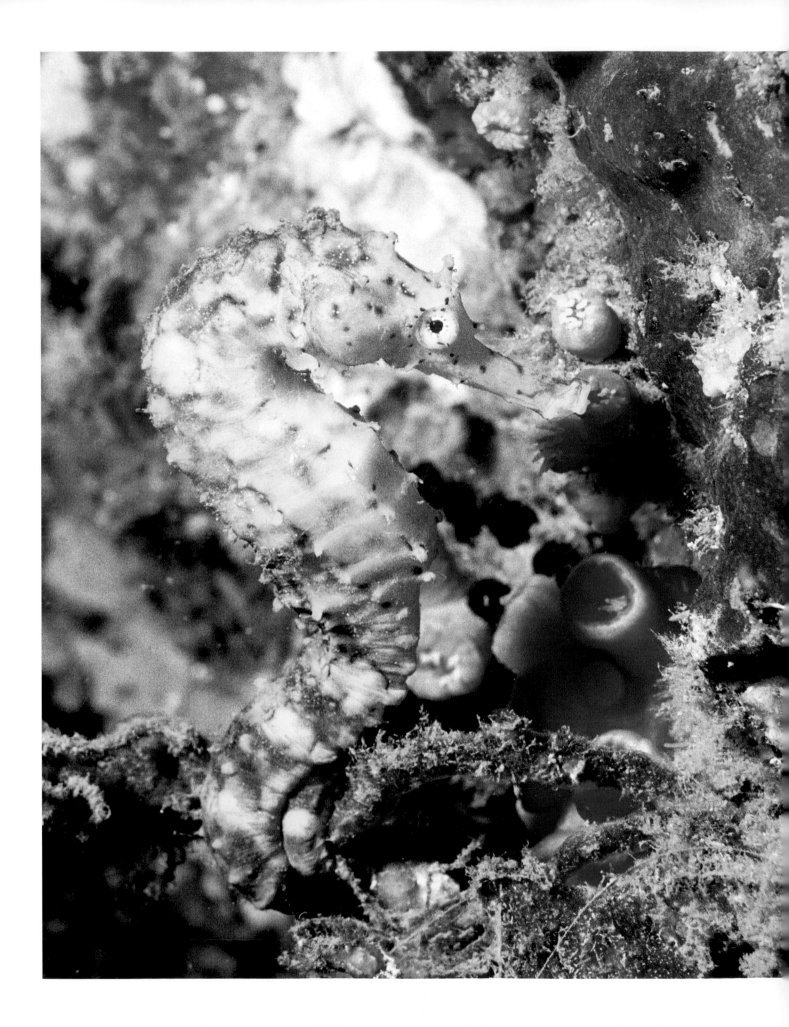

## PLIGHT OF THE SEA HORSE

As a consequence of warm waters that are less rich than others in nutrients, the Indian Ocean is not hugely productive, so it is not fertile territory for the commercial fishing industry. However, two species are exploited – sea horses and sharks. Populations of both are in sharp decline as a result of massive industrial operations to supply the highly lucrative Chinese market.

Sea horses, in particular, are prized as key ingredients in traditional medicine, to treat asthma, heart disease, skin disorders and impotence. In the East they are believed to be a powerful aphrodisiac and around 20 million animals a year are killed and sold for use in traditional medicines in China, Indonesia, the Philippines and other places. It's a massive trade with good-quality sea horses selling for about $550 per pound and even puny specimens sell for hundreds of dollars a pound. Accordingly, nine out of 33 sea-horse species are on the IUCN 'red list' as vulnerable, and one species in the Indian Ocean is officially endangered.

Sea horses are fascinating and uncommon creatures who shelter in algae, corals, mangrove swamps and seagrass beds, deeply disguised and almost hidden to the human eye. They can change colour to match their background and grow long skin appendages to mimic algae. They let encrusting organisms settle on them and can remain virtually motionless for hours at a time. They are delicate, slow-moving animals, which is why they rely so heavily on camouflage to catch their prey.

Famously, the male becomes 'pregnant' and carries the eggs that the female deposits in his pouch, caring for them for two to three weeks until he gives birth. The male and female mating pair is monogamous and most sea horses stay with each other for life. It is due to their monogamy and their attachment to a single, very specific habitat that sea horses are especially vulnerable. If a sea horse is moved or loses its mate it is highly unlikely to find another mate and continue to reproduce. So the intensive fishing of these creatures has the potential to quickly decimate the sea-horse population.

*OPPOSITE A seahorse can change colour to match its background. They rely on this camouflage to catch their food.*

In the East they are believed to be a powerful aphrodisiac and around 20 million animals a year are killed …

## THE CORAL NURSERY

The long expedition is coming to an end. Over the past four weeks, the team has explored the impact of the sea on mankind and seen the effect of human activity on the sea. And now, as the final stages of the trip loom, we are able

*All the world's coral reefs are under threat, but an experiment being carried out on the reef in Zanzibar is bringing a ray of hope to the situation. 'Cuttings' from soft coral are being grown in nurseries on an undisturbed part of the reef before being transplanted into a degraded section. In this way it is hoped to regenerate the entire area. Early results are encouraging.*

All around the world coral reefs are in crisis … a third of these vital ecosystems have been lost already…

to reflect on one particular example that epitomizes the intense relationship between us and this complex and contradictory sea: the coral nursery.

At the beginning of the trip we saw how the power of the Indian Ocean carved its islands and created the conditions to make a stunning coral reef. But the impact of human-induced global warming has meant that in other parts of the ocean the sea temperature is rising and killing off the vital algae that live within the coral. As the algae die, the coral returns to its natural colour – white. Often the coral is recolonized with algae, but in many parts of the Indian Ocean the coral never recovers and the reefs are blighted with bleached, dead coral. But now there's a new and ingenious solution being pioneered on the reefs off the coast of Zanzibar. Diving these reefs, it is clear they are not as healthy as those at Pemba Island. Part of the problem is global warming and the devastating 1998 El Niño, but another factor is the expansion of the tourist industry in Zanzibar. The coral has been a key tourist attraction, but along with the tourist divers has come pollution, sediment that chokes the coral, and physical damage both accidental and deliberate. The local people rely on the income from tourism, so there is reluctance to stop the tourist divers coming; but there is also determination to try and restore the reefs.

Scientists working in Zanzibar take the expedition team away from the main coral reef to an undisturbed part of the ocean where a remarkable sight meets our eyes. A coral garden is growing on stretched nets suspended at midwater level. There are several nets strung flat and swaying gently in the current, and on each one is a mini forest of tiny coral 'cuttings' nestled into 9-centimetre rubber tubes secured to the nets. The scientists here are regenerating the reefs by using principles of land-based horticulture. The technique has been used successfully on land to regenerate forests; now it is being applied under water to coral. Tiny cuttings, called nubbins or spats, are carefully taken from healthy 'mother' coral and cultivated in this more protected environment for 292 days until they have grown into healthy, midsized sections of coral. This coral is then transplanted into a bleached or degraded area of reef where it's hoped it will establish, and regenerate the entire area. This is still an experimental technique, but early results suggest it is highly effective. The free-floating, midwater nurseries are safe from predators and sedimentation, and the water flow around the nets brings a constant supply of plankton, and oxygen dissolved in the water.

All around the world coral reefs are in crisis. According to the UN a third of these vital ecosystems have been lost already, and by 2030 the figure is predicted to be nearer 60 per cent. The hope is that coral

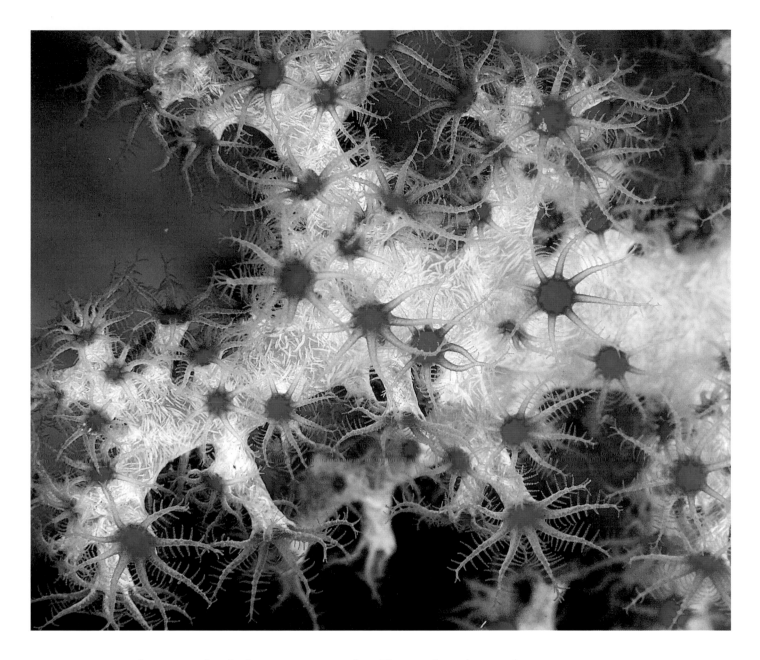

gardening may be the key to preventing this. This simple technique, being used for the first time in the Indian Ocean, could help restore coral reefs all over the world.

It is a fitting end to the Indian Ocean story: a perfect example of the complex interdependence between mankind and this powerful ocean. This trip has revealed an ocean of extremes. A sea that contains both mythical, enigmatic creatures and some of the world's largest fish; a sea with tides and currents that can both build lands and destroy them; and, above all, a sea that is intimately linked to the lives, history and future of the 30 million people who depend on it.

# THE RED SEA
## Ocean of Optimism

PREVIOUS PAGE *Lake Assal, in the Republic of Djibouti, is the saltiest body of water in the world. Though land-locked, the lake is supplied with sea water through tiny cracks in the surrounding rock, and its waters give rise to vast salt pans which are still mined today.*

RIGHT *A satellite image of the Red Sea. Though its northern end, which separates Egypt and Israel, is a Mecca for tourists, the southern end, isolated because of many years of conflict between Eritrea and Ethiopia, remains remote and undisturbed.*

OPPOSITE *A view of Massawa port in Eritrea – with the domed building on the right still showing the marks of the conflict that ended in 1993.*

The southern Red Sea ... is a pristine undersea wonderland.

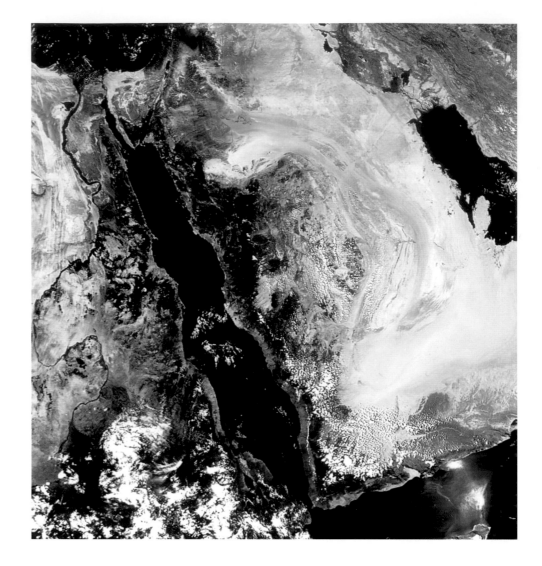

THIS IS PERHAPS OUR MOST AMBITIOUS MISSION YET, a journey into one of the last untouched marine environments of the world. We will dive parts of the ocean that have previously been seen by only a handful of people and observe creatures that are found nowhere else on the planet. Ironically, the location of this virgin territory is known as a tourist honeypot: the Red Sea.

While the northern Red Sea is one of the most famous and busy tourist dive sites in the world, the southern Red Sea, bordered by Eritrea and Sudan, is a pristine undersea wonderland. Many years of conflict between Eritrea and neighbouring Ethiopia have kept this part of the Red Sea remote and undisturbed.

It took nearly a year of complex negotiations for the *Oceans* expedition to gain the necessary permission for access and, as we arrive at Massawa port in Eritrea, it seems as if the war ended yesterday rather than in 1993. Battle-scarred buildings and shattered monuments surround us. Soldiers patrol the harbourside and military ships line the port, with not a yacht, cruiser or pleasure boat in sight. Fuel is still rationed here and we need thousands of gallons of marine diesel

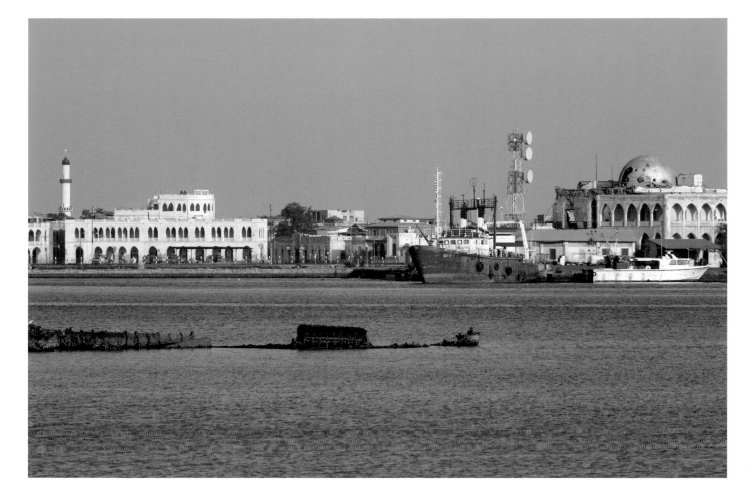

to complete our 600-mile trip. It's an anxious few hours until our additional fuel is agreed. Finally, with our papers stamped and our Eritrean navy minder on board, we set off. It is the first time an expedition like this has ever been in these waters.

## 'A CORRIDOR OF MARVELS'

It's worth all the effort. The southern part of the Red Sea is a significant site, succinctly described by diver Jacques Cousteau as 'a corridor of marvels'. It is a global hub of biodiversity with nearly a fifth of all the fish here found only in these waters. This is also the place where some of our earliest ancestors first encountered the sea and learnt to harvest its riches. The excitement is palpable as we set off – without knowing that this glorious marine wilderness would turn out to surpass even our highest hopes.

The Red Sea is a narrow strip of water separating the continental land masses of Africa and Asia. Technically it is an ocean because it was formed

by continental plates moving apart. It is the world's youngest ocean, only starting to open a mere 38 million years ago. And it's still growing, widening at just over a centimetre a year, about the rate of a fingernail's growth. But, perhaps most remarkably, on its fringes is the site of a completely new ocean. Fast-forward 200 million years and there could be water where the Horn of Africa presently sits.

> ... it is the world's youngest ocean ... And it's still growing.

We've travelled to the very south of the Red Sea in Djibouti, a remote country in the Horn of Africa bordering Ethiopia, Eritrea and Somalia. Our destination is the Devil's Cauldron, a bay on the edge of the Red Sea and one of only two places in the world where you can dive to see the birth of an ocean (the other being in the chillier climes of Iceland).

Lying at the bottom of the bay is the westernmost section of a huge crack, or rift, which divides the unstable African and Arabian plates. These plates are pulling apart, creating the new ocean.

Normally, these tectonic processes are hidden under glaciers or at the bottom of an ocean floor and covered by thousands of metres of sea water. But in Djibouti the evidence that the earth is being ripped apart can be seen in the shallow waters of this bay. Moreover, it is happening rapidly. During a three-week spell of tectonic shifting in 2005 the rift grew by 8 metres. Its rampant activity was observed from the European Space Agency satellite.

## AN OCEAN BEGINS

The team heads into the middle of the bay, passing Devil's Island, an extinct volcano rearing up from the water. Tremors are frequently felt in the surrounding area – our local guide felt one just a few days previously – and the surrounding land is strewn with lava flows. The water is jet black in colour from the volcanic basalt rock that lines the bay's floor.

> Tremors are frequently felt in the surrounding area ...

As the divers descend the water column one thing is immediately striking. There is abundant life under the surface of the water compared with the barren volcanic desert on the land above, drawn here for both the relative safety it provides from predators and for the swirling wealth of nutrients.

At around 30 metres the divers catch their first glimpse of the crack, or La Faille as it is called locally, cutting deep into the rock to the earth's crust below. Strange bridges of basalt have formed across it, like walkways for the millions of marine creatures living here. The rift is narrow, deep and dark. The divers descend, dropping into the rift and sinking between the two

OPPOSITE *The ragged and desolate coastline of the Devil's Cauldron on the Bay of Ghoubett in the south-eastern corner of the Red Sea – a site of ongoing tectonic activity.*

ABOVE *Devil's Island, an extinct volcano in the middle of the Devil's Cauldron.*

OPPOSITE *An Afar tribesman walks across one of the vast salt pans on Lake Assal. This nomadic Muslim tribe that lives on the shores of the Red Sea will give its name to the new ocean.*

tectonic plates. It is awe-inspiring to imagine the immense subterranean power that has pulled these vast plates apart.

As the plates move, fresh magma is forced up from the earth's core to fill the gap. As the gap widens, more magma rises up and solidifies to form a new ocean floor. This is how all the oceans on our planet have formed. Here in Djibouti, as the plates pull apart, the waters of the Red Sea and the Gulf of Aden will flood in, covering the land and creating a new ocean over this corner of Africa. At the moment its shoreline is impossible to predict. Some scientists think the Horn of Africa will break off from the mainland in the process. Even though the new ocean won't exist for maybe 200 million more years, it has already been given a name, the Afar Ocean, called after the immediate region and the nomadic tribe that inhabits it.

One place that will certainly be part of the new ocean is the extraordinary Lake Assal. A crater lake 6¼ miles long and 4⅓ miles wide, it registers as the lowest place in Africa at 154 metres below sea level. Although it is completely landlocked, there is a steady flow of sea water into it through hundreds of tiny cracks in the surrounding rock. Due to the constant supply of sea water, and high levels of evaporation, the lake is the saltiest body of water in the

world, some ten times saltier than the nearby Red Sea. This makes it an extremely hostile environment for animals. As a result, only colonies of bacteria are found here.

## WHITE GOLD

The highly saline waters give rise to the vast salt pans that surround the lake and which are still mined today. Geologists believe that in the past the Red Sea became as salty as Lake Assal when it partially dried out as a result of fluctuating sea levels. It's this fluctuation that has made the sea one of the most important sites in human history and given the team an opportunity to glimpse its long-distant past. When sea levels dropped, this allowed our earliest ancestors to cross out of Africa and begin to spread across the world.

> When sea levels dropped, this allowed our earliest ancestors … to spread across the world.

The notion that the human race originated in Africa is not new; Darwin first mooted the idea in the mid-nineteenth century. Of course, then there were no fossils or artefacts to support his claim. However, recent findings in Africa of ancient remains of *Homo sapiens* and the tools and weapons our ancestors used, point towards an African origin of the human race. Scientists have used these skeletal remains combined with DNA patterning of present-day world populations to estimate an emergence of *Homo sapiens* in Africa around 150,000 to 195,000 years ago. We also know that these populations had dispersed from Africa to most other parts of the world at least 60,000 years ago, where they replaced pre-existing populations, such as the European Neanderthals.

## LOOKING FOR CLUES

Some of the most central questions as to exactly how and why this dramatic population dispersal took place have never been clearly resolved. The team heads on to Eritrean soil to search for clues. As some early modern humans made their way north across the plains of Africa, the Red Sea would probably have been the first body of water they had ever encountered. The area was perfect, being safe, high and dry, and, remarkably, with abundant fresh water. The wells are still used by the military today. Shellfish could be easily collected – there was no dangerous hunting and no need for cooking – and only simple tools were needed to open them. Here, there are signs that early humans made a home by the sea.

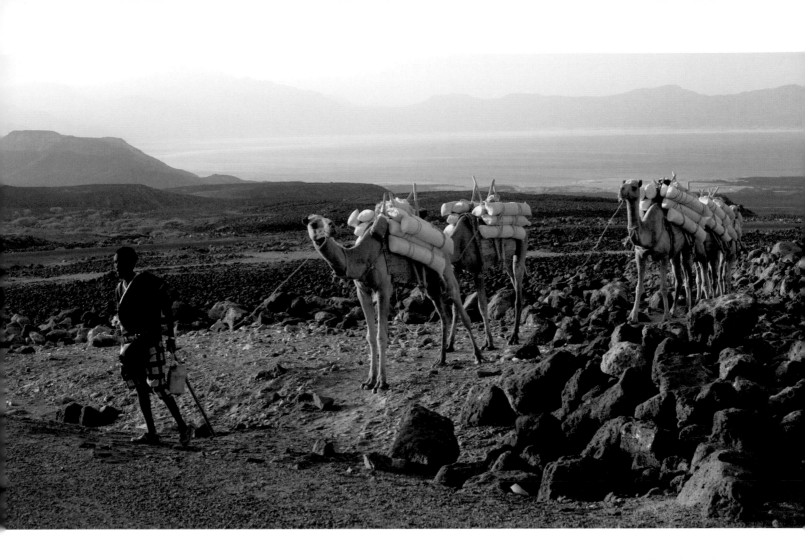

ABOVE *Camels are the most reliable means of transport for the salt mined in this inhospitable environment.*

LEFT *In this heavily militarized region this salt is worth its weight in gold. To the miners, whose average wage is about US $100 a year, it represents survival.*

> ... it is likely that the skills of fishing and living off the sea ... were first developed along the shores of the Red Sea.

So it is likely that the skills of fishing and living off the sea, which have nurtured humanity for millennia, were first developed along the shores of the Red Sea. A record of this first encounter lies preserved on the sea floor.

But, unusually, we don't have to dive to reach it as we've come to a stretch of coast where the sea has come to us. Here at Abdur in Eritrea a coral reef system has been forced 14 metres above sea level by geological activity. It's an important archaeological site, but the war and continuing border tensions have meant that access for researchers has been difficult. Now the area is a military outpost and, as we approach the shore, soldiers are watching our every move.

Finally we arrive at the raised coral reef. Marine creatures, such as molluscs and marine worms, became fossilized over time to form layers of limestone 10 metres thick. And, unmistakably, embedded in this fossilized reef are human artefacts. Obsidian hand tools, chipped and honed to a sharp edge were found here and dated to 125,000 years ago.

Two main 'tool kits' were uncovered: two-sided hand axes, used between 165,000 and 100,000 years ago; and obsidian flakes and blades, used in the Middle Stone Age between 300,000 and 50,000 years ago. But these are not the only finds. Further on, we come across a fossilized shell midden – a mound of discarded shellfish and oyster shells. Intriguingly, the obsidian hand tool fits neatly into the shell – perfect for shucking oysters. The simplest explanation for the occurrence of stone tools in this fossilized reef is that whoever made the tools used them to harvest edible marine molluscs and crustaceans in shallow water and butcher large land mammals near the shore. They then discarded the tools at the various food-processing sites. Two edible species of oysters are fossilized within the uplifted reef, as well as 31 species of edible mollusc.

## WELCOME OASIS

Prior to this, early humans might have survived on game hunted on the plains of Africa. Between 200,000 and 100,000 years ago they moved towards the coasts of Africa, perhaps driven by a series of mega-droughts, developing new survival methods such as fishing. Abdur would have been a welcome oasis, with its plentiful fish and water. For the first time humans would have had access to a new food source, one that was not dependent on the weather.

There is even speculation that the omega-3 and omega-6 oils in shellfish might have helped the brain development of early humans. It's a controversial

theory, but one scientist at least thinks it's an intriguing hypothesis. 'Anthropologists and evolutionary biologists usually point to things like the rise of language and tool making to explain the massive expansion of early hominid brains,' explains Dr Stephen Cunnane, a metabolic physiologist at the University of Sherbrooke in Quebec. 'But this is a catch-22. Something had to start the process of brain expansion and I think it was early humans eating clams, frogs, bird eggs and fish from shoreline environments. This is what created the necessary physiological conditions for explosive brain growth.'

In any event, written in these grubby remains on a military encampment is the start of our entire tradition of harvesting the sea. Once here, the early coastal dwellers had the opportunity, when sea levels fell, to explore further afield, moving across the sea to other lands.

During the ice ages over the last one million years, the sea level has consistently dropped, probably as much as 130 metres at a time. This means that a channel from Bab el Mandeb at the mouth of the Red Sea to Hanish Islands, near Yemen, virtually dried up. It was often reduced to a sinuous

**ABOVE** *Droughts first drove* Homo sapiens *towards the shores of the Red Sea in search of food and water between 150,000 and 195,000 years ago.*

stream just a few miles wide. This stretch would have been easy to cross and it's likely that some animals, as well as humans, did just that. Human populations also dispersed up the Red Sea coast to the north of Africa and across into the Middle East around 100,000 years ago, via a 'northern route'.

On our way back to the boat we drink sweet coffee with a group of Eritreans. It's a fitting moment to reflect on the richness of this Red Sea shore, and the profound implications it has had for human history.

## CORAL QUANDARY

If the Red Sea has fashioned our past, it may also help to shape our future. We had persevered in our efforts to come to the southern Red Sea because this stretch of the sea is distinctive in many ways, one of the most significant of which is its temperature. This part of the Red Sea is the warmest ocean in the world and marine life here may hold clues that will help oceans all over the planet survive the threat of global warming.

For some time, scientists have predicted that the world's coral reefs will be among the first ecosystems to suffer devastating damage from global warming. Already, 60 per cent of them have been damaged by human activity, many beyond recovery.

Coral is both a living plant and an animal. Inside its structure, algae exist that photosynthesize and produce vital energy for the coral, and give it its colourful appearance. But in high temperatures they cannot survive. After they perish, the coral is bleached of colour. Without the algae to nourish it, the coral itself then dies. All over the planet increased sea temperatures are causing wholesale bleaching, and acres of dead coral. This is a tragedy not just for the coral but also for an entire ecosystem. Coral reefs are the rainforests of the oceans, supporting an astonishing array of marine life.

Here in the Red Sea temperatures can reach 34° Celsius, a full 4 degrees higher than the maximum summer temperatures on the Australian Great Barrier Reef and far higher than temperature in which coral can normally survive. But, contrary to all expectations, the coral here is thriving. Under water it is a vibrant, lush array of colour and form, alive with myriad fish that signal a healthy reef. There are odd patches of bleached coral here and there, but it seems able to recover in a few weeks and there is no sign of the mass bleaching that would exist in other parts of the world in these conditions. It's clear that something rather remarkable is going on here.

One theory is that these coral are colonized by a special form of algae, one that has adapted and become heat tolerant.

… contrary to all expectations, the coral here is thriving.

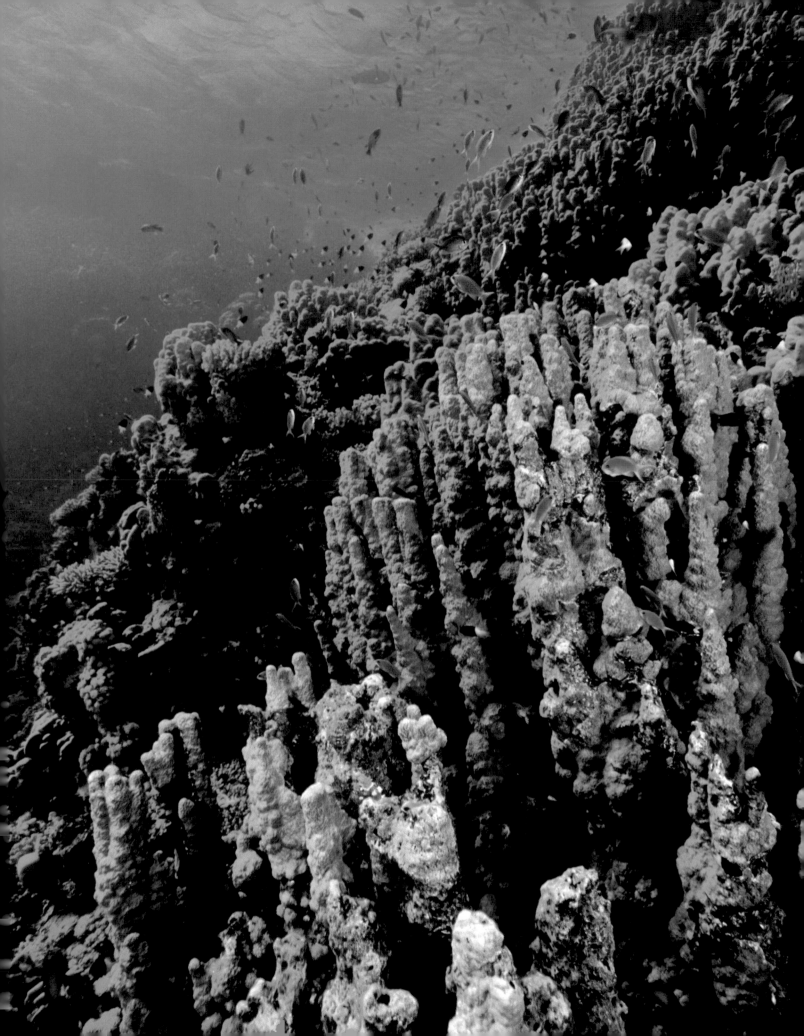

# Multicoloured Dive

**Our passage east from Massawa was idyllic**. Strong southerly winds heaped up the waves and hundreds of birds and dolphins accompanied our rolling journey. The hot dry wind combined with tonnes of spray coming on board from this, the warmest and saltiest sea in the world, meant we arrived at the reefs completely caked in salt. It was a great passage and, of course, it felt equally good to anchor in the shelter of the reef and hose ourselves off.

Fewer than a hundred divers come here in a year. By comparison, the northern part of the Red Sea hosts thousands of divers each year. So it follows that these reefs would be in a beautiful, pristine condition. But I had no idea just how remarkable they really are.

As I descended through the surging surface water and into relatively calmer depths at the reef edge it was obvious that these dives were going to be very special. The reef was exploding with colour and life. Soft corals, sponges, hard corals, fish of all sizes in their thousands and in every colour added to the wonderful burst of vibrancy in this immaculate unspoiled reef. So I felt a twinge of guilt that I was carrying a set of chisels and a large hammer. But my work here could help coral everywhere.

> ... these dives were going to be very special. The reef was exploding with colour and life.

The coral reefs of Eritrea may have a secret weapon that just might be able to save threatened corals around the world. The hypothesis is that in this area the traditional algae partner is ditched for a more durable variety. So my job on this dive was to take samples of the coral and algae. There is every chance that the heat-tolerant algae could be transplanted to act as a 'booster vaccine' for other corals.

To help understand the reef I dived again at night. Reefs change their aspect at night, mostly due to the feeding and hunting habits of the marine life. And strangely, some corals have the remarkable ability to fluoresce.

My dives here had a special twist: this would be the very first time that work on coral fluorescence had ever been done on these reefs. Instead of my normal dive lights I carried blue lights to excite the fluorescing coral and I wore a special filter over the top of my dive mask to enable me to study the phenomenon. It was a shock to arrive at the reef – I had to keep peering underneath my mask filter to stay orientated as I felt as if I was back in a 1960s light show.

## ... I could have spent months diving here.

I was surrounded by fields of brilliant green-yellow and purple. Some of the hard corals glowed only on the tops, some glowed at their edges and random patches of shocking colours were everywhere. It was so beautiful that I struggled to concentrate on my observations and measurements. On shallow dives like this you can spend a long time under water, but not long enough for me – I could have spent months diving here.

These reefs may have a successful combination of fluorescing proteins in the coral tissue and heat-resistant algal partners. It seems obvious that this has allowed the coral to thrive in what would be a hazardous environment for all other corals. But despite all the ongoing research, nobody really knows how this works.

Some scientists think corals use fluorescent pigments to regulate light. As in plants, strong light can exacerbate the effects of other stresses and, consequently, these pigments can protect them from a variety of stresses. This has yet to be scientifically confirmed – but our studies indicate that these fluorescent corals cope better with temperature stress.

So do we transplant the heat-resistant algae to threatened corals, or let a natural evolutionary adaptation occur? And what part does the amazing fluorescence play in all this?

The only way to find out is to increase our ocean research. The level of interest in the health of the sea has never been higher and the dives made by the *Oceans* expedition on these stunning reefs in the Red Sea contribute to that research.

**BELOW** *Our team's camera captured the brilliant colours of the fluorescent coral in this unspoilt part of the Red Sea.*

**OVERLEAF** *The sun sets on the Red Sea and the coral reef prepares its night time light show.*

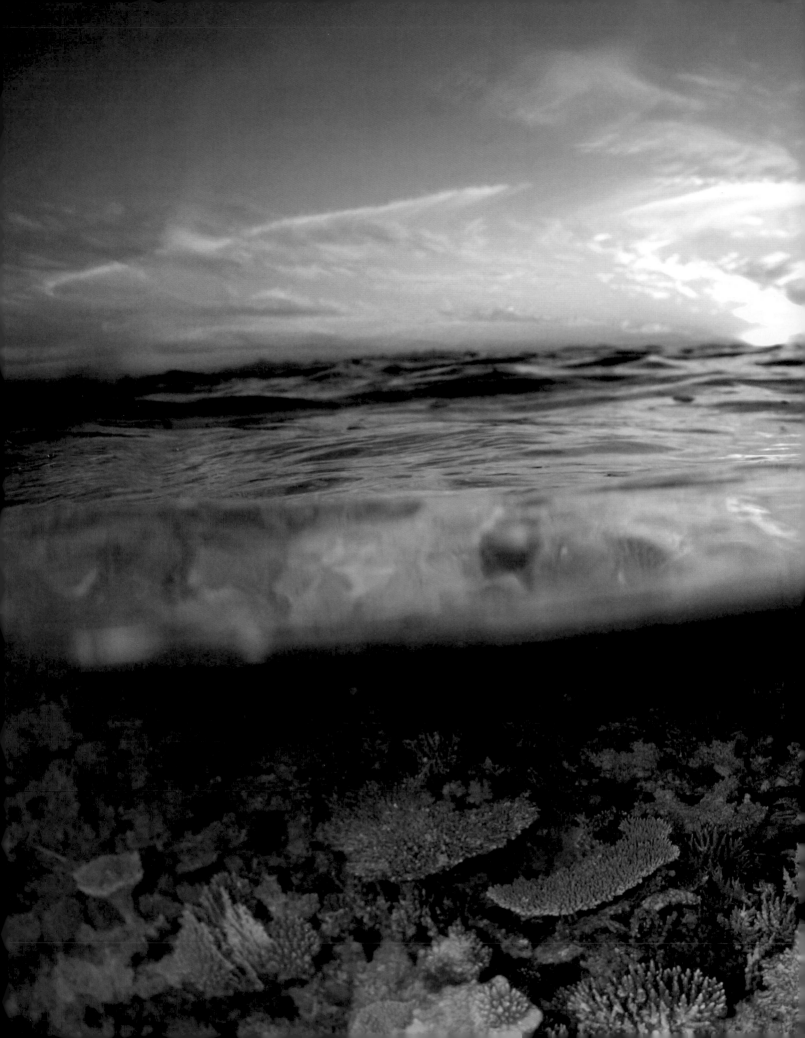

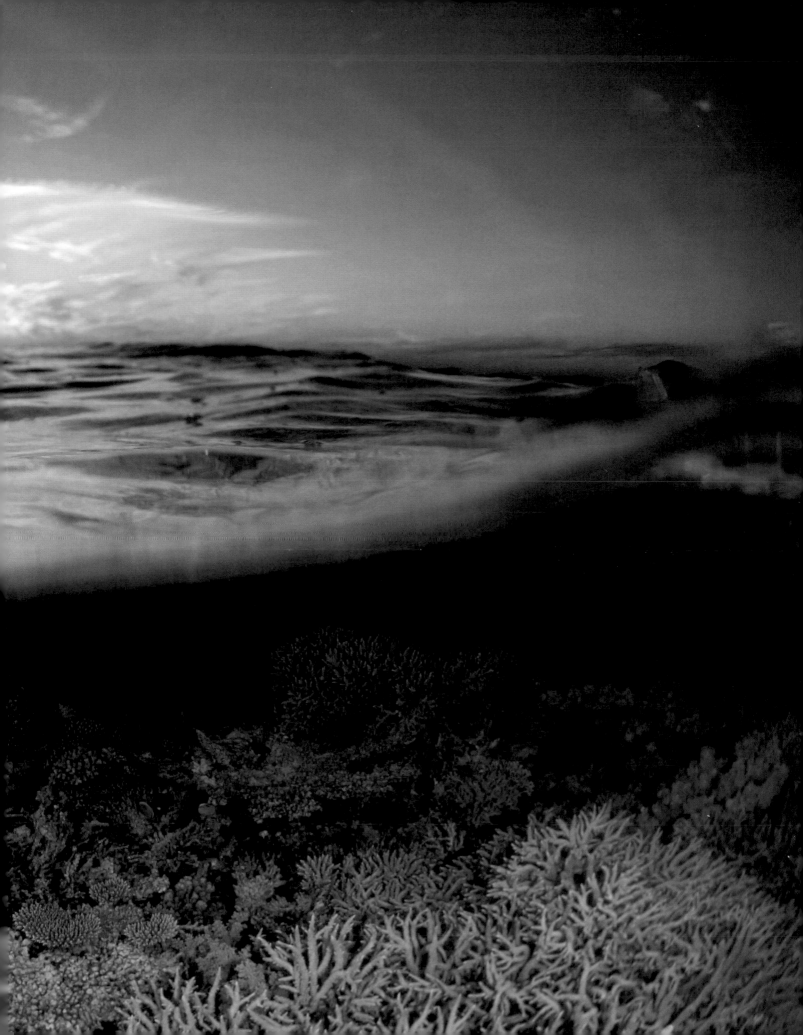

OPPOSITE, TOP *With few visitors, the reefs in the southern part of the Red Sea are flawless and home to an astonishing array of sea life.*

OPPOSITE, BELOW *This satellite image shows the narrow gap at Bab el Mandeb. When sea levels dropped, a sill at 120 metres acted as a barrier and divided the Red Sea from the world's other oceans. This is reflected today in the number of endemic species found in the Red Sea.*

As a world authority in coral fluorescence, he states quite simply that fluorescence is magic.

On its own this discovery of heat-resistant algae will not be enough to save the world's last coral reefs, which are threatened by pollution, over-fishing, tourism and other human activities. However, the team hope that by contributing to the knowledge of how coral species survive in Eritrean waters, they can offer some hope for vital coral reefs.

Coral fluoresces abundantly in this part of the Red Sea, and the ongoing scientific debate about the function of the proteins that cause fluorescence in coral could throw some light on the survival of coral species here. Dr Anya Salih and colleagues at the University of Sydney in Australia believe the fluorescent proteins protect the algae from high levels of light, by screening the symbiotic algae from the damaging effects of excess photons. The fluorescent proteins provide an intricate internal defence mechanism.

Anya and her colleagues also showed that fluorescent proteins enhance the resistance of coral to mass bleaching during periods of heat stress. During 1998, they found a noteworthy correlation between bleaching resistance and the concentration of fluorescent proteins within the coral tissue. Therefore, the abundant fluorescence in corals in the higher water temperatures of the southern Red Sea could protecting the coral.

Not all scientists, however, agree. Dr Charles Mazel, an expert on coral fluorescence, disputes the photoprotective theory, pointing out that 70 per cent of corals have fluorescent varieties. As a world authority in coral fluorescence, he states quite simply that fluorescence is magic.

## UNSPOILED COASTLINE

The flawless nature of the reefs in Eritrea is partly a result of the war with Ethiopia, which began in 1963 and culminated with Eritrea becoming independent in 1993. Very few people have chosen to live along the coastline, so mankind has little impact on the reefs. Even today, with a population of only 4 million, there are few settlements along the coast and only a small fishing industry.

There are few tourists, which is why the marine ecosystems in this part of the Red Sea have done so well. (In stark contrast, coral reefs at Eilat in the northern Red Sea are among the most heavily used in the world for recreational diving, with more than 250,000 dives per year on only 7½ miles of coastline, resulting in damage to the majority of stony coral colonies.)

The all but untouched environment of the southern Red Sea is home to an astonishing diversity of marine life.

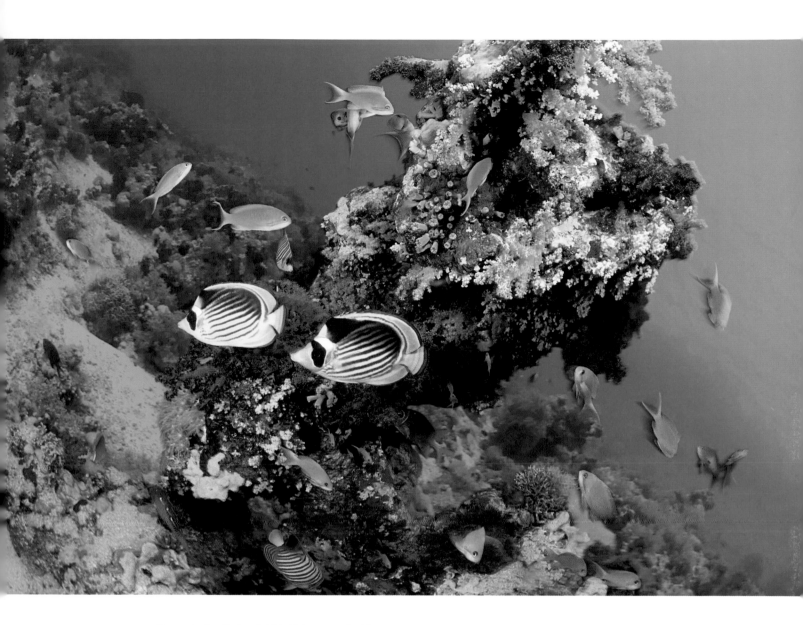

One-sixth of the 1400 fish recorded here are endemic, including butterfly fish, parrot fish, the Red Sea anemone fish and the surgeonfish, and the deep-sea moray eel.

This unusually high percentage might be due to the isolation of the Red Sea from the rest of the world's oceans, caused by the narrow gap at Bab el Mandeb where the Red Sea meets the Indian Ocean. At approximately 120 metres depth there is a sill, which would have acted as a barrier when the sea level dropped. This may have caused genetic segregations of populations in the Red Sea resulting in new species evolving which would only be found here.

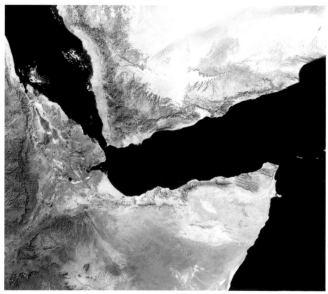

The sill at Bab el Mandeb, which means 'gate of tears', may also account for the unusually high levels of biodiversity found here. This is because it acts as a 'larval trap'. Huge volumes of larvae are carried into the Red Sea from the Arabian Sea by prevailing winds. Once inside, the larvae are trapped by the sill, allowing the build-up of a huge variety of different fish species.

With the day's dives over, the team sits in the balmy stillness of the night and shares hot local bread baked in the traditional way – buried in the sand on a bed of hot charcoal. The flickering embers glow in the perfect blackness and the inky sea laps rhythmically on the shore. Diving in these textbook ecosystems is a rare and remarkable privilege – a chance to witness one of our oceans' few remaining wildernesses.

## VICTIM OF WAR

Tomorrow we head north for Sudan, a two-day sail. The sea here is still relatively unvisited and again we will have to obtain special clearance, this time from Sudanese security, to continue our expedition.

As we set off the seasonal winds speed our progress. The Red Sea has always been an important trade corridor, with ships carrying slaves, spices and – during the time of Hannibal – even elephants. More recently it had strategic value during the Second World War. On a reef just outside Port Sudan a relic of the war sits on the ocean floor. She's the finest wreck in the Red Sea and she was sunk not by misfortune but because her captain scuttled her. But it's not the 150-metre Italian cargo ship that's of interest to the *Oceans* team – we are more interested in its top-secret cargo. The team members plan to dive the vast wreck, one of the most popular on the dive map, to discover for themselves what made the captain sink his own ship.

... we are more interested in its top-secret cargo.

In 1940, though Great Britain was at war with Germany, Italy remained neutral despite rumours of an alliance between Italian leader Mussolini and Hitler. However, for a country that had not yet taken sides, one of its ships, the *Umbria,* was behaving strangely. She made various stops along the Italian coast at ports such as Naples and Messina to collect 'supplies' before heading through the Mediterranean to the Suez Canal to reach Eritrea, an Italian colony.

*Umbria* was built in Germany in 1911 in the lead-up to the First World War. She was a vast steamship with five cargo holds and three decks, and weighed over 10,000 tonnes. She was capable of carrying 2000 passengers but on this trip there was only crew aboard.

By the time *Umbria* reached Egypt, the British destroyer HMS *Grimsby* was put on shadowing duty and tailed her to Sudan. Italian Captain Lorenzo Muiesan telegraphed ahead to Massawa declaring, 'There is a ship on my tail, be prepared'.

She arrived in Port Sudan on 6 June, just as word came through that the Italians had joined the war. Britain and Italy were now enemies. The British, who operated the Suez Canal, were on board the *Umbria* but, rather than let his precious cargo fall into Allied hands, the captain called an emergency lifeboat drill. With the crew safely off the ship he flooded the holds and she keeled over. She now lies just below the waves in what's become one of the most acclaimed wrecks in the world for divers.

As the *Oceans* team penetrated deep inside its structure, they started to understand what life at sea must have been like. Bread ovens in one of the holds were used to make fresh ciabatta and hundreds of wine bottles still littered the floor. Further along, in a second hold, three Fiat Lunga cars remained in remarkably good condition.

Deeper exploration into the last hold finally revealed the cargo that the *Umbria* had picked up on her journey: 5510 tonnes of explosives, 360,000

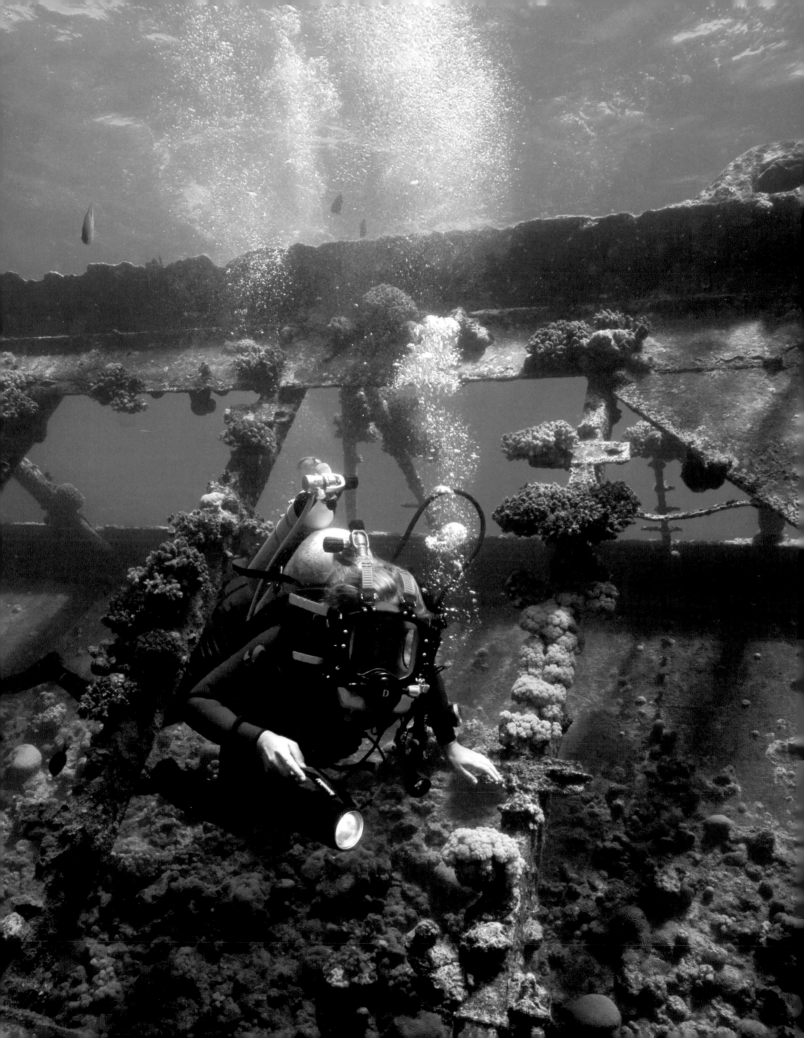

aircraft bombs, 3056 crates of fuses, 17,539 crates of ammunition and 624 crates of detonators. The bombs were a daunting sight, row upon row of unexploded firepower. If they went off half of Port Sudan would be destroyed. It is clear why the captain had gone to such lengths to prevent this substantial arsenal falling into enemy hands.

## RELICS OF A PIONEER

We're now leaving, heading from Port Sudan into the more remote waters of this stretch of the Red Sea, to a spot off the coast of Sha'ab Rumi, meaning 'Roman reef' in Arabic. The team's next challenge awaits on this secluded reef plateau off the coast of Sudan. It is the remains of an underwater village, named Conshelf II (Continental Shelf Station), which undersea explorer Jacques Cousteau built in 1963 to prove that humans could live under water for long periods. This was before mankind had fully explored space, and was at the cutting edge of underwater technology.

The village consisted of living quarters, a laboratory and a garage. The main living module was a large pod with radiating arms called, appropriately, Starfish House. It was an air-conditioned central base that contained sleeping quarters for eight people, a kitchen, dining room, laboratory and darkroom. The air they breathed was from a number of sources, including surface-supplied compressed air and scuba cylinders filled with air and mixed gas. Nearby was a tool house to store tools and underwater scooters.

Life inside in the underwater village was not as uncomfortable as you might imagine. The 'oceanauts', as they were called, were allowed to smoke in Starfish House; they had their own chef and even washed their meals down with champagne. Underwater pressure meant it lost its fizz, but never mind. They even had a visiting hairdresser. Interestingly, hair growth slowed dramatically, while their doctor noted that cuts and bruises seemed to heal more swiftly under pressure. As the oceanauts relaxed in their water-cooled and air-conditioned underwater environment, life topside in the support vessels became almost unbearable as temperatures soared and humidity reached 100 per cent. Living conditions were also pretty tough in a deep cabin that housed two divers separately from the rest of the team, at 30 metres, for a week. They complained of 'perspiring like fountains'.

The 'oceanauts'… even washed their meals down with champagne.

Still, the boundaries of knowledge about our planet's underwater world were pushed back. First and foremost, Conshelf II was an experiment in living under water. The main scientific endeavour was investigating the effects

of prolonged 'saturation diving' on the participants. During a long dive at a fixed depth a diver's tissues will become fully saturated with nitrogen. By maintaining pressure inside a diving structure, like Starfish House, that is equivalent to the pressure of the surrounding water, divers could have free access to the outside water. Only one decompression stop was required on returning to the surface, where divers stayed at a shallower depth for a time to remove the nitrogen that built up in their bloodstream. Saturation diving is still used by oil and mineral companies today.

But Cousteau and company's first love was marine life and on this remote reef the life was, and still is, extraordinary. Angel-, damsel- and

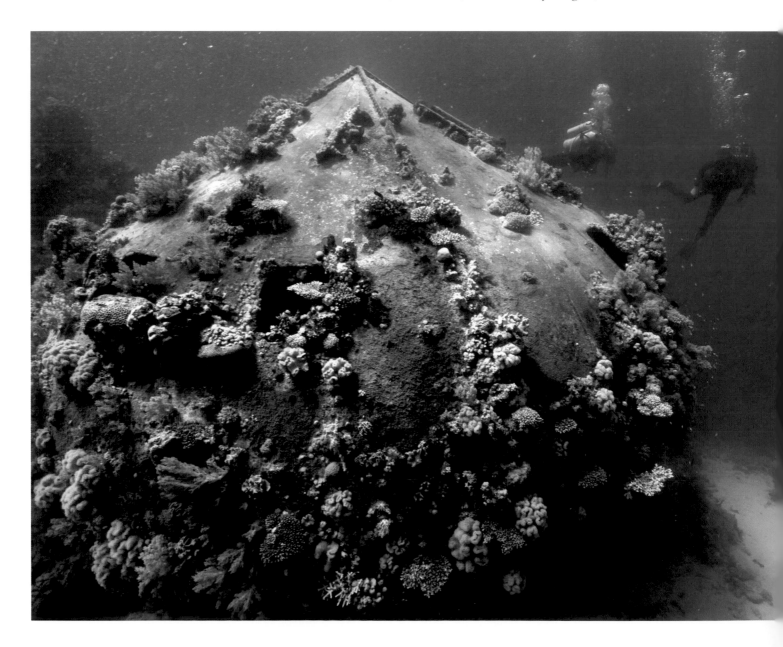

clownfish play in the reef. Rusty parrotfish and giant pufferfish swim by, and over 30 species of grouper including coral and greasy hide in the rocky crevices. Larger fish are common, among them checkerboard wrasse and goatfish, along with shoals of barracuda and silent, gliding, blue spotted rays.

Professor Raymond Vaissiere, the resident marine biologist on Conshelf II, collected fish in transparent plastic traps using bait. They were taken to the wet shed for inspection and sorting and were studied with the various dissecting microscopes he had in the laboratory. Exotic species were also selected for the Oceanographic Museum in Monaco. To see what reaction, if any, fish had towards colour the oceanauts carried flood lamps with variously shaded filters. Portable remote cameras dotted around the underwater village could be moved by the biologists to focus on the behaviour of particularly interesting marine animals. In this way some new species were discovered.

Today, the wet shed, tool shed and Starfish House itself have gone and all that remains of this quixotic experiment is a huge onion-shaped garage, which held the submersible vehicle that Jacques Cousteau and his oceanauts used to explore the surrounding reef. Nicknamed the 'Urchin' on account of its similarity to the marine creature, it was positioned at the edge of the reef so that the space between two of its legs faced the drop-off. In this way, the manned submersible, which Cousteau likened to a saucer, could fall away from the hangar to explore the ocean deep.

Philippe Cousteau, the grandson of Jacques, was part of our team. Although his family spent many years diving here in the Red Sea, Philippe had never been to Conshelf II before. As he descended to explore what remains of the underwater village it became a deeply personal mission. And Philippe was not alone in feeling high emotion during this part of the expedition. It was a poignant moment as he swam through the circular hatch, which once clamped the saucer in place, and up into the garage itself. Touching the rusting metal walls he experienced sensations his grandfather experienced nearly half a century ago. The floor of the garage is made of iron bars and light comes from windows that look out on to the reef.

The Urchin was sited next to Starfish House. The two buildings were near enough to each other for Jacques Cousteau and his team to take a breath and swim between the two.

OPPOSITE *All that remains of Jacques Cousteau's Continental Shelf Station (Conshelf II) is the remains of the onion-shaped Urchin, which housed the submersible in which the oceanauts explored the surrounding reef.*

ABOVE *Philippe Cousteau, grandson of the pioneering Jacques Cousteau, joined the Oceans dive team to explore the remains of this pioneering experiment in living under water.*

# Visiting the First Underwater 'Hotel'

**In 1963 my two life's heroes were in their prime**. Mike Nelson was saving downed jet pilots, wrestling with sea monsters and recovering ditched nuclear warheads in *Sea Hunt*, the TV series. Meanwhile, Jacques Cousteau had invented SCUBA diving, written *The Silent World*, was exploring the world's seas on the ultimate diving expedition on *Calypso* and was living under water with his team of 'oceanauts'. I had just failed my eleven-plus exams, hated school, loved the sea and knew nothing. Except that I wanted to be a diver.

Now, as our expedition ship sailed through the channel that Jacques Cousteau had blasted with dynamite to enter west Sha'ab Rumi and establish Conshelf II, I was overcome with emotion. This was a pilgrimage to see the work of an icon of a generation.

I made my way down to the Urchin. After 45 years on the bottom it is now home to a fabulous collection of marine life, but in my eyes it was just fizzing with the Jacques Cousteau legacy. I had only one thing in mind and that was to get inside it, take my regulator out of my mouth and enjoy being, for a very brief moment, my own version of a Cousteau oceanaut. The air trapped inside the Urchin is not fit for breathing, as it is contaminated with the toxic algae that grow on the insides of the structure. But I'd waited 45 years for this and enjoyed tasting that foul air.

At the time Conshelf II was created diving was almost entirely a military activity. Very few people were diving for recreation as the technology was still in its infancy. Jacques Cousteau wanted to prove that we could live and work under water for extended periods.

His experiment started in 1962 with Conshelf I, positioned in 10 metres of water off Marseilles. Two of Cousteau's team, Albert Falco and Claude Wesley, spent seven days in the unit. They were among the first to test a helium/oxygen mix breathing gas, and spent at least five hours a day working outside.

Conshelf II raised the stakes significantly. Five divers were planning to spend a month at the main habitat in 10 metres of water with another two divers living and working at 30 metres depth for a week.

There is a massive legacy from Jacques Cousteau's visionary work at Conshelf II which includes our understanding of diving physiology, saturation diving, the benefits of long-term ocean studies and the fact that it was an inspiration for countless budding marine scientists and divers. But one of the most tangible legacies is that today people are able to book into any number of underwater hotels – there are plenty out there and more are being built. If you do book into one it's worth giving a thought to those early heroes. I certainly did as I completed my pilgrimage and left the toxic air in the Urchin to explore the fabulously beautiful Sha'ab Rumi Reef.

**BELOW** *With Philippe Cousteau, my hero's grandson, during the dive to discover the remains of Conshelf II.*

Conshelf II was a defining effort in the study of diving physiology and so is Aquarius, an underwater laboratory off the coast of Florida funded by the US National Oceanographic and Atmospheric Administration. By employing the principles of saturation diving, it enables scientists to spend days studying marine life while minimizing the risks of decompression sickness. NASA also used its facilities to train astronauts to work under conditions of high atmospheric pressure.

Most of the buildings of Conshelf II may have gone, but the marine life that drew Jacques Cousteau to this sea is still rich and abundant. Here in the southern Red Sea, with little fishing or tourism, we are in an unspoiled ecosystem and have a chance to locate species that are threatened or endangered elsewhere. It's a rare opportunity. Scientists know little of what animals are present in many areas of the Red Sea because of the difficulty of getting access to this part of the world.

> … the marine life that drew Jacques Cousteau to this sea is still rich and abundant.

## SHARK HUNT

For the expedition, the species that were the focus of most concern were sharks. All over the world shark numbers have been decimated due to the commercial demand for fins. And we already knew that one of the hardest hit was the scalloped hammerhead shark. This curious-looking shark with its head flattened to form a wide 'hammer' will be listed on the 2008 IUCN 'red list' as globally endangered. These sharks used to swim in huge numbers but now it is rare to find groups. Just to spot them at all is a wonderful privilege with every sighting adding important information about their fate.

> All over the world shark numbers have been decimated due to the commercial demand for fins.

To find them, or any sharks, requires patience and a long spell under water, so the team decided to use re-breathers in place of normal scuba equipment to give themselves the maximum amount of time under water.

Hammerheads generally cruise at huge depths, more than 200 metres looking for food, but it seems that the highly sensitive electroreceptors on their hammer-shaped noses can also pick up minute changes in water temperature that would be indecipherable to humans. The theory is that hammerheads use haloclines, where hot and cold bodies of water meet, as a reference point for changing temperatures. The *Oceans* team planned to wait at these haloclines in the hope of spotting the sharks.

RIGHT *A sailfish, with its huge dorsal fin lifted to scare off predators.*

BELOW *Silky sharks are so-named because of their smooth skin. They normally grow to about 2.5 metres in length and are solitary in nature. They are often found on coral reefs like this one with a deep drop-off.*

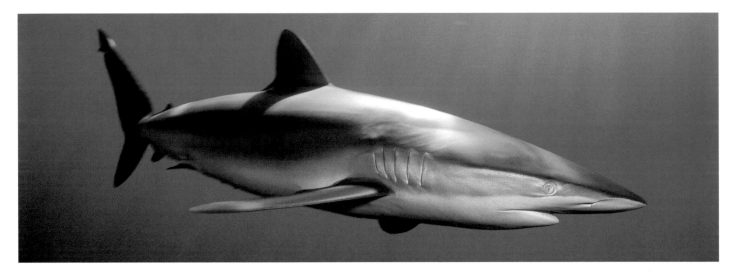

At a metre long, the sailfish is the fastest fish in the ocean.

The team carried out a series of dives and during them were lucky enough to spot a number of rare species. A sailfish shadowed one of our divers. At a metre long, the sailfish is the fastest fish in the ocean with a huge dorsal fin which inspired its name. When the sail is lifted up in order to scare off predators, the sailfish is a majestic sight. A silky shark also swam by. Sporadically menacing, these sharks are solitary by nature and have been named for the sheen and smoothness of their skin. A number of reef sharks surrounded another diver. But, although the view of the divers was largely obscured by a multitude of fish, no hammerheads were in sight.

It was only in the last minutes of the final dive before the end of the expedition that they finally saw hammerheads. And what a sight they were. A huge school of around 30 was swimming rapidly in the distance. Hammerheads are highly efficient swimmers, using the hammer-shaped head as an

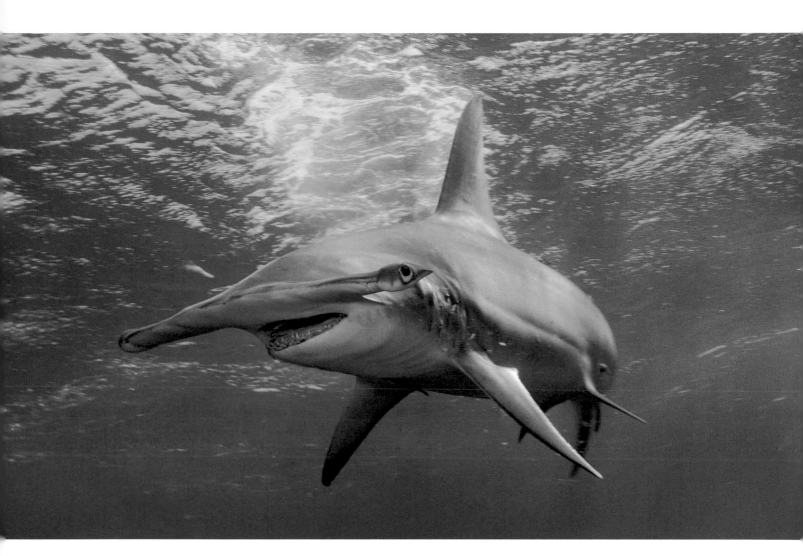

aerofoil. In cross-section the hammer is similar to the shape of an aeroplane wing, with a flattened lower surface and a rounded upper surface, making the shark more hydrodynamic. This shape may also produce lift, enabling them to pursue prey while following their every move. The divers relished the spectacle before the sharks peeled off into the deep.

To see such a large school is a remarkably positive sign. It means that in this area at least there are viable and healthy populations, when in other places all over the globe numbers are declining and the species is threatened. And, as we come to the end of our time here, we realize that this is what the Red Sea has given us: a sign of hope for the oceans of the world. Its coral shows that the vital rainforests of the sea can adapt to warmer waters, and the vibrancy of its ecosystems shows that the oceans can harbour abundant, diverse extraordinary life. Our oceans are fragile, but here at least there are signs that they can, and will, survive.

**ABOVE** *Though they had to wait, the team were finally rewarded with a display of superb swimming by a number of hammerhead sharks. Endangered in a number of the world's oceans, the school witnessed in the Red Sea is regarded as a sign of hope for the survival of this fascinating species.*

CHAPTER SIX

# THE SOUTHERN OCEAN
Small Sea, Big Water

RIGHT *This satellite view of the earth shows the Southern Ocean as it swirls around the South Pole unencumbered by any land mass and building up its massive power.*

OPPOSITE *In the bays and inlets around Tasmania the seas are often gentle and blue, out to sea the waters can be huge with waves sometimes up to 30 metres high.*

PREVIOUS PAGE *The Southern Ocean is home to the world's largest current. On arrival in Tasmania, adverse weather conditions served as a reminder to the team of the sea's notorious reputation for the violence of its waters.*

THE WEATHER FORECAST from the Tasmanian Bureau of Meteorology said it all: 'Clockwise wind about low 20/30 knots, increasing 30/45 knots in gale area and 45/60 knots in storm area. Moderate/rough seas increasing very rough to high in gale/storm areas. Heavy swell. Rain and local thunderstorms with visibility reduced to 1 nautical mile.'

The *Oceans* expedition has arrived in the Southern Ocean – a circular stretch of water, lying between Australia and the Antarctic and notorious for the violence of its seas. With the South Pole at its centre, this ocean sweeps right round the world uninterrupted by any land mass. With no land to slow them down, powerful westerly winds drive unchecked across the sea. These are the infamous roaring forties, a notoriously dangerous zone around 40° latitude that has plunged over a thousand ships to its depths. The seas here are big; there's talk of waves as high as 30 metres rearing out of the sea.

At the moment we are still in harbour on the east coast of Tasmania, and our boat, the *Odalisque,* is gently bobbing in the bay; but out to sea the waters are churning in a frenzy and the howling wind makes conversation impossible. It is clear that we are going to have to delay our exploration of this remarkable sea.

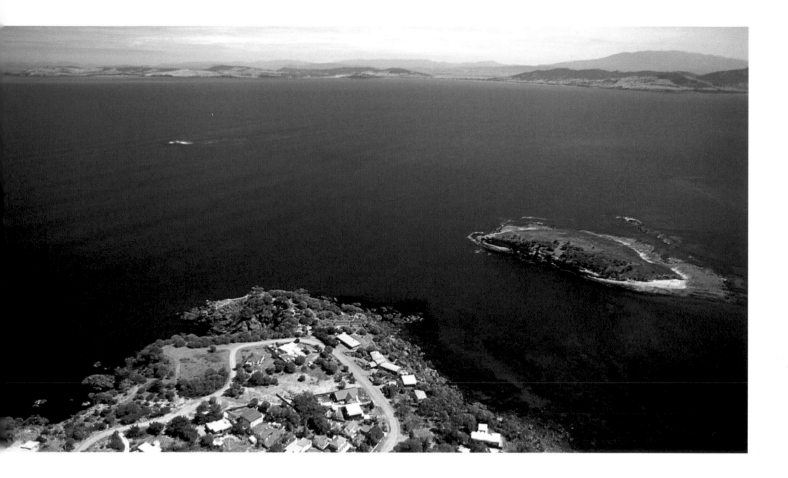

## PUNCHING ABOVE ITS WEIGHT

The Southern Ocean covers nearly 8 million square miles and is the second smallest of all our oceans. Only its opposite number, the Arctic Ocean, is smaller. But what it lacks in size it makes up for in significance. This ocean carries the world's largest current, the Antarctic circumpolar current; 13,000 miles in length, transporting 130 million cubic metres of water per second – that's a hundred times the flow of all the world's rivers combined. This vast current moves nutrients and heat around the globe and has a powerful influence on the world's climate. While not large itself, the Southern Ocean links all three of our biggest oceans: the Pacific, the Atlantic and the Indian oceans, acting as a vital crossroads of the major water masses of the world. But perhaps most importantly, the Southern Ocean currently plays a critical role in moderating climate change.

… the Southern Ocean currently plays a critical role in moderating climate change.

The cold waters here provide rich nutrients for huge numbers of plankton and algae, which absorb carbon dioxide. The Southern Ocean is the biggest carbon sink in the world, absorbing as much as 8 per cent of the global carbon dioxide emissions from human activity. However, this sea also offers a stark warning. Parts of the ocean here are warming up over two and a half times faster than anywhere else on the planet, and the impact is far-reaching.

This is a sea of wild and rugged beauty, astonishing seascapes and extraordinary creatures. It's a remote and unfamiliar sea and, as the team waited for the weather to clear, there was a sense that this, of all the expeditions, would be the most challenging – but perhaps also the most rewarding. Astonishingly within an hour the sea was flat calm. The wind dropped and the air took on the pellucid clarity that is characteristic of the aftermath of the most intense storms. Moments later the expedition was under way as we set off to reach our first target.

## RAINFORESTS OF THE SEA

The *Oceans* team is headed for Tasmania's south-eastern coast, north of the colourfully named Pirates Bay, to investigate one of this region's most iconic marine giants. Giant kelp is a brown seaweed. But it's no ordinary seaweed. This is the monster of all seaweeds. Kelp is the largest marine plant in the world, producing 'towers' of fronds that stretch 30 metres to the surface. The largest kelp plant ever recorded reached a staggering 65 metres – that's taller than Nelson's Column in London. They're also the fastest-growing marine plants, climbing 30–60 centimetres vertically every day. An entire forest can spring up in a week. Each plant has a holdfast that attaches to the rocky sea floor, and a long, slender stalk, or stipe, from which grow long leaf-like blades called fronds. And on each frond are the gas-filled bladders, or pneumatocysts, that keep the giant plant buoyant and upright in the sea.

> The largest kelp plant ever recorded reached a staggering 65 metres.

These majestic plants grow in vast 'forests' under water and, like forests on land, the dense canopy of fronds forms a system of micro environments, with a sunny canopy region, a partially shaded middle section and a darkened sea floor. Each 'level' of the kelp forest shelters different marine life. These are, in a way, the rainforests of the sea – one of the most biologically productive habitats in the marine environment.

The unique ecosystem provides a home for many elusive and enigmatic animals. The pot-belly sea horse and big-belly sea horse both live here as do larger fish like the golden weedfish and the crested weedfish. Some animals,

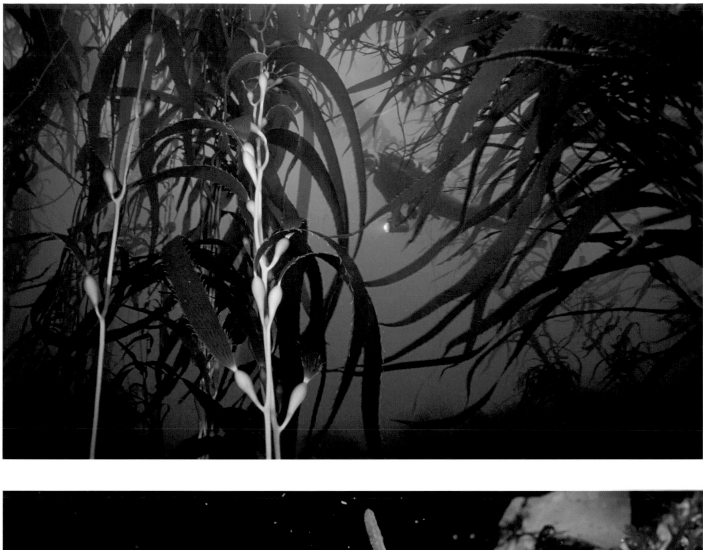

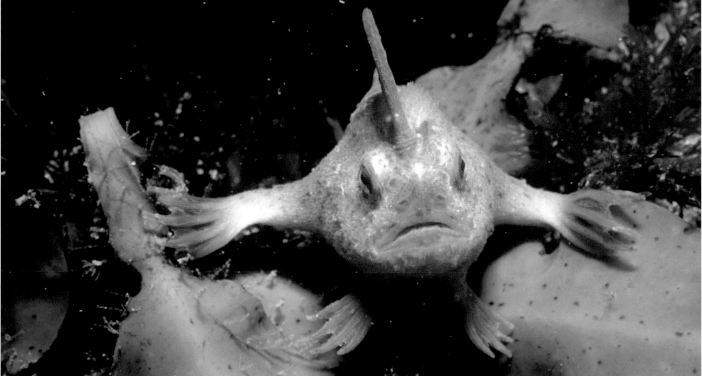

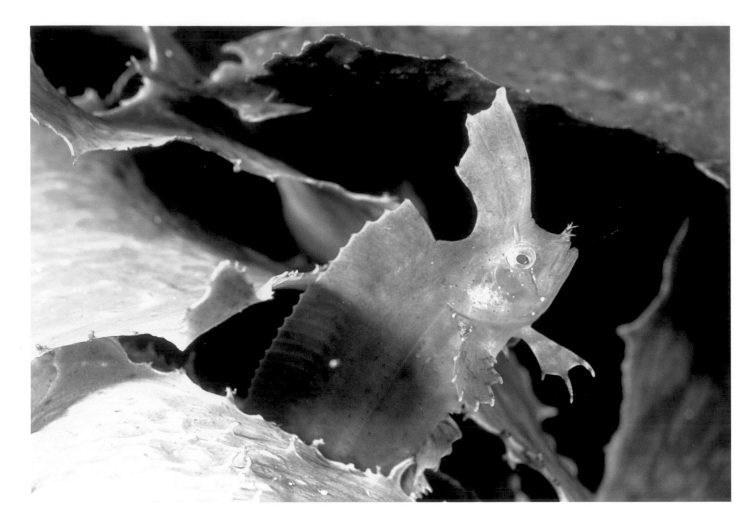

like the poisonous, spiky, cowfish are found nowhere else in the world. This is where the smallest octopus in the world lives, the pygmy octopus, which measures just 3 centimetres across. Rock lobster and abalone, and, perhaps most enigmatic of all, the tiny, red and yellow, spotted and fringed weedy sea dragon, depend on the kelp forests.

The expedition is here to investigate the current state of the kelp. The first survey is by helicopter. The team is armed with a map of what are traditionally the best kelp areas but from the air, the news is not good. There is no sign of lush mats of kelp or dense forests. In many places there is nothing at all and in others there are just sparse scattered clumps of kelp.

Giant kelp is a typical cold-water species and occurs in shallow coastal regions with cold, nutrient-rich waters. Sea currents are essential to allow fresh nutrients to be delivered across the kelp fronds, and a rocky sea floor is needed to provide a secure attachment for the holdfast. Tasmania's cold clean waters and rocky coastline therefore provide the perfect habitat.

Or at least they did. Over the last ten years the sea temperature here has risen by 1.5°C – faster than any other sea in the world – and now the *minimum* temperature of the water off the east coast of Tasmania is 11.5°C, with the average much higher. For kelp, which thrives in 6–14°C, these

temperatures are not ideal. And as a result, over the last ten years there's been a dramatic decline. Just 40 years ago the waters all along the coast were thronged with lush kelp forests, stretching over 124 miles and easily visible from the air as the fronds reached up to cover large areas of the sea surface. Now the kelp has all but vanished from many regions.

The helicopter flies over Fortescue Bay on the east coast of the island, which used to be one of the richest areas of kelp forest. There were tales of kelp so dense that people could walk from one side of the extensive bay to another across seaweed mats. Now there are just a few straggly plants.

Under water the picture is even more depressing. The kelp plants, once so majestic, are spindly and instead of the lush canopy of fronds the divers find a straggly covering of leaf-like blades. The problem is easy to identify. Measurement of the sea temperature shows it is 14°C; at that temperature kelp struggles to survive. But on the sea floor round the foot of the kelp the divers discover another problem. Sea urchins. These long-spined creatures are voracious and aggressive grazers on kelp, feeding relentlessly until the plants are wiped out. Normally sea urchins inhabit the warmer waters further north and don't thrive in Tasmania's cold temperatures, but as the waters here warm up, the urchins are invading. It's a double whammy. Now nearly half

the total kelp here has disappeared, and in some areas over 95 per cent has vanished. It's daunting to think that a warming of just 1.5°C has led to this devastation.

And recently overfishing has made the situation even worse. Rock lobsters are the only natural predators of the urchins, and many of these have been removed by intensive fishing. As a result, the number of sea urchins has exploded. With no predators, the urchins rampage unchecked, stripping vast areas of kelp. Along the coast, especially the northern areas, sea urchins have removed all the kelp – leading to vast areas of 'urchin barrens'. Already some species of fish that depend on the kelp are vanishing, among them the red handfish – a curious fish that 'walks' on its fins – and the magpie perch.

As the divers retreat to the surface they are dismayed by the wholesale destruction of this unique habitat, and the threat it brings to the many creatures that depend on it for their own survival.

## DRAGONS DEN

The weedy sea dragon is an almost mythical creature, related to the sea horse, which is found only in the kelp forests of the Southern Ocean. It is rare and elusive, its bizarre frond-like projections making it perfectly adapted to the seaweed in which it hides. And despite several dives into the kelp the divers had failed to get even a single glimpse of these quaint creatures. None of them had ever seen a sea dragon, and, given the state of the kelp, this could be the last chance ever to find one. It was nearly dusk, but time for just one last dive.

The weedy sea dragon is a very slow-moving animal, so it depends for its survival on camouflage. With its straggly shape and long frond-like appendages it is identical to the kelp. It hovers, perfectly still, deep inside the fronds of the kelp, virtually invisible. For a moment finding one seems an almost laughable quest: like searching for a four-leafed clover in a vast meadow. But

Each sea dragon has a unique face with its own distinctive pattern of spots.

then a tiny movement, just the merest flicker of an eye, and there it is – a weedy sea dragon. It is an incredible sight: gloriously, riotously coloured, red and yellow with hints of blue along its ribbed back. It drifts effortlessly through the water, the tiny movement of its fin barely perceptible.

Each sea dragon has a unique face with its own distinctive pattern of spots. Sea dragons are related to the sea horse but, unlike them, they do not have a pouch for rearing their young. Instead, the males carry the eggs fixed to the underside of their tails until they hatch. They feed on tiny crustaceans and other zooplankton

which they suck into the end of their long tube-like snouts. Watching the sea dragon is magical, and the divers stay until it finally drifts off into the seaweed.

The weedy sea dragon is just one of the many species that depend on the kelp ecosystem to survive. It's a curious irony that, while most of us are aware of the threat of losing the rainforests on land, across the world few people care, or even know, of the destruction of this vital ecosystem in our seas.

## PLANE TRUTH

There's a mystery to be solved here. Why are parts of this ocean warming up faster than the other oceans of the world? Estimates suggest that globally sea temperatures have risen by an average of 0.6°C. Here the rise is 1.5°C. The expedition is teaming up with scientists Dr Ken Ridgway, Simon Allen and Lindsay MacDonald from CSIRO Marine and Atmospheric Research to help with an experiment.

They've brought a glider. But this glider is designed for the sea, not the air. It's an underwater remote temperature sensor, fitted with GPS, a motor and wings. It is capable of adjusting its buoyancy to sink to depths of 200 metres before gliding back along pre-programmed trajectories collecting data as it goes and relaying it back to the research team by satellite. The team's task is to set it off on its first 'test flight'. As recently as 1998, scientists identified a powerful warm water current, the Eastern Australia current. As its name suggests, this current flows around eastern Australia and the northern reaches of Tasmania, but there are now indications that it's on the move. The aim of the glider research is to track this movement.

Previous research, measuring the current at different points suggests that the warm waters are being driven further south – a warm 'tongue' reaching right into the Southern Ocean along the coast of Tasmania. It's this change of the current's direction that is causing the waters here to heat so quickly. The shift of the current seems to be the result of stronger South Pacific winds that are driving it further south. At first sight, therefore, the warming appears to have little to do with climate change. But some scientists suggest that ocean winds may have become stronger as a result of both higher concentrations of greenhouse gases in the atmosphere and long-term ozone depletion in the stratosphere.

> The warming waters here are the result of ... human activity releasing greenhouse gases ...

The warming waters here are the result of a complex chain of events that starts with human activity releasing greenhouse gases, which leads to increased winds, to the shift of a critical current, to the decimation of a habitat and, eventually to the potential loss of the fascinating weedy sea dragon and many other species.

## RECOVERING SEAL POPULATION

Faced with the bleak outlook for the kelp and its linked ecosystems, it is hard to feel optimistic. However, there are signs of a brighter future, at least for some creatures. As the *Odalisque* makes for our next destination, ploughing through the seas, the team is surprised by a huge colony of Australian fur seals. The first encounter is aural – the sound of their coarse and deafening barking. But as the boat rounds the cove, there they are – a vast throng of noisy, busy, energetic seals, clambering all over the rocks, and diving and splashing in the sea. The Australian fur seal is the fourth rarest seal in the world. It was hunted to the brink of extinction in the last century, and the recovery of the population has been slow. So it is an exceptional delight to see such a thriving large colony.

OPPOSITE *Hunted to the brink of extinction in the last century, the population of Australian fur seals in the Southern Ocean is recovering.*

RIGHT *Perhaps the most encouraging sight for the team was the number of pups and young fur seals they found in the colony. It was a sure sign of the health of this community.*

Over ten days these seals can cover 310 miles in their hunt for food.

They are vast, magnificent animals. Males grow to 2.25 metres long and weigh a colossal 790 pounds. These are the largest fur seals in the world. The divers waste no time in getting kitted up to see them under water. Fur seals, like their cousins the sea lions, are reasonably nimble on land, as they can rotate their front flippers to 'walk' on the rocks, but under water they are extraordinarily agile. They twist and turn, flashing past and around the divers with consummate ease.

The spectacle is breathtaking; every movement of the seals releases a stream of bubbles from air trapped in the layers of fur that keep them warm. Their dense coats are made of woolly underfur and long, coarse outer hairs, which waterproof and insulate them. They are extremely fast swimmers, using their powerful front flippers to speed them through the water. Over ten days these seals can cover 310 miles in their hunt for food.

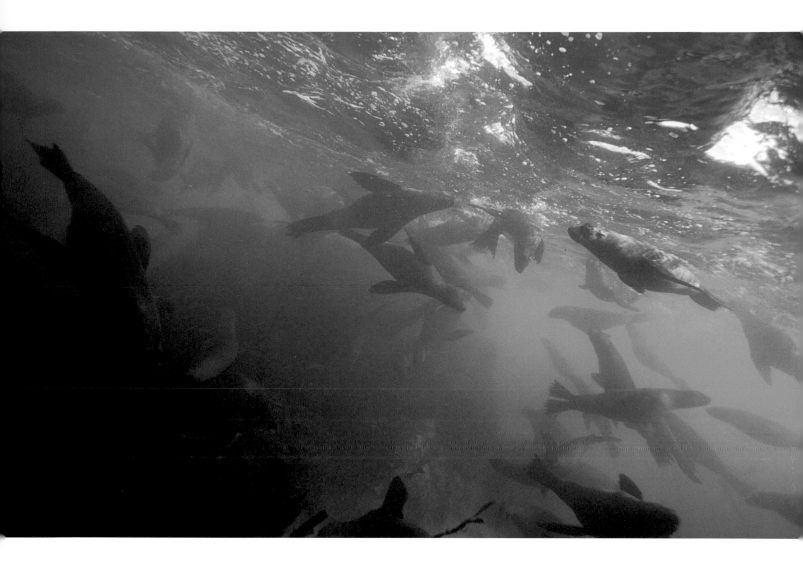

They eat mainly fish and cephalopods (squid, octopus and cuttlefish), and can dive up to 50 times a night to depths of over 100 metres.

A particularly positive sign here is the number of pups and young fur seals in the colony. Females give birth to only one pup at a time, and often fewer than half the pups will survive, so to see the vitality and health of this community is hugely encouraging. Australian fur seals are now wholly protected and their conservation got a welcome boost from an unlikely source. In 1926, a Hobart-born woman, Pauline Curran, married Prince Maximilian Melikoff of the exiled Russian royal family. When she died in 1988, she bequeathed a generous trust to help save the seals and dolphins in this area and today most Tasmanian seal and cetacean research is funded by her legacy.

The divers smile at each other as they watch the active, playful, thriving seals, each one blissfully unaware that it owes its life to a Tasmanian-Russian princess.

ABOVE *Although they are reasonably nimble on land, the seals are incredible swimmers – performing twists, turns and dives at speed for the dive team.*

OVELEAF *The Tasman peninsula is made of dolerite – rock so hard that it was used to make the pyramids. The rocks here are actually giant magma crystals, but are similar to the basalt columns of the Giant's Causeway in Ireland.*

## BIRTH OF AN OCEAN

Having seen a glimpse of the future of this ocean, the expedition's next objective is to travel into its past. The *Odalisque* sets sail along the Tasman Peninsula. The team is planning to investigate the birth of the Southern Ocean itself. Part of this extraordinary story lies deep inside sea caves that drill into the foot of massive rocky cliffs. As the boat passes by, these cliffs and rock-stacks along the shoreline tower 300 metres above it with unusual rock formations. Huge hexagonal columns of basalt rock jut out from the water – very similar in structure to the Giant's Causeway off the coast of Ireland. The huge columns are actually giant magma crystals known as dolerite. Tasmania has the largest and most extensive dolerite formations anywhere in the world.

Waterfall Bay is a relatively small bay about 2½ miles south of Eaglehawk Neck. Below sea level this coast is marked by a series of submarine caves. And in these lies evidence of how the Southern Ocean was formed. About 300

million years ago, tectonic activity lifted up the eastern side of the peninsula. As it did so, it trapped sea creatures, which were then fossilized in the rocks. Now those fossils are deep under the sea, in the labyrinth of sea caves under the cliffs.

The fossils here are a diverse range of ancient sea creatures including brachiopods, bryozoans (coral-like colonies), bivalves like molluscs, and gastropods. The ones the *Oceans* team is interested in are the brachiopods, small two-shelled marine creatures that resemble modern-day clams though they are not closely related. These brachiopods are a time capsule. They date from around 300 million years ago during the Devonian period and survived right up to the beginning of the Jurassic period around 160 million years ago. Throughout this time they went through distinct and rapid evolution creating a series of specific forms of brachiopod, which can be precisely dated. This makes them an ideal index fossil for dating specific geological formations.

When one of the fossil rocks that the divers brought up from a sea cave was broken open, something rather remarkable emerged: a brachiopod fossil, very specifically linked to one point in geological time and, surprisingly, exactly the same as brachiopods found in the Antarctic – over 1,860 miles away. It's crucial evidence that at one time Tasmania and the Antarctic were

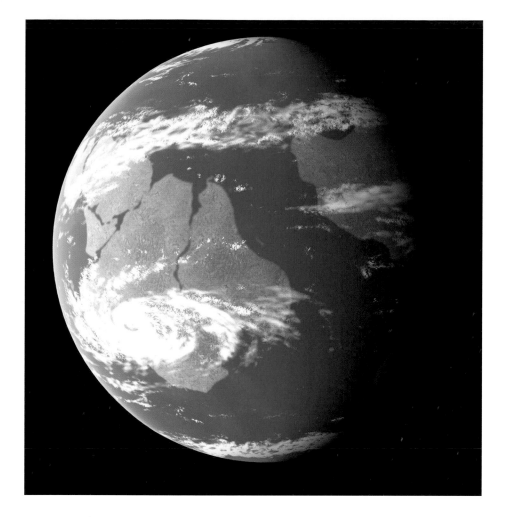

LEFT *This image shows the giant land mass, Gondwana, which was made up of what would become Africa, Antarctica, Australia, India, New Zealand and South America. The eventual break up of the land mass resulted in the formation of the Southern Ocean.*

OPPOSITE *The brachiopod fossils found at Waterfall Bay in Tasmania, are exactly the same as some found in the Antarctic some 3000 miles away. This is crucial evidence in showing that at one time Tasmania and the Antarctic were linked together as one land mass.*

linked together as one land mass and that the Southern Ocean had yet to exist at all. This fossil is a moment from ancient history, when one vast continent, Gondwana, dominated the southern hemisphere. This huge piece of land, which included the land masses that would become Africa, Antarctica, India and South America, was gradually broken apart by massive geological forces. The land masses went their separate ways, with New Zealand breaking away 80 million years ago and Australia splitting from Antarctica about 45 million years ago. Tasmania was the last land mass to separate from Antarctica, and the Southern Ocean was formed.

As Tasmania drifted away, it left one single, uninterrupted sea circling the entire globe. The Antarctic circumpolar current evolved, and the Southern Ocean became the only place in the world with a fully circular current. This vast current deflected warm waters away from Antarctica, which gradually became iced over forming the southern polar ice cap.

And in our hands, on the grubby dive deck of the *Odalisque*, we are holding tiny fossils that tell that epic story.

This fossil is a moment from ancient history, when one vast continent, Gondwana, dominated the southern hemisphere.

# Diving into History

**It seemed incredible** that I could get close to the Antarctic and begin to truly understand the birth of the Southern Ocean and the emergence of all its marine life by diving sea caves under the Tasman Peninsula. But our research notes showed us that the key was to find some particular rocks on a cave floor. Easy, until you think about how these sea caves evolved. The rock is dolerite, formed by molten magma being squeezed to the surface between continental plates and then cooling rapidly. It's amazingly hard stuff and at the top of Friedrich Moh's rock strength table. The Egyptians used balls of it to cut granite to build the pyramids.

For millions of years the sea has been pounding these cliffs with seemingly little effect. But in a few rare spots it has found a weakness, maybe a tiny fissure where the molten rock formed around a small imperfection. The relentless sea exploited this weakness, first pounding it into a small crack and then into larger holes, until eventually a great, complex cave system was developed. It makes sense but it's still very difficult to believe when you see it.

On the floor of one of these caves were our elusive rocks. The trouble was that the powerful waves and surges that created the caves long ago still exist and make diving dangerous. Local knowledge says you can only dive in these caves when the surge is less than half a metre. There have been spectacular accidents, with experienced divers getting tangled in their safety lines, the surges wrapping them up in a rope cocoon, disorienting them in the foam at the top of the caves and spitting them out dead weeks later.

We had a surge of about 2 metres and had anchored our dive boat about 10 metres from the cliff wall. We rode the swells more or less comfortably, but the waves reflecting back from the cliffs seemed to induce seasickness in almost everyone. An occasional bigger surge seemed to come from nowhere, so I agreed to do a reconnaissance dive to check out the conditions.

It was fine away from the cliffs, but as soon as I got near the sea wall I knew this would not work. I had no control whatsoever. As the current shot me past the entrance it felt as if I was going to be sucked in. And once inside I would have little chance of escape. It was clear we had to wait for the surges to die down. I did not want to move the boat, as our position was perfect. So we hung on. We had a huge stroke of luck after about two hours when the surges began to lose their power and we were able to make a second attempt. Tooni and I descended into the wonderful world of the swaying kelp forests and it was immediately obvious that this time the conditions were workable.

> ... the waves reflecting back from the cliffs seemed to induce seasickness in almost everyone.

**OPPOSITE** *The team's boat* Odalisque *had to be moored some way from the cliffs as a powerful sea and hard rock are not a good combination for ship's timbers.*

**ABOVE** *The waves have been pounding these cliffs for millions of years. In that time the water has found a number of weaknesses, gradually opening them up into cracks, fissures and eventually a huge cave system.*

It was hard to find the entrance to the cave and we lost valuable time making a few wrong turns before finding our way in. As we left the natural light behind us it was fantastic to relax into the dive and enjoy the blue shafts of light coming down through narrow fissures in the rock. The cave's floor was clean – there isn't much for any life to get a grip on, especially when the smooth surfaces are in a constant surge zone. This was good news for us as we could sort through the boulders and hunt for fossils. It was great to find the first one – a beautiful brachiopod on the surface of a hand-sized rock. The trouble with surface fossils like this is that they have spent millions of years being rolled around a cave floor, so their features are rounded off. But we bagged the rock and then collected about 55 pounds of similar-sized rocks in the hope that we could break them open and find virgin fossils inside.

We swam our inflated lift-bag full of rocks back to open water and, by adding more air, sent it up to our waiting support crew. As we made our slow ascent and decompression stop I became impatient and could barely bring myself to hang around for all the necessary time. I'm no geologist, but I have worked with the best and seen them open rocks with sledgehammers. I tried this at the back of our boat and only managed to break the bread board and hit just about everyone with shrapnel. But I found that by looking for signs of possible weakness in the rock, it was easy to split them open with little force. And nearly every single one of them was rich in fossils: beautiful, clearly defined shells.

It was a fine moment – rolling around in those heavy seas holding in my hand a small rock that told the story of continents separating millions of years ago, and the birth of marine life in the southern hemisphere.

## THE POWER OF THE OCEAN

This is a deeply beautiful part of the world, and the huge skies are luminous with glorious cloud formations that take the breath away. Yet it's hard to shake off the sense of 'otherness' that prevails in the Southern Ocean. The land and seascape seem slightly alien; the dawns and sunsets appear subtly altered and the night skies are unsettlingly out of kilter. To those of us born and raised in the northern hemisphere, this half of the planet is both familiar and unfamiliar, so this expedition is taking on a faintly *Alice in Wonderland* quality.

> The land and seascape seem slightly alien; the dawns and sunsets appear subtly altered …

It's impossible to measure the power of the great Southern Ocean. There are no units that can make sense of the endless westerly winds that drive the seas into moving mountains that travel around the world. This far south the *Odalisque* was in the roaring forties where there is no land to interrupt the flow, so there is always a massive underlying ocean swell with the longest wave length on earth.

As time passed between destinations the team watched albatrosses cruising effortlessly on probably their umpteenth circumnavigation, whooped as dolphins formed up at the ship's bow, and spent hours scanning the sea below flocks of birds because that's how you spot whales. They casually wondered how long the swells were, how big the albatrosses really were. We know their wingspan is over 2 metres, but with no sense of scale your brain deceives you into thinking they are seagull size. That is until without any discernable effort, let alone a single precious wing flap, one comes next to the boat and, when he is dead level, glances to the left and looks you square in the eye. He's huge. And the look on his face says it all. None of us had ever seen birds that looked so wise, calm, superior, powerful, old. A joy.

As we headed west our comparatively underdeveloped human senses finally picked up the feeling that the sea was changing – the swells were not relaxing, there was a sense of immense power. The tops of the swells became flat plateaus and the troughs were deeper, longer. The wind was unchanged; the sky had the same fabulous clarity. We realized that the sea change was not due to any local influence. No; somewhere around the great Southern Ocean global circuit there was a storm and its power was being transmitted eastwards.

In ocean terms, in heading west the expedition was going the wrong way. The old sailors knew this. With sail power you didn't go west in the roaring forties. But the *Oceans* team had diving targets to hit and this was its only chance. So we pushed on against the rising seas. The enhanced movement brought a kind of madness on board – everyone moved faster, laughed, shouted, jumped up at the perfect moment when the boat reached the crest

of a wave, faced the wind and whooped. Vital power from the sea – we felt it coursing through us. The waves in the Southern Ocean go round and round the globe, and we absorbed some of their majestic energy.

The sense of being weightless on the crests of the waves was great at first. But it was harder to take when the waves were so long and flat on top there was time to think about the descent into the deep troughs on their other sides. The fun stopped, and as the boat began to pound against the waves, we couldn't help but wonder whether we were moving forward at all. It felt as if we were going up and down in the same place.

We made a great team at sea and could handle almost anything, but nevertheless this part of the expedition was hard. We were constantly recalcu-lating the passage and working out the knock-on effects of being slow. The physical workload was demanding as we secured the diving and boat

ABOVE *The sunsets over the Southern Ocean are spectacular and contributed to an 'other worldly' feeling that affected the whole team.*

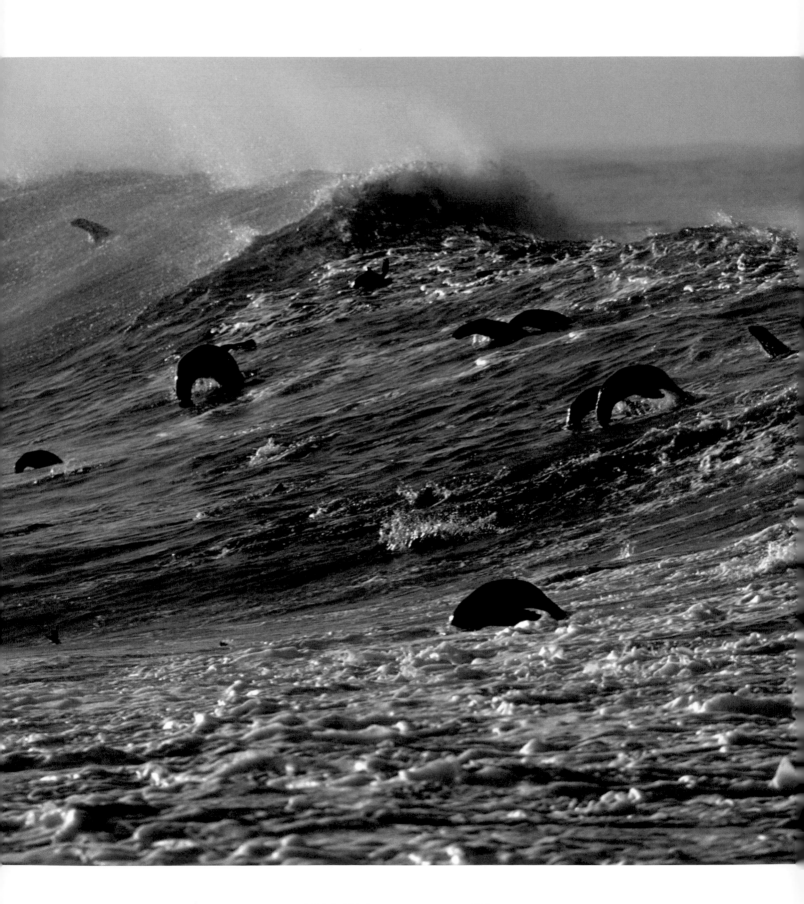

equipment, science kit and, of course, the mountains of filming equipment, and did the normal duties of standing watches and keeping lookout, as well as chasing after runaway boxes, fenders, refrigerators, buckets, ropes and diving cylinders as they made a break for freedom in the first early rolls of the storm.

A sea voyage in waters as rough as these stops being fun when the knocks and bruises multiply. Everyone gets knocked around at sea – just as your senses get in tune with the seas and you are complimenting yourself on the cool moves you are making on the rolling decks, a rogue sea screws up the rhythm and you crack your knee, elbow or head on a sharp bit of boat. Five minutes later you bash it again. And so it goes on – for days.

## A SECRET DEEP-SEA WORLD

The sense of other-worldliness was about to get even stronger as the team headed off for the next dive. Its destination was an untouched wilderness on the other side of Tasmania – Port Davey and the Bathurst Channel. It is arguably the most pristine estuarine system in southern Australia, and one of the most unusual. This natural harbour is completely isolated; there are no roads for 1,240 miles in any direction, and the only way in is from the air or the sea. The sea crossing goes right through the very worst of the roaring forties, so there are only certain times when it is even remotely possible to attempt it. It's not the isolation of this part of the island that makes it special, but a feature that has created a unique marine environment: a deep, steep-sided, narrow, drowned river valley – the Bathurst Channel – about 7½ miles long and 1170 yards wide, connecting Bathurst Harbour with Port Davey.

The waters are stained brownish-black from the peaty soils that surround the channel. This dense tannin-filled fresh water sits on top of the salt water and prevents any sunlight reaching the lower layers. Combined with low nutrient levels, this creates a remarkable habitat that mimics the depths of the oceans. And here, in just a few metres, live deep-sea creatures normally only found hundreds of metres down on the sea floor. It is thought that as the waters flooded into the valley some 6000 years ago they brought deep-sea species in with them. Because the channel is effectively blocked from the open sea by an island, Breaksea Island, which sits across its mouth, these species were trapped.

It's extremely difficult to study deep-sea creatures, for the quite obvious reason that they live deep in the ocean, normally way beyond any diveable depth, so the opportunity to see them was well worth the risky crossing.

OPPOSITE *The power of this ocean cannot be measured, but the sea creatures that live here are totally in harmony with whatever it chooses to throw at them.*

… here, in just a few metres, live deep-sea creatures normally only found hundreds of metres down …

# The Sunken Valley

**From the heaving Southern Ocean** we made our way past Breaksea Island and into the Bathurst Channel area. Suddenly everything changed. The water was totally, unbelievably glassy flat. Further into this most beautiful of natural harbours the water turned from near-shore ocean blue to hazy brown, and still further in it turned totally dark brown, like very strong black coffee.

I was about to make a unique dive with marine life that is normally found in between 50 and 400 metres of water and here lives at 10 metres. Marine scientists who work in this area identify a new species, or one that has been described only locally, on almost every dive they make.

Leaving the surface is an odd experience here – the moment your mask touches the water there is zero visibility. It's as if its outside had been brushed over with dark brown paint. There are ferocious currents here, too, so with no visibility the descent is a disorienting experience. But at 7 metres I could see again. I turned on my dive torch and looked up; the layer above me glowed reddish-brown and I was now in totally black water, but it was clear.

My torch beam lit up a world from the deep abyss. There were gardens of glorious bright orange and yellow sea pens all inflated for their feeding sessions. I watched some raise themselves out of the bottom sediment and orient themselves across the current to feed. It was magic to see them turning to find the direction of the current. The sediment was incredibly soft and it was quite difficult not to disturb it and ruin the visibility. It was hard to think that sea pens are actually simple invertebrates – they look much more complex.

As I came on to fields of sea whips it was like travelling back in time. I had last seen these while diving a lot further south and a lot deeper. These amazing gorgonians are about 2 metres long and their yellow, red and orange colours were so bright that they seemed to be glowing in the dark waters.

As I got closer to the sea whips my torch picked out some silver pouches attached to them with what looked like yellow string. As I got closer I could see that these pouches were actually draughtboard shark egg cases. It is incredible to think that the sharks attach each egg case to the sea whip with an intricate knot. Nobody knows how they do it. It's never been seen. I spent a long time shining my torch into the egg cases, looking at the wriggling baby sharks inside and wondering how a shark can tie a knot.

**OPPOSITE** *Paul Rose and Tooni Mahto admire the swaying sea pens in feeding position.*

**BELOW** *We found orange sea whips so bright that they seemed to be glowing in the dark.*

**BOTTOM** *A diver's torch lights up shark egg cases attached to the sea whips.*

## DANCE OF THE SEA PENS

The marine environment of the Bathurst Channel is biologically unique. The aquatic organisms found here include relict fauna from over 80 million years ago, and there are elements from the ice age that are extinct elsewhere but can still be found here. But it's the extraordinary deep-sea creatures that are the big attraction. The deep-sea environment is hostile and extreme – low levels of light and nutrients mean that deep-sea creatures have to adopt complex and unusual strategies to survive.

The sea pens, named after their feather-like appearance, reminiscent of antique quill pens, look for all the world like large ferns, waving on the sea floor. In fact, a sea pen is a colony of polyps, each uniquely adapted to form a different part of the invertebrate. One polyp develops into a rigid, erect stalk (the rachis) and loses its tentacles, forming a bulbous 'root' or peduncle at its base. Other polyps branch out from this central stalk, forming water intake structures (siphonozooids), feeding structures (autozooids) with nematocysts, and reproductive structures. Sea pens feed off plankton carried past them by the current and have evolved a curious mechanism to maximize their feeding opportunities while remaining safe from predators. They spend much of their time hidden in a crumpled lump under the sediment on the sea floor. However, every now and then they emerge from the sediment to feed. They pump water into their tissues to inflate them and rise up to 2 metres in height. The eddies of the downstream current trap plankton and suspended particles and swirl them around the sea pens' feeding polyps. After a while, the sea pens retreat back into the sediment. Since their feeding cycle is not tidally linked, and since it is dark, it's hard to see how this can be only a day or a night cycle. It was suspected that the sea pens continue to feed at night, but nobody had ever seen them; so here was a chance to do some research that had never been done before.

With little idea what to expect the team set up the equipment, a single time-lapse camera that took a shot every 10 minutes overnight, to record the sea pen behaviour. It is only in the unique environment of the Bathurst Channel that this is even possible.

> There, in front of our eyes was the 'dance of the sea pens'.

When the footage was finally replayed it was exhilarating. There, in front of our eyes, was the 'dance of the sea pens'. They do carry on feeding at night, and the film showed a field of the creatures inflating, turning this way and that in the current, and then deflating in a synchronized, choreographed ballet.

Thrilled with this discovery, we left this *Alice in Wonderland* part of the Southern Ocean, where the sea is brown not blue, where deep-sea creatures are found in shallow waters, and where a sunken valley lies beneath the waves.

## LOBSTER TO THE RESCUE

The expedition is coming to an end but there is one last mission to carry out. The hope is that it will be a welcome antidote to the downbeat start of the trip when the decimation of the kelp forests was revealed.

The team is about to join Craig Johnson of the University of Tasmania for lobster. Rock lobsters are one of Tasmania's main commercial catches and they are a delicacy right across Australia. But Professor Johnson is not interested in eating them; he's using them in a ground-breaking project to try to restore the kelp forests. Rock lobsters are natural predators of the sea urchins that are destroying the kelp around Tasmania and this unique project plans to reintroduce them to the damaged kelp areas in the hope that they will control the numbers of invading urchins.

ABOVE *The spiny rock lobster is the natural predator of the sea urchin. In a unique experiment they are being introduced into the kelp forests in the hope that they will control the number of invading urchins.*

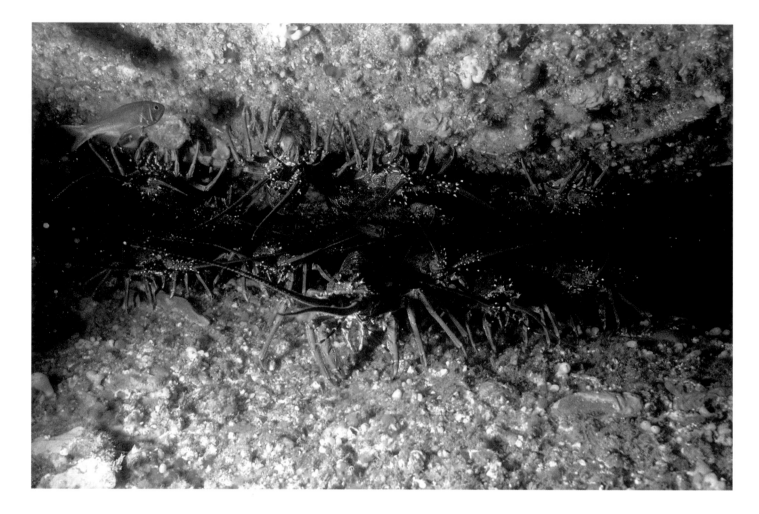

**ABOVE** *The first lobsters were released in an area that was once a thriving kelp forest but is now barren. Early indications were favourable with the specially selected large lobsters showing an interest in the urchins. Only time will tell if the experiment is successful in repelling the invaders and restoring the kelp forests.*

Professor Johnson will be working with the spiny rock lobster (*Jasus verreauxi*), which is a species found throughout the coastal waters of southern Australia and New Zealand. These lobsters live in and around reefs at depths ranging from 5 to 275 metres. They are colourful creatures, dark red and orange above with paler yellowish abdomens. Rock lobsters crawl on the bottom of the sea or swim backwards by flexing their tails sharply from their extended position to beneath the body. Their antennae are sensitive to water vibrations and, where active fisheries exist, they are quite timid and quick to withdraw further into their dens. Otherwise they are relatively active ocean-bottom explorers, and feed on almost anything that they come across.

Professor Johnson's laboratory contains tanks and tanks of enormous lobsters. Each one is a monster weighing over 22 pounds and measuring more than 140 centimetres in length. These giants have been specially selected from the deep sea for the project because only the biggest lobsters have claws that can reach around the long spines of the invading urchins, turn them over and attack their soft bellies. It is known that urchins are a favourite food of

lobster – when they are dropped near to lobsters they are eaten instantly, 'like popcorn'. But what no one knows is what will happen if the reverse is done, and lobsters are introduced to high-density urchin areas.

So today is the moment of truth. The team is heading out to Elephant Rock, near Binalong Bay by St Helens, on the Tasmanian coast. In the back of the van are crates containing 350 enormous live lobsters. The divers are about to release them into the damaged kelp areas along the bay.

Each lobster has been injected in one leg with a harmless coloured resin (bright green, pink or yellow) called elastomere, which will show around its joints making it easily identifiable. Because these lobsters are part of a conservation experiment, it is illegal to catch them, and this colouring is designed to deter fishermen from doing so. To identify each lobster individually they have also been injected with electronic 'PIT' tags, similar to microchips used for domestic dogs or cats, which will allow the scientists to keep track of the movements of the lobsters.

Once at the release site, the crates are lowered to the divers in the water. Unleashing the enormous lobsters is no easy task. As the crates are opened, the lobsters thrash and fight their way out, nipping our fingers as they go. It's an astonishing sight to see several hundred lobsters jerking and flexing their tails as they pogo their way through the water to find a niche on the rocky sea floor. This is an area that used to be a thriving kelp forest until the sea urchins took over; and the hope is that the lobsters will hunt and eat the urchins, and allow the kelp to recover. There are urchins all over this stretch of sea and it's not long before a lobster shows interest in pursuing one of the spiny invaders. It's an encouraging sign. As the last lobsters are shaken out into the water they seem to take readily to their new environment. If this release goes well, the plan is to release a total of 1500 lobsters into the kelp areas. With any luck they will take up their natural place as predators and will restore the balance of life here, protecting and preserving the kelp forest and restoring this unique and important ecosystem.

> With any luck they will take up their natural place as predators and will restore the balance of life here …

This is biological conservation in action, and success here will offer hope to other threatened ocean environments all around the world. It's an optimistic finale to the *Oceans* team's exploration of this most unusual sea which has, by turns, frustrated and exhilarated us, frightened us and given us real hope. It has shown the devastation that humanity can cause but it has also shown how the ingenuity of man can reverse that picture. And, in the end, this somewhat surreal *Alice in Wonderland* sea has turned, quite simply, into a wonderland.

# THE ARCTIC OCEAN
## Earth's Climate Controller

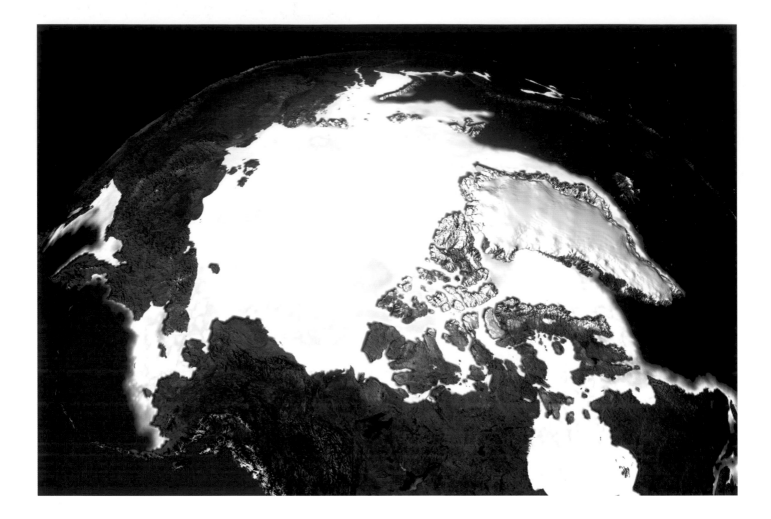

ABOVE *This satellite image shows the maximum extent of the ice on the Arctic Ocean in 2006. Ice cover has reduced further since then, at an alarming 37,300 square miles a year.*

OPPOSITE *Polar bear tracks on the ice near the Lance's mooring. The tracks reinforced the team's need for armed guards when members were working out on the ice.*

PREVIOUS PAGE *Icy wastes at Svalbard in the Arctic Ocean, once one of the world's major whaling grounds.*

THE SOUL-SPLITTING GRAUNCH that rings out as thick ice splinters makes it feel as if the earth itself is ripping asunder. There's the residue of an uncomfortable echo over chilly polar seas while the boat's sharp prow continues to scythe through pack ice. The *Oceans* expedition team has gathered on the deck of the ice-breaker *Lance* at 2 a.m., unable to sleep in the round-the-clock daylight of the Arctic midsummer. All around there bear tracks are imprinted on the surface of the ice heading off towards the horizon, the sole sign of life in this white wilderness.

Suddenly the maker of the tracks appears, the largest land carnivore on the planet and among the few species known to attack humans. This polar bear stands tall and shaggy, and is less than 10 metres from the ship. Silhouetted against the night sunlight, the undisputed master of this blank, white environment looms large and menacing. The team had arrived in the Arctic and was face to face with its most iconic inhabitant. Indeed, the Arctic, derived from the ancient Greek word *arktikos*, means land of the great bear. Weighing in at about 1760 pounds, he cuts an impressive figure.

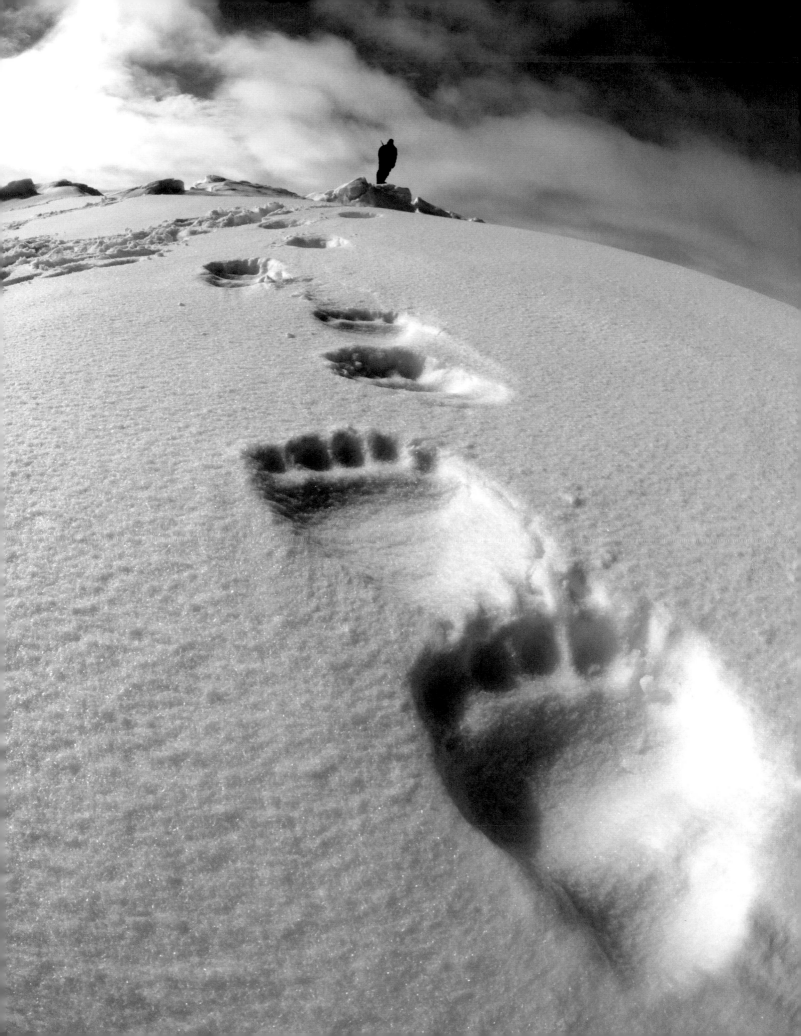

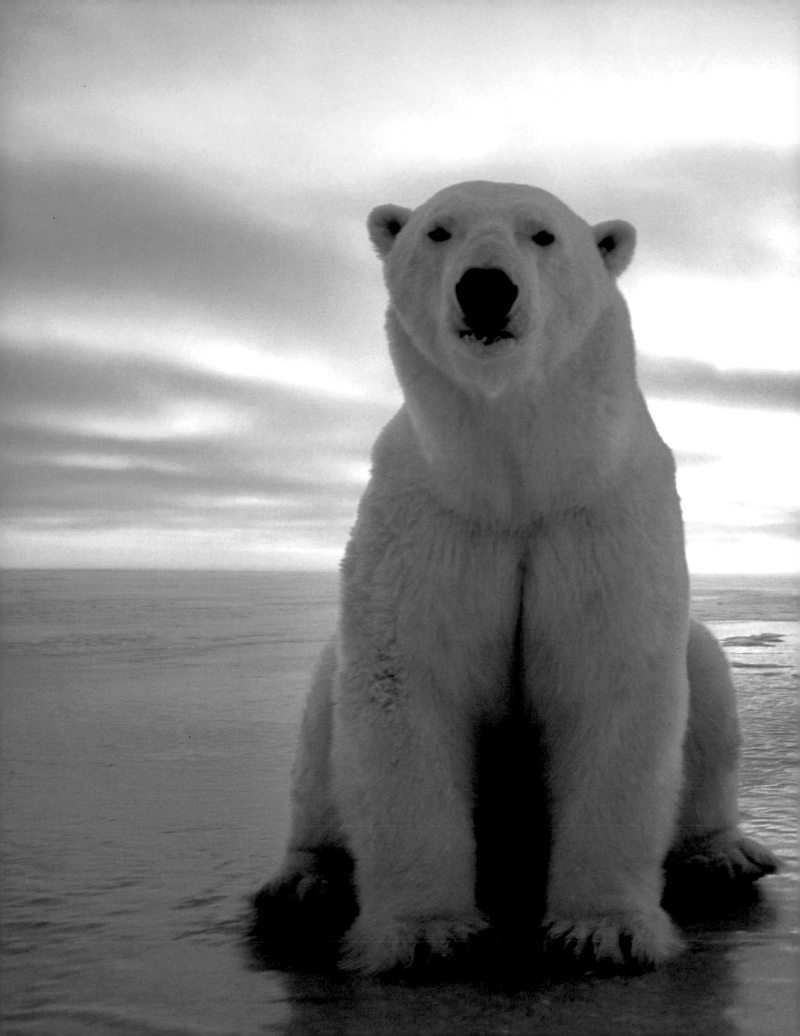

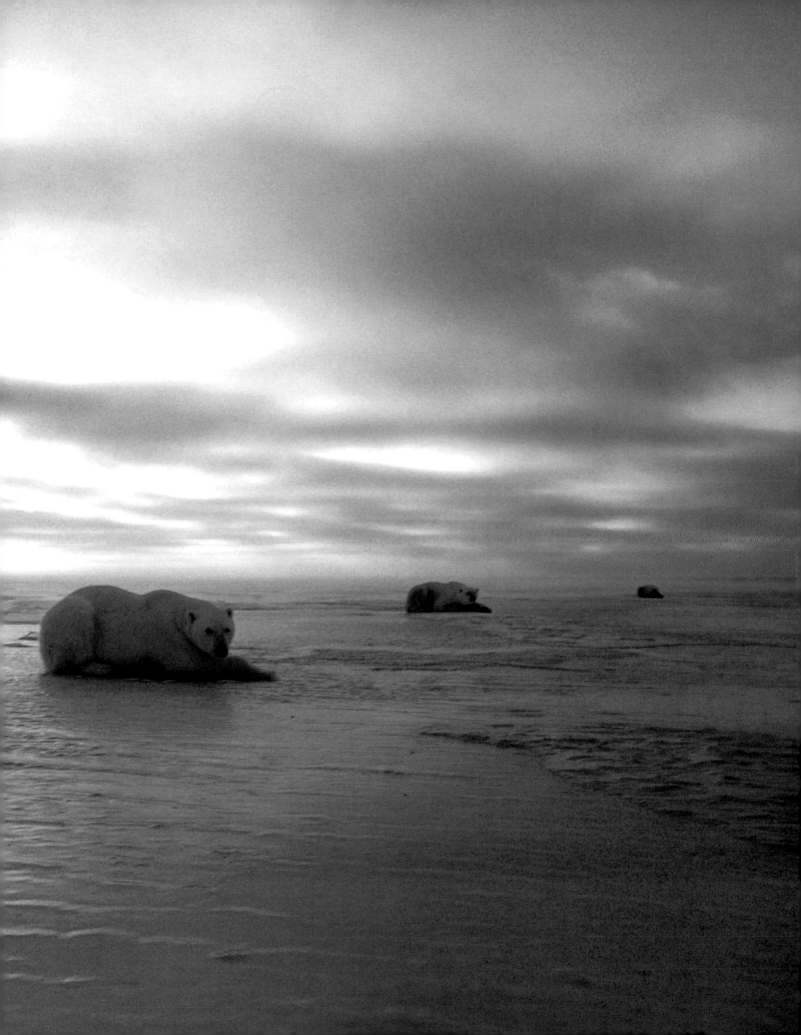

PREVIOUS PAGES *Top of the food chain: polar bears are perfectly adapted to life in the frozen wastes of the Arctic – the 'land of the great bear'.*

RIGHT *Polar bear fur is, in fact, devoid of colour, they appear white because of the way it reflects light.*

BELOW *The* Lance *at anchor some 500 miles from the North Pole. The team came this far north so that they could investigate the state of older and, so far, permanent multi-year ice.*

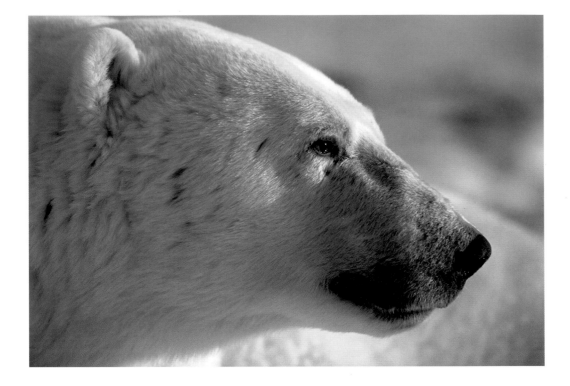

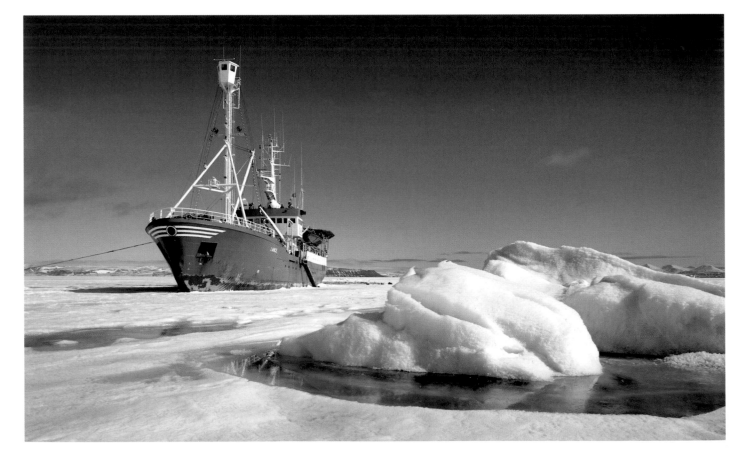

## CHANGES IN THE CHILL FACTOR

The Arctic Ocean is the smallest and shallowest of the world's oceans, but its cold water plays a pivotal role in helping to control the temperature of the oceans and, as a result, the weather and climate across the globe. Any changes have an enormous impact on the earth and the way we live. And the Arctic is changing, fast. Here the planet is thought to be warming two or three times more rapidly than elsewhere. Even a tiny tilt on the chill factor scale can have far-reaching effects on the landscape.

*Any changes have an enormous impact on the earth and the way we live.*

Until now, these snowy surroundings have reflected heat back into space, with thick ice blanketing the land and the sea beneath it so that they stay cold. But higher temperatures have taken their toll on the ice and snow and there's less of them than ever before. Meanwhile, the land and water absorb the heat rather than reflect it, and the more they are exposed the warmer the region gets. So, as the snow and ice melt the ability of the Arctic to reflect heat back to space, known as the albedo effect, is reduced, speeding up the overall rate of global warming.

Accordingly, 37,300 square miles of sea ice are being lost each year, and in 2007 the Arctic ice cover reduced to about 1.5 million square miles, the smallest it's been in modern times. A warmer Arctic will affect the vital ocean circulation systems around the world, and melting ice on land will also contribute to the rise in sea levels across our oceans.

This, the last *Oceans* expedition, will explore the changes taking place and their impact on the unique ecosystems of this extraordinary ocean.

## POLAR BEARS AT RISK

The polar bear, meanwhile, has tossed his head in a vaguely threatening way and ambled off, disappearing almost immediately into an indistinct landscape. Polar bears are perfectly adapted to life in this extreme environment, where temperatures fall to minus 30°C in winter and never get beyond 10°C, even at the height of summer. Under its dense fur, which traps warmth, a polar bear's skin is black to help it absorb the meagre heat of the Arctic sun. Beneath that skin lies a layer of fat more than 11 centimetres thick to maintain body heat. In fact, polar bears are so well insulated that they have to move slowly in order to avoid overheating. A relative of grizzly bears, polar specimens have lost all colour in their fur – they only appear to

*Polar bears are perfectly adapted to life in this extreme environment …*

be white thanks to the way their fur reflects light. But this adaptation allows them to remain hidden as they lie on the ice in wait for seals, beluga whales or even small walruses. Polar bears hunt mainly during the winter months as they need ice to access their seaborne prey. During this time they build up vital fat reserves to see them through the shorter ice-free season.

Like most life here, the bears are threatened by a warming sea. Even a slight temperature shift means the ice melts earlier in spring and forms later in autumn. Hunting time is therefore getting shorter and the bears' overall condition is deteriorating. For every week of ice lost, they end up 22 pounds lighter, and that can be crucial for the survival of pregnant bears and cubs.

Consequently, the team is keen to investigate how the pack-ice cover is doing this year. The health of the pack ice depends not just on how far it extends, but also on its thickness. An extreme dive under the ice is being planned, to explore this vital resource. The dangers of being on a ship, let alone being in the water, are starkly apparent. If someone fell overboard in these freezing seas the panic and shock they would suffer is usually sufficient to induce a heart attack. Cold water soaks up body heat 32 times faster than air does, so survival time would in any case be short.

In a few cases, the mammalian dive reflex has occurred in cold water. This is an extreme survival mechanism that kicks in on contact with icy water. The body's metabolism virtually shuts down, diverting blood away from the arms and legs to circulate, at just six to eight beats per minute, to the vital organs — the heart, brain and lungs. It might be the difference between life and death if rescue is imminent. These thoughts race around the minds of the team members on deck who are helping the divers. Those going into the water are wrestling with a separate, although equally alarming, set of issues.

As well as the perennial dangers of diving, there's a textbook or two when the plan is to dive beneath pack ice. With several metres of ice above them, escaping to the surface is not an option if anything goes wrong under water. And as the pack ice is constantly moving it could shift and seal off their entry and exit point, leaving them trapped. Despite the hazards, there is no question of avoiding this dive. Observing the ice from underneath will give an important insight into its thickness and welfare.

Unlike freshwater icebergs or glaciers, sea ice is frozen ocean water. It forms from ice crystals of sea water that have risen to the surface then coalesced. The ice layers thicken as more crystals aggregate and, over time, they form a vast floating and drifting layer that can cover up to 6 million square miles. The pack ice is not connected to a shoreline or to the ocean bottom, and can shift as much as 6 miles in a single day on tides and currents.

> With several metres of ice above them, escaping to the surface is not an option if anything goes wrong under water.

## AN ALIEN WORLD

This frozen waste seems to stretch for ever. Sea and land ice, together with glaciers, form a gleaming panorama. But to the trained eye, ice is altogether more complex and comes in a range of varieties. Apart from pack ice, there's the more loosely fashioned drift ice, newly formed pancake ice that's roughly circular in shape and fast ice that is anchored firmly to the shoreline.

The dive is prepared and the divers are roped to the ship on the surface to ensure they can be hoisted out if they get trapped. There are armed guards on polar bear patrol. Finally, the divers slip into the water. Under water, the seascape is spectacular. Above and all around are ridges, hills and hummocks of ice like inverted mountains and valleys. Vast keels of ice reach down to the depths with crests and scalloped ice carved and shaped by the movement of the sea. Where neighbouring floes have collided, the ice has been forced up into great rubble mounds on the surface and pressure ridges below. (The same happens when tectonic plates press together to form mountains and hills on land.) Dim blue-green light filters through the depths of the ice above so the underwater world appears to be unnervingly alien.

**BELOW** *Paul Rose takes the plunge into the icy waters, heading for a dive right underneath the Polar pack ice.*

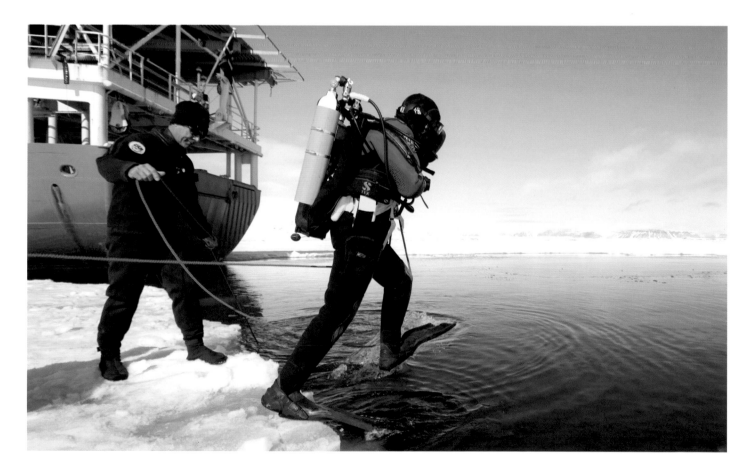

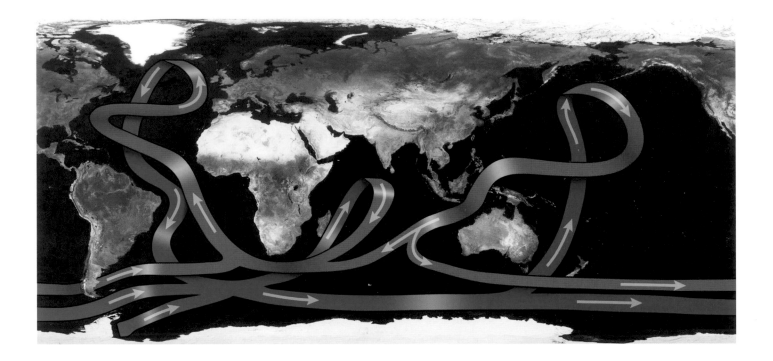

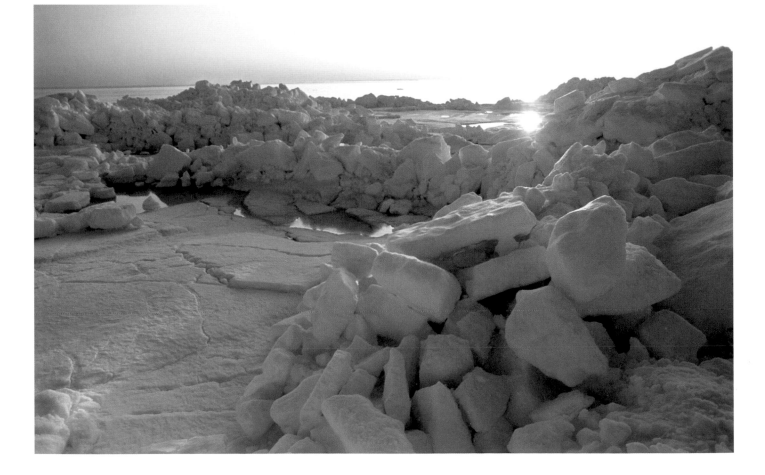

Most ice-thickness measurements come from remote satellite mapping, so data collected directly from the pack ice is very valuable in monitoring the rate at which the ice caps are melting. Ice forms over several years. Multi-year ice is thicker and more stable than first-year ice, which can melt swiftly.

Under water there are signs of melting. In places the ice cover has thinned drastically, forming blue melt ponds where the light cascades down through sea 'skylights'. Scalloped formations are visible at the edges of ridges, a result of fluid flow and heat transfer just adjacent to the ice. There are several signs that this is young ice. Overall, it is flatter than older ice, there are fewer large keels and deep ridges, and those are more jagged and sharper as they haven't been weathered by the action of waves. The thinner ice is less blue than the thicker ice because it contains more salt. Over time the salt in the ice drains out, leaving fresh water. Some old ice was fresh enough for polar explorers to have used it as drinking water. Frozen fresh water scatters light differently and appears blue, as do freshwater glaciers.

On the surface of the ice, members of the team are taking direct measurements of its thickness by boring holes through it. They will take several core samples over a wide area, but first comes the all-important 'taste test'. Ice from the cores can be melted and tasted like a fine wine. The more salty it is, the younger the ice. The water here is certainly salty and a more thorough salinity test confirms that the ice is likely to be young. For the direct measurements, four separate holes are drilled across the ice floe and a line is dropped down to the bottom of the ice. Anything more than 2–3 metres would indicate multi-year ice that's been laid down over several seasons and is less likely to melt. But the readings are all much less – 1.76 metres, 1.60, 1.56, 1.65. The floe comprises thin, first-year ice and is unlikely to be around for long. This confirms the satellite surveys. In 2008 the majority of the ice cover of the Arctic was thin ice, which is likely to melt with even a fractional temperature increase. It's more evidence of the erosion of the permanent ice cap, a recent and disturbing trend. Scientists once estimated that by 2030 the cap would have completely disappeared for parts of the year. But the ice is thinning so rapidly that a recent study by American scientists suggests this could be as soon as 2013.

The loss of ice cover in the Arctic has many profound consequences. As well as speeding up global warming as more heat is absorbed by the oceans and land, it also has a dramatic impact on the ocean circulation across the planet. All our oceans are linked into one vast ocean system. Heat and nutrients are transported around the world on powerful ocean currents that act like conveyors, and the Arctic is one of the major engines of this ocean circulation. When sea ice forms, salt is released

OPPOSITE, TOP *The world's oceans are linked into one vast system. Water is driven around the planet by temperature and water density – this is called the thermohaline circulation system. The Arctic acts as one of this system's major engines, cooling water that flows north from the Atlantic and pushing it southwards towards the tropics.*

OPPOSITE, BOTTOM *When two pack ice floes meet the ice is forced up into mounds of 'boulders'; this is similar to when tectonic plates press together to form hills or mountains on land.*

It's more evidence of the erosion of the permanent ice cap, a recent and disturbing trend.

ABOVE *The team bored holes into the ice to test its thickness and to take core samples. The ice was thin, first-year ice, which is more prone to melting.*

into the ocean water making it more dense. This cold, dense polar water sinks and moves along the ocean bottom towards the Atlantic and on to the tropics where it drives heat from the warm tropical waters around the world's oceans. The entire system is called the thermohaline circulation and is vital for the distribution of heat around the planet. This helps to control the climate and weather of the world, which in turn directly affects the lives and livelihoods of every one of us. A reduction in the amount of sea ice combined with the resulting influx of fresh water from the melt could reduce the amount of Arctic water that sinks, slowing down the thermohaline circulation.

On the evening of the dive the team gathered on the boat in the glare of the 24-hour daylight and it seemed the empty, white wilderness couldn't be more remote from the rest of the planet. And yet, as we were learning, we were in the heart of its weather engine. So much of the world's welfare and our way of life is intimately connected with this unknown, isolated outpost.

## SPRING BLOOM

The divers were back under the ice the next day and this time they were looking for life. The Arctic is one of the most hostile habitats in the world and yet, surprisingly, the ice itself is teeming with small to minuscule forms of life, all perfectly adapted to these extreme conditions.

The physical and biological properties of this ocean are unique, with extreme ranges of light and year-round ice cover. So life forms in the ice have made some remarkable adaptations. Since the organisms are the same temperature as the ice, their survival depends on preventing ice crystals forming in their bodies during the cold winter months. Many organisms have special proteins in their blood that act as a kind of anti-freeze, and accumulate large deposits of fats or fatty material to stop themselves freezing. Food is scarce here so some are sufficiently evolved to survive up to ten months of starvation.

Food is scarce here so some are sufficiently evolved to survive up to ten months of starvation.

There is one short annual pulse of prolific life, known as the spring bloom. The ice cover is reduced, the sun is out and nature makes the most of it. The nutrient-rich waters are exposed to high light levels, creating a bloom of phytoplankton that trails the edges of the ice and can stretch for more than 30 miles.

Microscopic algae grow in high concentrations on the underside of the ice, attached to ice crystals and pockets of salt water in the ice. Ice algae have a higher concentration of fats than phytoplankton, so are a rich food source. Inside the microscopic algae are even smaller diatoms. These have photosynthetic pigments that use the light to generate energy. Diatoms are considered the most important primary producers of energy within the ice, with more than 200 species occurring in the Arctic.

The Arctic spring bloom is short and the further north you go, the shorter and later the season. So energy is available in huge quantities but only for a limited time. The Arctic calanoid copepod has adapted specially to this. The tiny invertebrate eats the food available during the bloom and stores the energy in the form of energy-rich lipids. It then lives off these fat stores for the rest of the year, while providing year-round food for the rest of the food chain.

## THE HUMBLE AMPHIPOD

The creatures the expedition is interested in are slightly further up the food chain – the Arctic amphipods. Like the rest of life here, these tiny crustaceans are specially adapted to live in the unstable and extreme conditions of the pack ice. They have a ponderously slow metabolic rate, due to limited food availability and the low temperatures, and to secure reproduction in this harsh environment they live longer than other organisms, with some amphipods reaching the ripe old age of five years. And to further maximize the chances of successful reproduction, males and females spend most of their life swimming close together. Amphipods will eat anything – algae, detritus in

the water, and even, perhaps, each other. It's thought that junior amphipods of one species colonize new ice in order to avoid being eaten by adults.

Amphipods are hugely important because they are the main link to the major animals of the Arctic. They provide food for fish like the polar cod. These are then eaten by larger marine creatures, like seals and whales, who themselves are the food of the apex predators such as orca whales and polar bears. It's a complex food web, and it all starts in a very small way with the tiny life forms in the sea ice.

If current climate change predictions are correct, the reduced sea-ice cover will be a major problem for the amphipods that inhabit it. Like canaries in a gold mine, these vital creatures will be the first to die, signalling the hazards ahead. And, as they are a primary link in the food chain, their extinction will have a fundamental knock-on effect on all life in the Arctic, from fish to polar bears.

The divers' task was to collect specimens of the amphipod populations and other ice creatures, for the Arctic Ocean Biodiversity Project. Current knowledge of Arctic biodiversity is limited and has significant gaps. But now, with the tremendous ongoing changes to the Arctic Ocean, the

> Like canaries in a gold mine, these vital creatures will be the first to die.

RIGHT *The old whaling ground at Svalbard is littered with the relics of a trade that was at its height in the seventeenth century. Once the water here was teeming with whales.*

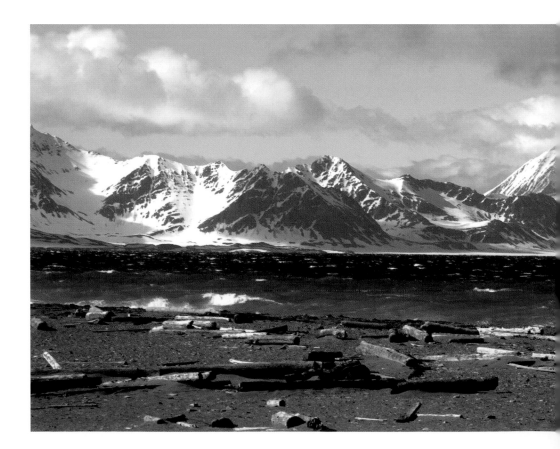

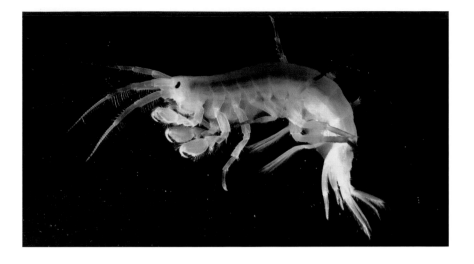

*The amphipod is a vital link in the food chain that keeps all creatures of the Arctic alive. Amphipods are specially adapted to life in the pack ice and their survival depends on it. Current reductions in the ice cover here puts them seriously at risk.*

effort to identify the diversity of life there has become an urgent issue. Collecting samples of the vibrant life living in and around the ice itself was no easy task. Most of it is tiny to the point of being invisible to the naked eye. But eventually a significant number of voucher specimens had been collected, all of which will be recorded and act as baseline data to monitor changes in biodiversity.

The tiny amphipod, curled over like a prawn, is a crucial part of life in the Arctic. As the ice retreats many of us think only of the polar bear. Perhaps we should be more worried about the humble amphipod.

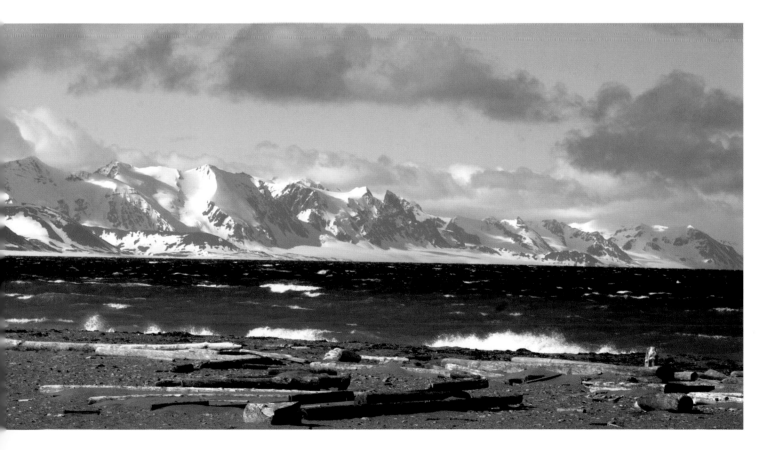

# Diving at minus 1.8°C

**I woke with a start when I felt the ship move.** Knowing the vessel was firmly anchored when I went to sleep, I threw on some kit and ran on to the deck into the blinding daylight of four o'clock in the morning to investigate. At first glance everything seemed normal. We were surrounded by polar pack ice, there was no wind and I could hear the ice grinding in the background as it always does. But we were slowly rotating around the huge ice floe when we should have been immobile.

Looking over the port side I could see that our forward line was loose and the wooden holding pole I had drilled 2 metres into the ice was lying flat on the surface of the floe. I leant further over the rail to see a polar bear grunting as he finished pulling out the midships anchor. Then he lumbered away to the stern anchor to complete the job of casting us loose. It took me a few moments to take this in, so by the time I had raised the alarm the bear was sauntering off into the distance.

As we reset the anchors I cast a wary eye along the horizon, looking for more bears. But it's almost impossible to see them out on the ice, as they blend so well with the pressure ridges and windblown features of the polar landscape. It certainly reinforced the need for our armed polar bear guards to be on duty at all times when we were out on the ice.

We had spent days breaking a route north in the dense ice pack and we were now at 81°N, 540 miles from the North Pole. Coming this far north was important as we needed to dive under multi-year ice so that we could study its formation, collect some of the life living underneath it, and take core samples from the surface to play our part in a NASA remote-sensing experiment. It also meant that we would be diving in water that was minus 1.8°C, the freezing point of sea water.

I love the preparation that takes place before a challenging dive as it clears my mind completely. It creates a sense of focus that gives me a huge amount of energy, which I know is what keeps me alive. Diving under ice requires more planning and organization than open water diving as the equipment, diving techniques and safety procedures have to be spot on.

With solid ice all the way to the North Pole and for 60 miles heading south, we had found a small pool of open water, about 7 metres by 2 metres. This was perfect for our diving as it would save hours of cutting through the 2 metre-thick ice. I jumped in and was immediately struck by the lack of visibility. I had hoped for fabulous clarity but I could only see a few metres ahead because of the profusion of algae that added a greenish tinge to the water.

Once I was a good distance under the ice I held my breath a few times to see if I could hear whale song. I had heard this many times diving under Antarctic ice and was keen to enjoy it in the north. But all I heard was the grinding of the polar pack as billions of tonnes of ice moved with ominous force. The movement is generated by the Beaufort gyre, the

> I cast a wary eye along the horizon, looking for more bears.

> … the preparation … creates a sense of focus that gives me a huge amount of energy.

**OPPOSITE** *Paul Rose swims through the icy Arctic water. He was surprised at the lack of under sea visibility caused by the profusion of algae that lives in the water and that gives the sea here its green tinge.*

great clockwise current that circles the entire Arctic Ocean. Along with the Arctic weather systems, polar-pack movement caused by the Beaufort gyre pushes the pack ice together and makes great ridges on its surface and on its bottom. I was now swimming past these under-ice ridges, which act like keels to the floes.

By following the ice keels I found areas where huge floes had overlapped each other and made caves and tunnels. Squeezing through to explore these caves in the ice just added to the fabulous sense of putting the Arctic Ocean into a personal perspective.

As I emerged from the pool I could see that the surface team had been far more uncomfortable than me, as there was a wind and the air was full of blowing snow. We warmed up before we began a series of dives to take measurements and collect samples of marine life.

Aside from the algae, I hadn't been able to see any life on the first dive. Then Jorgen, our science adviser from the Norwegian Polar Institute, told me that the amphipods we were hoping to find were white. So, of course, they were almost impossible to see. On the next dive, I changed my collection technique and kept the net open all the time, waving it around under the ice and hoping I was getting something.

When it comes to the Arctic Ocean we are in a race against time. The ice is disappearing fast. Within our lifetimes the region will become unrecognizable. Trans-Arctic will be the normal route for shipping and the loss of the ice will be a massive driver in changing the rest of the earth's climate. So it is essential that we learn and understand as much as possible about the Arctic Ocean ecosystem while we can. It felt good to know that even randomly waving a big net was helping this research.

I handed the net over to Jorgen, hoping there was something useful in it, and got busy working on my dive gear, packing the surface support unit and thinking about clearing the team off the ice and moving the ship south. Once aboard there was a huge amount to do – but I couldn't resist the temptation to check in with Jorgen. 'Anything useful in the samples?' I asked, casually. Pointing to the collection jar he said, 'A ja! Dette er en ny art!' (Oh yes! This one is a new species!).

## MOBILE MENACE

There's another, more insidious threat to Arctic life and it's one that's only recently been identified. Industrial pollutants, including cadmium, mercury, lead, caesium, uranium, organophosphates and coolants, properly called polychlorinated biphenyls or PCBs, are turning up in the body tissues of creatures throughout the food chain.

Although it is generally a pristine environment, pollutants are blown to the Arctic or brought by the ocean currents from industrialized nations further south. Cold temperatures mean that contaminants are slow to break down and the lack of sunlight further lengthens the degradation process. Both factors increase the likelihood that toxic chemicals will find their way into the food chain.

More problematic still is the fact that these poisons are largely fat-soluble and all Arctic animals have plenty of fat. Everything from amphipods to the polar bear is relatively long-lived, so toxins build up to dangerous levels and are concentrated as they travel up through the food web. Compared to land-based ecosystems, the food chain in the Arctic is complex with many layers, so animals at the top of the food web eat all the chemicals consumed by their prey, and their prey's prey, building up high concentrations of poisons.

While the levels of toxic compounds are still fairly minimal among lower orders – less than those found in other oceans of the world – they are significant in seals and are troublingly high in predators like killer whales and polar bears. No one knows what impact this is having on the health of animals in the Arctic, but studies of humans and animals under laboratory conditions have shown the disturbing effects of these pollutants. For a start, they appear to interfere with the production of sex hormones, affecting reproduction rates and the health of the young. They can inhibit the workings of the immune system, reducing the ability to fight disease, and can lead to skin damage, impairment of the nervous system and increased tumour rates. While it's difficult to assess the impact of toxic compounds on the wildlife here directly, the laboratory evidence provides a stark warning sign. When it comes to pollution, this remote wilderness, it seems, is not nearly remote enough.

The *Lance* is moving south now, away from the pack ice to the fjords of Svalbard in search of one of the Arctic's most engaging marine animals: the beluga whale. The name derives from the Russian word *belukha*, which means white, reflecting the animal's ghostly hue after a summer moult. Sometimes belugas are known as white whales.

> toxic compounds … are troublingly high in predators like killer whales and polar bears.

OPPOSITE *Following the ice keels allowed Paul Rose to access the caves and tunnels formed underneath the ice when huge floes overlap.*

## WHALE WATCH

Like most creatures of the Arctic beluga whales depend on ice, feeding around the edges of glaciers and the fast ice connected to shorelines. They also depend on tiny amphipods, existing at the rear end of the food chain. The amphipods feed the polar cod and polar cod is one of the main sources of food for belugas.

The population of belugas in Svalbard is notoriously shy, being unused to human contact. Belugas are even thought to actively avoid boats, so although they are easily distinguishable by colour spotting any will be a challenge. Two boats are sent out to scour the likely feeding grounds but, after watching and waiting for hours in the bitter cold and biting wind, there is no sign of the whales. Instead, a bearded seal is spotted, resting on an ice floe, his face ruddy from snuffling about on the sea floor where iron deposits have collected in the sediment. These stick to the seal's whiskers and oxidize to rust in the air, turning these sober-faced creatures gingery red. Bearded seals are common in the Arctic, and are the largest of all the seal species found here, with an average weight of around 440 pounds.

But it's not seals the team are trying to find and there's a sense of frustration that they haven't seen any beluga. They are almost ready to abandon all hope when someone catches a glimpse of something white breaching the surface of the water a short distance away. At last, a beluga whale breaks cover. And not just one as, typically, belugas are social creatures who travel in an average pod size of ten. More and more appear until the team are surrounded by about 30 whales glistening white and arcing in the waters of the bay.

Belugas may not be the largest of whales but a group of them still cuts an impressive spectacle. Males can reach about 4.5 metres in length and weigh around 3300 pounds. They have several talents, including being able to swim forwards and backwards, and the ability to survive in shallow water. But perhaps their most charming characteristic is the high-pitched clicks, whistles, twitters and clangs with which they communicate.

Belugas resemble dolphins and, like them, appear friendly with a gentle 'smile'. They have square, blunt heads and a prominent, oil-filled 'melon' that they use for echolocation. They are able to change the shape of the melon by blowing air around their sinuses and this, rather oddly, allows them to change their facial expression. It's thought that belugas do this, just as we do, to display different moods like aggression or appeasement.

> The population of belugas in Svalbard is notoriously shy, being unused to human contact.

> Belugas resemble dolphins and, like them, appear friendly with a gentle 'smile'.

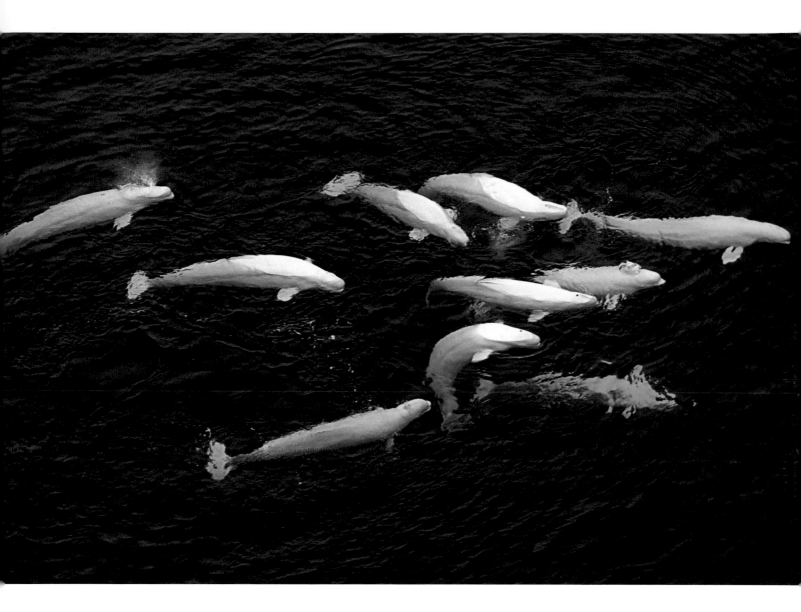

As the team watched the belugas they could see how perfectly they are designed for the hostile, harsh Arctic. These whales have a huge layer of blubber that insulates them against freezing water temperatures. Up to 40 per cent of body weight is blubber and it forms a layer up to 15 centimetres thick under their skins. The skin itself is remarkable, being ten times thicker than that of any other marine mammal and 100 times thicker than that of terrestrial mammals. It is an active, cork-like organ used for insulation, storage of high quantities of vitamin C, and possibly as protection against abrasion caused by the ice. Like other Arctic whales (bowhead whales and narwhals) the beluga has no visible dorsal fin. This might be to reduce the surface area over which heat could be lost, or simply to make swimming through the ice-covered water easier.

ABOVE *A pod of beluga whales. These social animals, at home in the cold waters of the Arctic, depend on ice, feeding in the waters on the edges of glaciers and the fast ice connected to the shoreline.*

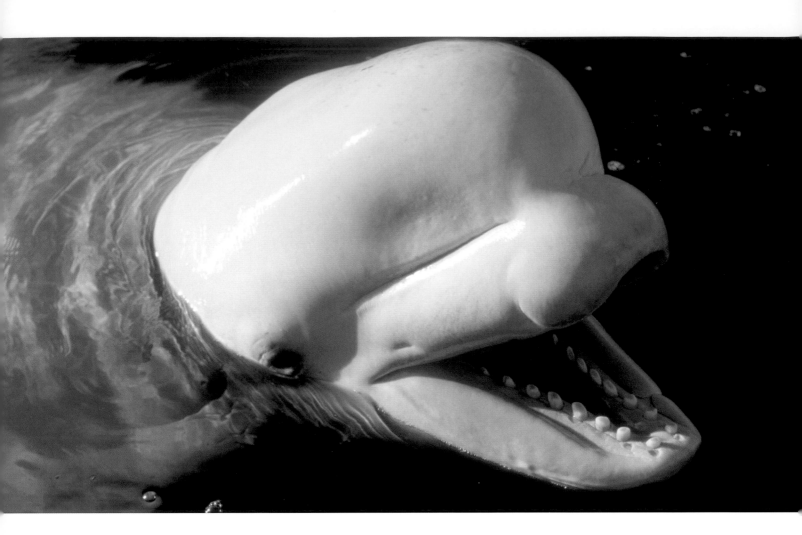

Recently it was thought that belugas restricted themselves to open sea or areas of loosely packed ice, but satellite tracking has revealed that they can move relatively rapidly in heavy pack ice, looking for thin slivers of open water where they can feed. They are remarkably efficient at finding these tiny openings, but how they do it is still a mystery. We can only presume that echolocation is the key.

*… commercial hunting of belugas continues and as a result their numbers are declining.*

Cold and discomfort are completely forgotten as the team watches these gracious beasts, elegantly and effortlessly cutting through this harsh ocean. Currently the population in Svalbard is thriving as belugas are a protected species here. But across many areas of the Arctic commercial hunting of belugas continues and as a result their numbers are declining.

Over the years, whaling has caused the destruction of whale populations and some have never recovered. The *Lance* has arrived at a blowy, snowy outpost along the shores of the Svalbard, which was once the heart of the first intensive whaling operation in the Arctic. Smeerenburg, meaning Blubber Town, is now an empty, desolate stretch of shore but in the seventeenth century it was a thriving settlement. Its wealth was built on one thing: the capture, killing and processing of whales.

## WHALING NATIONS

Standing on the beach and looking out to sea, it's hard to imagine that these waters were once heaving with whales. But early in the seventeenth century that's what drew Dutch and English whalers to this part of the Arctic. Smeerenburg was a Dutch outpost servicing up to 250 whaling ships. When whaling there was at its height (up to about the mid-seventeenth century) 200 people lived in the town and there are still the remains of huge furnaces that were used to melt the whale blubber into commercially valuable whale oil. The oil was used for light, heat, soap, cosmetics and industrial lubricants. Further, it featured in the preparation of rope, cloth and textiles, and as a mixing agent in pigments and paints. Gradually use was even found for the baleen, the bony plate at the roof of the whale's mouth that filters the zooplankton: it hugged the tiny waists of Victorian women in the form of stays in corsets.

Originally, whales were caught near to shore and processed on land in Smeerenburg and other towns, but as the industry developed in the second half of the century it moved to the open water. Whales were flensed (stripped of blubber) alongside whaling ships and the blubber was frequently boiled on the vessel to make oil.

Fuelled by the high price of the oil, whaling operations were intensive. Over the course of 200 or 300 years 122,000 whales were killed. Soon there were so few whales it became impossible to make a living, and the trade dried up, leaving many species permanently decimated. One species that was

OPPOSITE *The 'smiley' beluga is often thought to resemble a dolphin. But the blunt oil-filled melon at the front of its head houses a sophisticated echolocation system.*

LEFT *This early nineteenth century illustration shows a whale hunt in progress, with a man in the prow of the boat about to throw his harpoon.*

Now, there are
fewer than 10,000
whales across the
entire Arctic ...

particularly affected got its name from the whaling operations: the Greenland right whale. This vast creature, also known as the bowhead, is between 12 and 18 metres long and weighs between 50 and 100 tonnes. But despite its colossal size it is easy prey. It moves slowly in the water, and when dead it doesn't sink but floats on the surface. And it has a rich, thick layer of blubber. This made it the 'right' whale to hunt, the 'right' whale to kill. Once 46,000 of these lived around the waters of Spitzbergen. But the population was annihilated by the whaling industry. Despite the decline of the whale trade and the moratorium on whaling in the 1960s, the bowhead population has never really recovered. Now, there are fewer than 10,000 whales across the entire Arctic, and virtually none in the waters around Svalbard.

## WALRUS WONDERLAND

There's another Arctic creature whose story is much more positive: the vast, ungainly mass of blubber and tusk that is better known as the walrus. Walrus were also hunted intensively for their meat, skin, tusks, fat and bone, and by the middle of the nineteenth century, the population had plunged. By the time hunting stopped in 1952, they were on the point of extinction with only about 100 individuals left in the Arctic. Although numbers are still low, the protected population here is thriving and growing. And as food sources are plentiful they can continue to thrive; in short, there are plenty enough clams for everybody.

Walrus feed in shallow waters and on truffle bivalve molluscs like clams and mussels, which live on the sea bottom. Compared to the barren waste on land, the sea floor of the Arctic Ocean abounds with colourful life, especially in the shallower waters. Coralline algae – filter-feeding invertebrates – anemones and soft corals create a riot of colour. The cold waters are rich in nutrients and here the divers are surrounded by vibrant life. Crabs, sea cucumbers, sea lilies and sponges, as well as the clams and mussels loved by walrus, are abundant. Rich algae like kelp stream in the cold currents and a blaze of sea anemones and corals is breathtaking. Yet again, this extreme, isolated, apparent wilderness has upended any preconceptions.

As the expedition comes to an end and we return to warmer climes, we recognize that this trip has revealed a remarkable ocean, one that seems distant and remote yet is intimately connected to the lives of people all over the globe. An ocean that seems harsh and extreme yet supports a vibrant abundance of life – and one that appears pristine and untouched but is under threat, not from its own pollution but from ours.

OPPOSITE *The walrus is ungainly on land but awe-inspiring under the water. A fully grown male has tusks up to 40 centimetres long which it uses to spar with its rivals when finding a mate.*

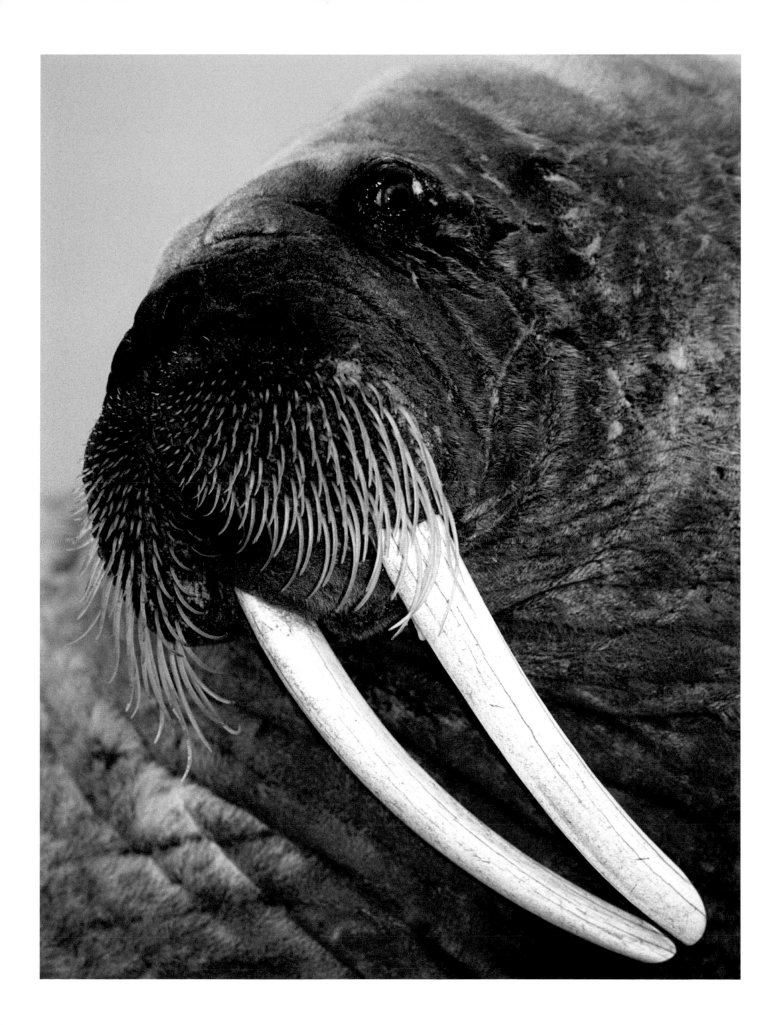

# Paul Rose versus the Walrus

**Tooni and I had been fortunate** to get very close to a group of about 40 walrus on the beach. We had started downwind of the beach so they couldn't smell us, kept ourselves very low so they couldn't see us, and had also been careful not to get between them and the sea as we didn't want to be flattened when they headed for the water.

The group comprised all males, as females and calves stay further north in close contact with the pack ice. This behaviour has evolved as a successful strategy to spread the feeding grounds, therefore increasing the likelihood of the young calves' survival. All the walrus were relaxed and seemed very sociable as they squeezed up next to each other. This close-quarter contact is key to communication between them. But they also communicate verbally, and occasionally they all burst into a great variety of snorting, shuffling, sniffing, coughing, growling, grunting, barking, clicking, rasping and even whistling.

They walrus were pale, which indicated that they had just completed a series of long dives to feed on clams. Walrus gorge themselves in bursts of two to three days and, in that time, make about 400 dives and consume a staggering 20,000 clams. After spending about 20 hours on the beach they will return for another feeding session. So walrus have an enviable lifestyle, spending three-quarters of their time at sea feeding and one-quarter on a beach. Before they head back into the sea they return to their usual brown/pink-tinged colour.

Their activity on land is fascinating, and it didn't matter to us in the slightest that it was a cold day complete with gale-force winds. We were as happy to stay on that beach as were the walrus. But I felt we were really missing out if we didn't study them under water. If they spent the majority of their time in the sea, that's where I wanted to see them.

The gale-force wind had whipped up the sea but I felt there was a chance of getting our walrus cage close to the haul-out beach, where there was a calmer eddy. The water looked murky but I thought it was worth a try. We spent a few hours towing the cage through the big seas and positioning it about 25 metres from the beach.

As I prepared to dive I remember saying to Tooni – a tad self-righteously – that this was the real way to study walrus. It's great to be with them on land but you've just got to get in there with them to really appreciate how they move. As ungainly as they are on land they would be like ballerinas when I saw them from my cage.

Tooni was smart enough to stay on the boat, and was having a superb experience studying the group from the seaward side. The moment I entered the cage I knew this was going to be difficult. Visibility was only about a metre. The walrus were very curious about us and came over in groups of three or four. Some were young, with tusks about 10 centimetres long. And then we would get a visit from a huge full-grown male with tusks at a full-sized 40 centimetres. To see these huge animals coming at you from the water

---

**Walrus binge-feeding: the numbers**

**5–7 minutes** a single feeding dive
**50 clams** per single dive
**8–9 clams** eaten per minute when diving
**1¾ pounds clam meat** per single dive
**110–154 pounds clam meat** ingested per day
**400 dives** per feeding trip
**20,000 clams** per feeding trip

---

**OPPOSITE** *Female walruses and their calves live separately from the males so as to spread their feeding grounds – a policy that has been successful in increasing the survival rates of youngsters.*

**OVERLEAF** *In the Arctic circle summertime heralds 24-hour daylight – this is the midnight sun.*

is awe-inspiring. They are massive and fast. In fact, they can reach a speed of 22 miles per hour.

When the walrus got close I ducked under the surface to see them – but I just could not see anything. I popped up and they were right there; I went down and saw nothing. I had no idea what they would look like under water but imagined they would appear to be incredibly powerful as they swam along to the feeding grounds at high speeds. I was face to face with any number of walrus on the surface and could see some of their behaviours up close. It was fun to watch how they make their eyeballs bulge in order to get a good all-round view. They came so close that I was worried that one might get a tusk caught over the top of my cage. But in the end I had to leave the walrus to their natural element. I had been at this for over an hour and had seen absolutely nothing.

Not only had they beaten me under water, but the walrus are winning in a much more important way, too; they are triumphing as the earth gets warmer because as the sea ice retreats the clam population will increase dramatically. Plus, walrus will get more access to their feeding grounds and more sites where they can haul themselves out of the sea will become available.

> I popped up and they were right there; I went down and saw nothing.

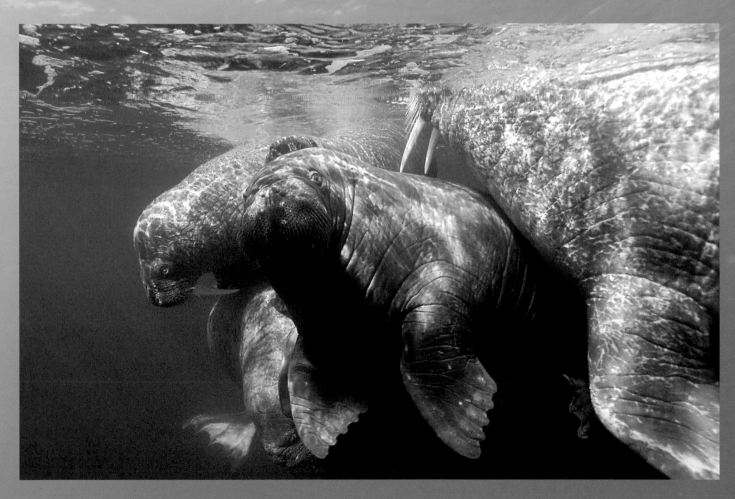

# INDEX

# ACKNOWLEDGEMENTS

This book, like the series on which it is based, is the result of an enormous team effort and we are hugely indebted to so many people for their support and encouragement.

This project could not have happened without the driving force of our series producer – half woman, half human dynamo – Helen Thomas, to whom we are extremely grateful. Huge thanks are also due for the endless hard work and dedication of Rebecca Lavender, Sophie Chapman and Gemma Thomas.

We'd also like to thank the producers of the *Oceans* series, who not only created the individual television episodes, but also kindly read and checked the chapters in the book: Daniel Barry, Matthew Dyas, Matthew Gyves, Milla Harrison, Hannah Robson and Penny Allen. We are more than grateful to the team who trawled the world to bring us the most fascinating marine science: Ruth Dyson, Helene Ganichaud, Ingrid Kvale, Helen Lambourne and Elizabeth Vancura. Particular thanks are also due to Peter Collins for his meticulous work on the drafts of the Red Sea and Atlantic chapters, and Fiona Marsh.

Thanks are due to the people that made the diving safe and possible: Richard Bull, John Chambers, Pete West, Phil Short, Gavin Newman, Brian Kakuk, Wes Skiles and his great team. And to the fantastic camera and sound crew: Scott Tibbles, Mike Kasic, Simon Reynell, Paul Atkins and Michael Pitts. Ian Kellett and Hugh Miller not only assisted and operated the cameras for the shoots, but also took many of the stunning pictures in the book.

The team travelled as a big group with over two tons of equipment and an almost impossible schedule. Thanks are due to all the team's host-nation colleagues, science collaborators, boat captains and crews, local guides and experts.

And of course, thanks to the rest of the presenting team: Lucy Blue – who also took time to read the chapters and make sure they were archaeologically honest – Philippe Cousteau and Tooni Mahto.

Thanks are due to the people who were instrumental in getting the entire project off the ground: BBC commissioner Emma Swain, who drove the development of the idea through to commission, Roly Keating of BBC2 and Martin Davidson. Thanks also to Alison Gregory, who started the project, and to Martin Redfern, who brought us to BBC Books.

At BBC Books we would especially like to thank Karen Farrington for her patient and good-humoured work turning our fractured prose into smooth sentences, and Julian Flanders – a calming and supportive presence who steered this ship beautifully into port. Thanks to David Cottingham who sourced some breathtaking pictures, to Linda Blakemore for her great work on the design, and to Lorna Russell, Muna Reyal and Christopher Tinker, who were hugely encouraging throughout.

On a personal level, Paul would like to thank Nina Ness for providing limitless support and for the steering of the Gonzo factor, his Mum for sound advice, Scott Rose for looking out for him, Nigel Winser of Earthwatch for being his inspiration, David Williams of Impact International for the massive support and the Royal Geographical Society and Marine Education Trust for their encouragement.

Anne would like to thank her family for their unstinting support and encouragement. Her sister Fran for everything, especially the daily texts, and her children Dan and Sezi, who were endlessly patient with an abstracted mother who spent most of her time sweating over a keyboard.

# PICTURE CREDITS

**Corbis** 8–9, 50, 69, 92 (above), 116, 120, 121, 183, 189, 198, 200 (above); **Geoscience Features** 51; **Getty Images** 33, 34, 45, 67, 155 (below), 157, 176–7, 189, 203, 233; **Image Quest Marine** 52–3, 62 Mark Conlon, 81 Carlos Villoch, 87 Mark Conlon, 91 Masa Ushioda, 96 Jeff Yonover, 127 Roger Steene, 145 Jez Tryner, 162–3, 165 (above) Carlos Villoch, 175 Mark Conlon, 231 Kelvin Aitken; **Mary Evans Picture Library** 229; **Naturepl.com** 46 (below) Doug Perrine, 47 Luis Quinta, 56–7 Doug Perrine, 70–1 Onne Van der Wal/Bluegreen, 108–9 Brandon Cole, 150, 152, 153 Marguerite Smits Van Oyen, 174 (above) Jeff Rotman, 179, 181 (above) Roberto Rinaldi/Bluegreen, 187, 188 Vincent Munier, 195 Roberto Rinaldi /Bluegreen, 200 (below) Jurgen Freund, 212 (above) Eric Baccega, 227, 228 Doc White; **Photolibrary Group** 4–5, 22–3, 29 (above), 29 (below), 31, 35, 48–9, 59, 82–3, 88, 99 (above), 114–15, 122, 135, 136–7, 146–7, 149, 181 (below), 182, 190–1, 197, 204, 206–7, 210–11, 234–5; **Science Photolibrary** 12 NOAA, 24, 41, 54, 63, 65, 72, 84, 85, 86, 98, 99 (below), 117, 124–5, 142, 148, 159, 165 (below), 178, 192, 193, 208, 216; **Seapics.com** 3 Doug Perrine, 90 Bob Cranston, 94–5 James D. Watt, 101 Tim Rock, 102 Bob Cranston, 105 Reinhard Dirscherl, 131, 132 Tim Rock, 174 (below) Doug Perrine.

**Ian Kellett** (BBC) 6, 7, 10, 13, 15, 17, 20, 37, 38, 42, 43, 46 (top), 58, 76, 93, 103, 106, 111, 112, 118, 129, 139, 141, 152, 155 (top), 167, 168, 170, 171, 172, 185, 194, 201, 212, 215, 216, 218, 222, 224
**Hugh Miller** (BBC) 56, 60, 75, 79 (both), 160–1, 209, 220.

University of California Press, one of the most distinguished university presses in the United States, enriches lives around the world by advancing scholarship in the humanities, social sciences, and natural sciences. Its activities are supported by the UC Press Foundation and by philanthropic contributions from individuals and institutions. For more information, visit www.ucpress.edu.

University of California Press
Berkeley and Los Angeles, California

Published to accompany the BBC television series *Oceans*, first broadcast on BBC2 in 2008.
Presenters: Paul Rose, Philippe Cousteau, Lucy Blue, and Tooni Mahto
Executive producer: Anne Laking
Series producer: Helen Thomas

First published in 2008 by BBC Books, an imprint of Ebury Publishing. A Random House Group Company.

Commissioning editors:
Martin Redfern, Lorna Russell and Muna Reyal
In-house editor: Christopher Tinker
Project editor: Julian Flanders
Copy editor: Karen Farrington
Designer: Linda Blakemore
Picture researcher: David Cottingham
Maps: Nick Heal
(Base-mapping courtesy of Tom Patterson)
Production: David Brimble

Printed and bound in China by C&C Offset Printing Co., Ltd.

Colour origination by AltaImage, London